ADVANCED
PHOTOSHOP® CS4
TRICKERY & FX

STEPHEN BURNS

Charles River Media

A part of Course Technology, Cengage Learning

COURSE TECHNOLOGY
CENGAGE Learning™

Australia, Brazil, Japan, Korea, Mexico, Singapore, Spain, United Kingdom, United States

COURSE TECHNOLOGY
CENGAGE Learning™

Advanced Photoshop CS4 Trickery & FX
Stephen Burns

Publisher and General Manager,
Course Technology PTR: Stacy L. Hiquet

Associate Director of Marketing: Sarah Panella

Content Project Manager: Jessica McNavich

Marketing Manager: Jordan Casey

Acquisitions Editor: Megan Belanger

Project and Copy Editor: Marta Justak

Technical Reviewer: Lee Kohse

PTR Editorial Services Coordinator: Jen Blaney

Interior Layout: Shawn Morningstar

Cover Designer: Michael Tanamachi

CD-ROM Producer: Brandon Penticuff

Indexer: BIM Indexing & Proofreading Services

Proofreader: Sue Boshers

For product information and technology assistance, contact us at

Cengage Learning Customer and Sales Support,
1-800-354-9706

For permission to use material from this text or product, submit all requests online at
cengage.com/permissions

Further permissions questions can be emailed to
permissionrequest@cengage.com

Adobe® Photoshop® is a registered trademark of Adobe Systems, Inc. in the U.S. and/or other countries. Windows® is a registered trademark of Microsoft Corporation in the U.S. and/or other countries. Apple® is a registered trademark of Apple Inc. in the U.S. and/or other countries. Wacom® is a registered trademark of Wacom Company. All other trademarks are the property of their respective owners.

Library of Congress Control Number: 200893942

ISBN-13: 978-158450-683-6

ISBN-10: 1-58450-683-0

Course Technology, a part of Cengage Learning
20 Channel Center Street
Boston, MA 02210
USA

Cengage Learning is a leading provider of customized learning solutions with office locations around the globe, including Singapore, the United Kingdom, Australia, Mexico, Brazil, and Japan. Locate your local office at:
international.cengage.com/region

Cengage Learning products are represented in Canada by Nelson Education, Ltd.

For your lifelong learning solutions, visit **courseptr.com**
Visit our corporate website at **cengage.com**

Printed in the United States of America
1 2 3 4 5 6 7 11 10 09

*This book is dedicated to my mom and dad
for having inspired me to always excel at what I do.*

*I also dedicate this book to my students that they may
continue to find new inspiration for their digital creations.*

FOREWORD

What is an artist anyway?

Is he what he makes and how he makes it or how well he makes it? Is he the lifestyle that he lives or the product that he creates? Is he obligated to pass on what he knows as a teacher and mentor? Is his success or failure based upon his sales or his prestige in the eyes of the critics or his value and reputation amongst other artists? What defines an artist anyway or does he defy description? Are his ideas judged by how well he respects the past and tradition or how defiant he is of the norm and standard of traditional art and his individuality and creative nature of rebellion?

Stephen Burns is all of these things and more—artist, photographer, visionary, teacher, mentor, and author. He creates beautiful artwork of traditional and nontraditional imagery. He is unique and creative in all that he attempts. His value and reputation as a teacher and mentor are well documented by any who have had the privilege of taking one of his classes or seminars, many of which are free to all who can cram into the rooms. His contribution as a leader and organizer are well known and valued by the Adobe User groups that he leads and develops.

However, as an author, he shines in all of these modes and more. Stephen has the unique and talented ability to lead the beginner or seasoned veteran through the varied and adventure-filled pathways of Photoshop. His knowledge of this program and its relevance to other 2D and 3D programs is astonishing.

I am a printmaker, photographer, and artist who has been teaching digital and analog printmaking for years. I have had the good fortune of using and teaching Photoshop on many levels to a variety of students. I approach the use of the Photoshop program as a tool for the creation of something out of nothing. It is far more than the digital darkroom that it appears to be. Use of its tools for anything other than that for which it was originally created is of supreme importance and attraction for me. Anyone who can demonstrate an application of those tools in creative ways, surprises and delights me! Stephen Burns is one of those rare individuals whose facility and understanding of those tools and techniques is beyond comparison. In his hands, Photoshop becomes the

instrument of a virtuoso performer. The methods he has developed and the imagery which results become the symphonies of harmony, color, and form which delight the eye and spirit in much the same way that a great soloist evokes wonderful music from the instrument that he or she has mastered.

Advanced Photoshop CS4 Trickery & FX takes us beyond what we think we may have known was possible in Photoshop and transports us to a realm where all is possible.

Stephen's understanding of the 2D and new 3D features is astounding. I was delighted with the many examples of exciting imagery that he created and the complex but understandable steps he takes to arrive at these gems of imagery.

Take the journey with him and become as transfixed and delighted as I was while you travel through the visions of his mind!

Jack Duganne

ACKNOWLEDGMENTS

Without the support of so many others, this book would not have been possible.

I would like to thank Jennifer Blaney and Lee Kohse of the Course Technology team for their patience and professionalism in seeing this book come to fruition properly. I also want to thank Marta Justak, Shawn Morningstar, and Sue Boshers for their work on the production of this book.

Thanks to Wacom for creating the Cintiq tablet, which is a wonderful tool for the digital artist. Particularly, I want to thank Steve Smith, Scott Gustav, Doug Little, and Pete Dietrich for their never-ending support to share the Wacom tablet with other digital artists.

Thanks to Jim Plant, Michael Kornet, Donetta Colbath, Jay Roth, and Chilton Webb of NewTek (www.newtek.com) for listening to my suggestion to create the "LightWave Importer for Photoshop" and diligently coming through with it.

In addition, a huge thanks to Adobe for creating such outstanding software, as well as Zorana Gee and Pete Falco of Adobe who patiently put up with all of my consistent questioning.

Also, I would like to thank the members of the San Diego Photoshop Users group (www.sdphotoshopusers.com) for their dedication and support in helping me build a strong network of digital artists from which I draw inspiration always.

ABOUT THE AUTHOR

Stephen Burns (www.chromeallusion.com) has discovered the same passion for the digital medium as he has for photography as an art form. His background began as a photographer 28 years ago and, in time, progressed toward the digital medium. His influences include the great Abstractionists and the Surrealists, including Jackson Pollock, Wassily Kandinsky, Pablo Picasso, Franz Kline, Mark Rothko, Mark Tobey, and Lenore Fini, to name a few.

He has been a corporate instructor and lecturer in the application of digital art and design for the past 14 years. He has exhibited digital fine art internationally at galleries such as Durban Art Museum in South Africa, Citizens Gallery in Yokahama, Japan, and CECUT Museum Of Mexico.

Digital Involvement

Stephen teaches Digital Manipulation Workshops nationwide, but you can also join him online at www.xtrain.com/stephen. In addition, you will often see him as an instructor at SIGGRAPH (www.siggraph.org) in the Guerrilla Studio.

He is the author of several books published by Charles River Media. They include *The Art of Poser & Photoshop, Advanced Photoshop CS3 Trickery & FX, Advanced Photoshop CS2 Trickery & FX,* and *Photoshop CS Trickery & FX.* Each chapter is a step-by-step instruction on creating digital effects and artwork. He has also been a contributing author in the book *Secrets of Award Winning Digital Artists* (Wiley Press) and *Photoshop CS Savvy* (Sybex). Go to www.chromeallusion.com/books.htm for more information.

Stephen is the president of the San Diego Photoshop Users Group (www.sdphotoshopusers.com) of which there are currently 3,000 members strong and growing.

On the fine art level, Stephen has organized exhibitions with galleries and artists from South Africa, Europe, Mexico, and Switzerland. Please see his resume at www.chromeallusion.com/aboutartist.htm.

TABLE OF CONTENTS

INTRODUCTION

In my last book, *Advanced Photoshop CS3 Trickery & FX*, my goal was to share that the greatest advantage that a digital artist has is that his/her medium—the computer—combines all creative art forms and gives the artist the potential to communicate on a whole new level. It only becomes "potential" when the artist is willing to broaden his perspective to include other creative traditions like painting, photography, sculpting, and animation.

Adobe has turned this potential into reality with Photoshop CS4 Extended. Photoshop CS4 Extended (www.adobe.com/products/photoshop/compare/) is the most significant upgrade from any of its predecessors. It brings together the functionality of 2D, 3D, and video into its interface. This latest version drastically improves the 3D functionality over its predecessor and gives us the potential to experiment even more abundantly. Be sure to check out the system requirements for both Windows and Mac at www.adobe.com/products/photoshop/photoshop/systemreqs/.

Each chapter is a complete tutorial that gives you insight into the possibilities for taking your creative skills to the next level. Please keep in mind that this book assumes that you already have a basic working knowledge of Photoshop's interface and the functionality of its tools. It also assumes that you are somewhat proficient with putting concepts together using multiple imagery through the use of layer masks and adjustment layers. The tutorials are organized so that most users can follow along and complete the tutorials. (You'll find them available for download on the Web site: www.courseptr.com/downloads.)

What this book does not assume is that the Photoshop practitioner is proficient in utilizing 3D texturing or animation, which we will be using to create some of the tutorials. All of the files needed, including the 3D files, are included either on the CD or on the server at www.courseptr.com/downloads. We are going to continue to use compositing and special effects to create work, but this time we will take a deeper journey to discover the potential of CS4 Extended's greatly improved 3D tools and functionality to aid our creative vision.

The goal of this book is a continuing understanding of our digital medium so that we can spend more time developing our artistic voices and less time struggling with the challenging technical learning curve. We are learning another language, and the more we use it, the more we will become fluent with its dialect.

Throughout this journey, you will be exposed to the traditional or analog approach to creating so that you can start to make a connection about how things were done in the past. Having an insight into the past not only helps us with understanding the terminology being used in Photoshop, but also serves as insight about what we are doing throughout the creative process. However, as time and technology progresses, traditional concepts are slipping further away from today's students. Their exposure from the beginning is not based on analog technology; instead, it is based on the computer. It will be interesting to see what type of artists this new age will produce.

ABOUT THE CD-ROM

The CD-ROM included with this book contains the full-color JPEG images displayed in each chapter. These files are set up by chapter in a folder called "images." Also, you will find the brushes that you can use for the tutorials in the book inside a folder called "brushes" (the file is named CS4 Trickery & FX.abr).

To access the files necessary to follow along with the tutorials, please go to the following URL (www.courseptr.com/downloads). Download these files, place them on your hard drive, and reference them from there. They will be in a folder called "tutorials" and separated by chapter number.

SIMPLIFYING THE INTERFACE

Whenever a digital program is updated, the intention is to improve its workflow, and Photoshop CS4 Extended does just that. Chapter 1 describes the new features included in the Photoshop CS4 layout and gives you a deeper insight as to how to improve your creativity with this program. To make sure we are on the same page in terms of navigating the interface, I'll provide you with a brief explanation of Photoshop CS4 Extended's interface, which includes ACR (Adobe Camera Raw), Bridge, creating brushes, and the 32-bit environment. Practical and creative uses of the tools will be covered in later tutorials.

OPEN GL IN CS4 EXTENDED

Another one of Photoshop CS4 Extended's new capabilities is that it uses the graphics card hardware to function more effectively in an Open GL (Open Graphics Language or Open Graphics Library) environment. Programmers for 3D and video programs have worked diligently to design their software so that the user can produce work more effectively without any slowdown, which usually results from rendering. Rendering is simply the process of producing shading, texturing, reflection, and lighting details to achieve a more photorealistic look. Typically, rendering takes an inordinate amount of time and decreases your productivity, which is why Adobe has created CS4 Extended to take advantage of the Open GL if the graphic card has that capability.

Open GL gives 3D animation software users the capability to see the maximum amount of texturing without actually rendering. So what you are getting is a type of proxy using shaders to simulate the texture capabilities that you have specified for your 3D surface details or video effects. Since shaders rely on vector technology, the results are instantaneous. If you plan to make the most out of CS4 Extended, then make sure that you have purchased an upgraded video card that has Open GL capabilities built in. Adobe, according to its specs, has recommended graphic cards with "Shader Model 3.0 and OpenGL 2.0" capabilities.

WACOM TABLET…AN IMPORTANT PERIPHERAL FOR ARTISTS

The one peripheral that is used by most digital artists and can help you revolutionize your workflow is the Wacom Cintiq (www.wacom.com). The Cintiq comes in two sizes: the Cintiq 12WX and the Cintiq 21UX (see Figures 1.1 and 1.2).

The 21-inch version will be your main monitor for the desktop workstation. The 12-inch solution is great to place into your laptop case and work on location. It is especially useful for plein air painting. Using this product, your workflow should be as intuitive as placing paint on canvas and creating with your brush.

FIGURE 1.1 Cintiq 12WX.

FIGURE 1.2 Cintiq 21UX.

The Wacom tablet will replace both your monitor and your mouse because you can draw or paint directly onto the Cintiq monitor. This tool gives you direct eye-to-hand functionality that simulates drawing, painting, and drafting.

PHOTOSHOP CS4 LAYOUT

Adobe continues to revolutionize the art of image making. Photoshop CS4 brings 2D and 3D workflow closer together in its environment.

The newest interface has a similar efficient layout to the one that was established in CS3. You can access the Interface options in the Preferences panel (Ctrl+K/CMD+K). You have the option to change the interface or its borders to medium gray, black, or any custom color of your choosing.

Note that this is the first version that integrates a 64-bit environment. If your processor and operating system are both 64 bits, then the installer will give you the option to install both a 32- and a 64-bit version. You can choose one over the other, but 64-bit processing is still being perfected and some hardware devices may have some compatibility issues with it. So load both versions to be safe.

Keep in mind that the intention of this chapter is not to provide an intensive listing of all the tools and commands in Photoshop. We'll assume that you already have a basic understanding of Photoshop's interface. However, we will cover some of the new features in CS4 briefly here and extensively later in the tutorials.

You will be able to access all of your commands in Photoshop CS4 in three places: toolbar, menus, and palettes (see Figure 1.3).

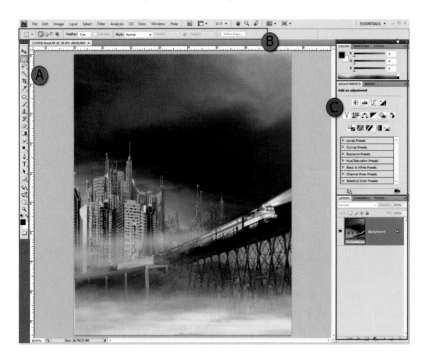

FIGURE 1.3 The Photoshop interface includes A) Toolbar or Tool Box, B) menus, and C) palettes.

When you load the program, the interface will be in the Standard Screen Mode. The beauty of this interface layout is that it's more customizable to each individual's unique workflow needs and it maximizes screen real estate. Notice that the Palette Well is gone and has been replaced with floating palettes that can be attached and detached from the edge of the interface or from one another. We will talk about palettes in more detail later in this chapter.

You can access your window viewing modes (View > Screen Mode), which are Standard Screen Mode, Full Screen Mode with Menu Bar, and Full Screen Mode (see Figure 1.4).

You can toggle through each mode by using the F key on your keyboard. In CS4 the background color stays the same default medium gray in the first two modes except for the Full Screen Mode, which is black. While holding down the spacebar, press the F key to toggle your background color to view your gray, black, or any other color that you designate. To get a custom-designated color, select the Fill tool on the toolbar, and while holding down the Shift key, click the colored interface surrounding your image. The color that is designated as your foreground color of the Tools palette will be the new color applied to your background.

FIGURE 1.4 Access the three different screen modes from the View menu.

Let's take a look at the interface for each mode. Figure 1.5 displays the default screen mode when you first load and open CS4, which is the Standard Screen Mode.

FIGURE 1.5 View of the Standard Screen Mode.

Your toolbar is attached to the left side of the interface and the palettes are on the right.

Figure 1.6 shows an example of the Full Screen Mode with Menu Bar. This will fill the screen with the image you are focusing on and hide the Tab view.

FIGURE 1.6 View of the interface in Full Screen Mode with Menu Bar.

Figure 1.7 shows an example of the Full Screen Mode, which fills the screen with the image you are focusing on and hides everything else.

FIGURE 1.7 View of the interface in Full Screen Mode.

Figures 1.8 and 1.9 show the Full Screen Mode with the gray background and the blue background, which, in this case, is a custom color. Remember to toggle through these different colors by holding down the spacebar and pressing the F key.

Let's go to the toolbar next.

FIGURE 1.8 View of the interface in Full Screen Mode with the gray background.

FIGURE 1.9 View of the interface in Full Screen Mode with the blue background.

TOOLS PALETTE

The Tools palette is the vertical slender bar that houses a visual representation of the variety of brushes and tools that you will use in your creations. Notice that it is displayed in a single column by default (see Figure 1.10).

You can also go back to what you're used to seeing in the previous versions by clicking a toggle switch in the top left-hand corner of the toolbar, as shown in Figure 1.11.

When each icon is clicked, the Options bar changes accordingly. This is because, like a painter, you are usually taught not to apply 100 percent of your pigments straight from the tube onto your canvas; instead, you will normally start in lower opacities or washes of those pigments to build form, saturation, and density over time. I think it's the technique that provides you with control over your work. Also, notice that the bar is divided into sections by a thick line. The first section contains your selection tools. The next section contains your painting tools. Below the painting tools are the vector graphic tools. The last section contains the 3D toolset. As you work through this book, you will be using the painting and selection tools quite regularly.

You also can tear the toolbar away from the interface corners. To do this, click and hold the thin tab at the top of the toolbar and drag it (as shown in Figure 1.12).

You can reattach the toolbar in exactly the same way by dragging it to the edge of the interface. When it comes close to the interface, a blue vertical line will appear on the left-hand edge, as shown in Figure 1.13. When you see this line, release your mouse to reattach the palette to the interface.

Another nice feature is the capability to float documents inside of other document palettes. Figure 1.14 shows several documents within a single window. You can access these documents by clicking their tabs along the top of the window.

Click and hold one of the tabs and pull the document out of the floating palette. Now open several other images and notice that they will all be placed inside of the current activated floating palette (see Figure 1.15).

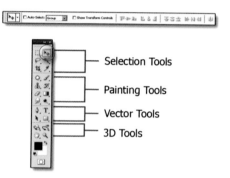

Selection Tools

Painting Tools

Vector Tools

3D Tools

FIGURE 1.11 View of each tool set and the double column toolbar mode.

FIGURE 1.10 View of the single column toolbar.

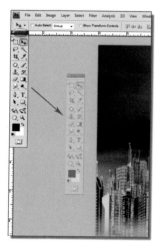

FIGURE 1.12 View of toolbar as a floating palette.

FIGURE 1.13 View of toolbar being attached to the interface.

FIGURE 1.14 View of the floating palette.

FIGURE 1.15 View of multiple floating palettes.

PALETTES

You can also access Photoshop's commands in the command palettes. Command palettes are basically visual shortcuts to many of the commands that can be found in the text menus. All palettes have a drop-down menu located on the top-right corner that looks like a small black triangle, as shown in Figure 1.16. This will give you other options for that palette.

The palettes, like the toolbar, also have customizable features. You can minimize them by clicking the toggle button on the corner of the palette, as shown in Figure 1.17

FIGURE 1.16 CS4 palettes. **FIGURE 1.17** CS4 palettes minimized.

When they are minimized, you can place your mouse on the divider between the two palettes and by clicking and dragging, you can resize them to be even smaller (see Figure 1.18).

Since we no longer have the Palette Well, you can expand the individual palettes, which in this case are the Layers, by clicking the designated icon (see Figure 1.19). When you are finished using the palette, just click anywhere on the interface, and it will automatically minimize into an iconic mode. Make sure that in your Preferences panel (Edit > Preferences) under the Interface menu that you check the Auto Collapse Icon Palettes box to enable this feature.

Auto collapsing your layer palettes can be very handy since the Palette Well is no longer available in CS4.

Just like the Tools palette, you can tear a particular palette away so that it will float on your desktop (see Figure 1.20).

FIGURE 1.18 CS4 palettes minimized even more. **FIGURE 1.19** Auto Collapse floating palettes.

These palettes are customizable in that you can attach them not only to the interface but also to one another by clicking and dragging the title bar and placing your mouse on any palette location, as shown in Figure 1.21 (A, B, and C). If the palettes are still in your way, you can access the Preferences dialog box and tell Photoshop to automatically collapse all palettes when you're done accessing them (see Figure 1.21D). This will allow you to work much like you did with the Palette Well, in which a small icon was always available when you needed to access the palettes.

FIGURE 1.20 CS4 palettes floating on the desktop. **FIGURE 1.21** Reattach the palettes to a chosen location.

If the palette positions are still too annoying, press the Tab key to make all of the tools disappear. To access them again, just move your mouse to the outer edges of your workspace to the gray bars where your palettes used to be, and they will temporarily pop up to allow you access. When you're finished using them, click anywhere on your interface, and they will completely disappear again.

Another way that you might like to customize your workflow is by placing all of your palettes into one large folder so they are not split up into sections. Figure 1.22 shows a progression from a maximized palette being repositioned within a series of palette stacks. That series is then reorganized into one large palette. Whichever way you prefer for your workflow, CS4 has the most customizable interface ever. Now let's take a look at the menus.

FIGURE 1.22 Organize your palettes in a single folder to assist you with your workflow.

MENUS

You can also access Photoshop's commands in the drop-down menus. The term "menu" refers to cascading text menus along the top left side of the interface, as shown in Figure 1.23. Within each one of these menus are submenus that give you access to deeper commands within the program. Let's take a look at the new commands added. In the File menu, Share My Screen allows you to share your desktop remotely with up to three people, which is great for sharing Photoshop techniques live with others over the Internet.

The Edit menu has a new feature called *Content-Aware Scale* (see Figure 1.24). This feature will transform the size of any photo but not affect or distort important aspects of the photograph. We will cover this feature in a later chapter.

In the Image menu, you'll find Auto Tone, Auto Contrast, and Auto Color (see Figure 1.25). These features are fairly self-explanatory and are a quick way to optimize photos that will be used on the Web.

Also new in the Image menu is the capability to apply a color space that allows for a higher dynamic range (see Figure 1.26). In CS4, you can edit files with a 32-bit channel color space.

FIGURE 1.23 Photoshop menus.

FIGURE 1.24 The Edit menu with Content-Aware Scale circled.

FIGURE 1.25 The Image menu.

FIGURE 1.26 The Image Mode options.

In the Adjustments submenu (choose Image > Adjustments), there is one new color alteration called *Vibrance* (see Figure 1.27), which is a more controlled version of Hue/Saturation. Vibrance will focus on altering the saturation in the middle gray areas of your image.

The 3D layers have received a significant facelift from their predecessor. If the use of 3D content is part of your workflow, the 3D Layers menu displays the new advancements in CS4 Extended (see Figure 1.28). Not only are you given default primitive shapes to experiment with, but you can also create 3D objects in another program and import them into a special layer called *3D Layers.* In

addition, you can edit their textures, add lights, and then move them around as if you're still in another 3D application. You will be introduced to 3D content in depth in Chapter 3, "Integrating 3D Concepts with Photography." You might also like to take a look at my latest book *The Art of Poser and Photoshop* that will take you deeper into the world of 3D in CS4 Extended.

FIGURE 1.27 The Vibrance option is a new feature in CS4.

FIGURE 1.28 The 3D Layers menu.

Wouldn't it be nice to have the same flexibility that you have with a traditional canvas to move and rotate it at will? Press R on your keyboard to activate the Rotate View tool (see Figure 1.29). Now you have the capability to rotate your canvas freely.

FIGURE 1.29 Appling the Rotate View tool.

In addition, the new interfaces give you a better way to access multiple documents within the interface. Figure 1.30 is an example of the Arrange Document command.

FIGURE 1.30 View of the Arrange Document command.

You can choose from a variety of layouts that you are most comfortable with. Experiment with these to develop a better workflow that fits your unique situation.

UNDERSTANDING THE PAINT BRUSH ENGINE

Since Photoshop 6.0, the Paint Brush engine has gone through extensive changes. You can now produce effects such as fire, smoke, sparks, and textures by using the Paint Brush's animated options. This engine has been optimized to use a digitized pen like that of the Wacom tablet. Let's get to know the basics of animating and altering brush properties and saving custom brushes.

When you click the Paint Brush icon in your toolbar, you'll see the Options bar. Click the Brush Preset Picker.

A drop-down menu of default paint strokes is listed. You can resize this menu by clicking the bottom-right corner of the palette and pulling it to any size to see more options. Use Figure 1.31 as a guide.

You can apply or view any variable brush properties in the Brush palette (Windows > Brushes) to achieve dynamic special effects via the Paint Brush. We will explore the creative possibilities in detail beginning in Chapter 6. Figure 1.32 shows the Maple Leaf brush selected.

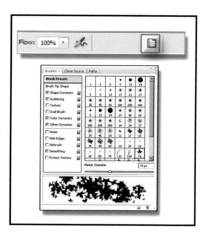

FIGURE 1.31 The Paint Brush tool.

FIGURE 1.32 Display of the variable properties of the Maple Leaf brush.

CREATING YOUR OWN ANIMATED PAINT BRUSH

Now let's see how each dynamic works to create a single animated brush.

1. Select the Maple Leaf brush and clear the Shape Dynamics option of any jitter properties (see Figure 1.33A).
2. Select Brush Tip Shape at the top of the left column. New options will appear in the right column of the Brush palette. At the bottom of the new options, you will see the Spacing function. Play with this slider to spread out the frequency of the brush strokes. You will see the result of your changes displayed in real time in the preview window (see Figure 1.33B).
3. Additionally, play with the diameter by clicking the dots on the outside of the circle and altering the shape and rotation of the brush (see Figure 1.33C).
4. Click the Shape Dynamics option and make sure that all variables are turned off. The stroke of the brush in the preview window should show one continuous size and spacing (see Figure 1.33D).
5. While still in the Shape Dynamics, adjust your jitter to 92% and notice the stroke update in the preview window, as shown in Figure 1.33E. Jitter is simply the random application of a technique over the length of the stroke. The higher the percentage, the more drastic and varied the result will be.
6. Move the Minimum Diameter slider and watch how the size of the stroke is varied over time (see Figure 1.34F).
7. As you adjust the Angle Jitter slider, notice that the brush applies a percentage of rotation over the length of each stroke. This is great for debris and cloud effects (see Figure 1.34G).

8. As you experiment with the Roundness Jitter slider, notice that this option allows you to apply the full diameter of your mouse shape or squish it for an elliptical effect over the length of the stroke (see Figure 1.34H).
9. Use the Minimum Roundness slider to set the minimum distortion that you want to apply to your image. In conjunction with the other properties, this adds a little more control (see Figure 1.34I).

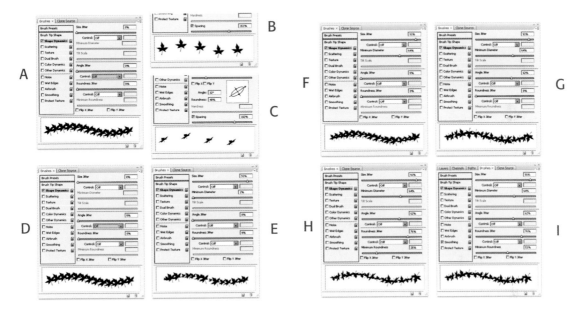

FIGURE 1.33 Brush properties are set to normal.

FIGURE 1.34 The Brush palette options give you the ability to adjust the stroke variables and size of your brush.

10. Click the Scattering layer and watch what happens in your preview window, as shown in Figure 1.35J. This is a favorite brush property—it's great for explosions.
11. Slide the Count slider to the right to add more of the brush effect to the scatter. Both Scattering and Count applied in combination can be visually powerful (see Figure 1.35K).
12. Click the Texture layer to add presets to your brush pattern, as shown in Figure 1.35L.
13. Click the Dual Brush options, as shown in Figure 1.35M, to add custom brush presets that will blend your current animated brush.

14. Change the colors of your foreground and background swatches by clicking the (front or foreground) color swatch near the bottom of the Tools palette to bring up the color picker. You can choose a color for that swatch and experiment with each of the sliders to understand its effects. There is no preview for this in the stroke window, so you will have to alter each property by drawing on a layer filled with white.

15. Select the Other Dynamics layer. Here you can tell the Brush engine how to apply the effects. Your options are to apply the technique with the Wacom pen's pressure sensitivity, fade over a specified number of pixels, or use the pen tilt, stylus wheel, or pen rotation.

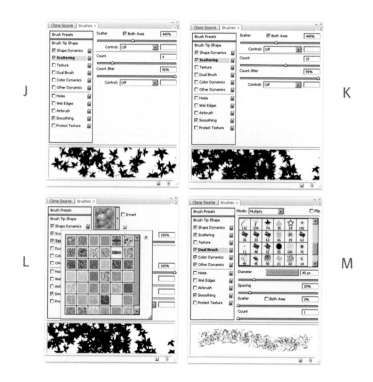

FIGURE 1.35 Add angle and roundness effect.

CREATING YOUR OWN CUSTOM BRUSH PALETTE

After you create a few custom brushes, you will want to create a custom Brush palette. In Figure 1.36, the objective is to save the custom brushes that are highlighted in red into their own palette and discard the rest.

1. With your Brush Presets cascaded, click the submenu icon and click Preset Manager, as shown in Figure 1.37.

FIGURE 1.36 View of custom Brush palette. **FIGURE 1.37** Activate the Preset Manager option.

2. Highlight all of the brushes that you are not interested in saving with a Shift+click on the first and last brush. Now click Delete to discard them (see Figure 1.38).
3. Your Brush palette should now look something like Figures 1.39 and 1.40 in the stroke view on your Options palette.

FIGURE 1.38 Highlight the brushes
to delete them.

FIGURE 1.39 Final brushes in the
Preset Manager option.

4. To save your brushes for later access, open the Brush palette submenu and click Save Brushes. Next, navigate and create a folder that you know you will be able to find when you need access to your brushes. In this example, the Folder on the desktop is named Brushes and the file name is Custom Brushes (see Figures 1.41 and 1.42).

FIGURE 1.40 Brush stroke preview on the Options bar.

FIGURE 1.41 Save brushes.

FIGURE 1.42 Save the brushes' location.

Experiment with your brush settings and discover the wide range of creative uses of the Brush engine. Also, be organized by saving the brushes under meaningful names that relate to your workflow, for example, hair brushes, smoke brushes, texture brushes, and so on. Now that you have an understanding of the brushes, let's take a look at the new Adobe Bridge interface.

THE ADOBE BRIDGE INTERFACE

The new Adobe Bridge has gone through some significant changes to allow more effective organization and categorizing of imagery. Selecting, categorizing, applying metadata, editing metadata, and previewing digital images can be done faster within an interface that is visually appealing and fun to work with.

The interface, as shown in Figure 1.43, looks very much like its predecessor.

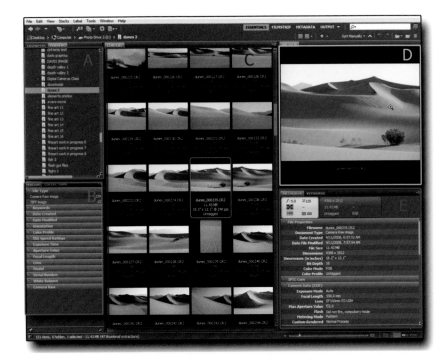

FIGURE 1.43 The Adobe Bridge interface.

The interface is divided up into five sections as follows:

Folders (A): Access any location on your hard drive through this folder browser.

Filter (B): Preview the thumbnails that have any or all of the designations that you choose from the Filter menu section. Some of the options used to preview your images are Ratings, Keywords, Date Created, Date Modified, Orientation, and Aspect Ratio.

Content (C): View the results of your filters or any images from a selected location on your hard drive.

Preview (D): Get an enlarged preview of the selected image or images.

Metadata/Keywords (E): Preview and edit your metadata. In addition, in the Keywords tab, you can create and designate keywords to one image or a group of images.

When previewing a large group of images, it is also helpful to be able to adjust the size of the image for easier viewing, as shown in Figures 1.44 and 1.45. Use the slider to resize your thumbnails on the lower-right corner of the interface.

FIGURE 1.44 Reducing thumbnail size.

FIGURE 1.45 Increasing thumbnail size.

BRIDGE VIEWING OPTIONS

Next, you'll see a series of images that will reflect the various workflow styles. On the top right-hand corner of the interface, you can see a series of displayed options. By default, Essentials is selected. Click the Filmstrip, Metadata, and Output to view the interfaces we organized to accommodate your individual work style (see Figures 1.46–1.48).

FIGURE 1. 46 View of Essentials workflow.

FIGURE 1. 47 View of Filmstrip workflow.

FIGURE 1. 48 View of Metadata workflow.

Each interface should look fairly familiar to you with the exception of Output. Bridge now has the capability to output files in a PDF format. It uses a filmstrip view along the bottom to preview your content (see Figure 1.49A). You can create proof sheets of your images or upload them to the Web with a variety of cell column and width configurations as listed under the Output options (see Figure 1.49B). In the Document section, you also have great flexibility to create in any document size, background color, and output quality. In addition, you can configure your document to be password protected (see Figure 1.49C). Under Layout, you can configure your proof sheets of your images by specifying Column and Rows (see Figure 1.49D). If you want to overlay text on top of your printout, then you will use the Overlays section to accomplish this (see Figure 1.49E).

FIGURE 1. 49 A view of the PDF workflow.

THE LABELING METHOD

If you have a client who is previewing images that you have created, the labeling method is handy for categorizing and giving rank to each of the files. Right-click the highlighted images and select the Label submenu to assign a color to the images (see Figure 1.50).

FIGURE 1.50 Right-click the selected thumbnails
to assign a color and star ratings.

WORKFLOW IN BRIDGE

Bridge is optimized for a more effective workflow in terms of organizing your photos from the digital camera to your storage drive. In Bridge, you can categorize your photos just by adding subfolders to a location on your hard drive. Knowing where all of your photos are located creates an effective organizational system. It is a good idea to have a separate hard drive to store all of your images. There are a number of external storage options on the market, so consider the number of photos that you capture regularly and purchase an external hard drive system for your needs. A lower cost alternative is to purchase an external hard drive case for under $50. Then you can purchase any size hard drive that you need and place it into the case. Most of these external cases use USB or FireWire connections and come with a built-in fan to cool the storage device.

The external drive will register as a separate drive letter on your computer and may be designated as a Removable Disk drive. Depending on the number of devices on your system, it will be given a drive letter that will range from D to Z. Now, in Bridge, navigate to your external drive.

Make sure that the Folder tab is selected in the top-left window. The window where you would normally see your thumbnails will be blank, so right-click this space and choose New Folder. Give the folder a name that best represents the photos that will be placed into it, for example, "Wedding Photos" or "Night Shots," or you can organize your shots by date. Within these folders, you can add subfolders, such as "Night Shots in New York," and so on.

After you set up a variety of folders on your hard drive, navigate to any storage card that your camera used to deposit your files. You will usually see a folder called DCIM that will have subfolders with your digital photos stored in them. View your photos in Bridge on the right and make sure that you can see your newly titled subfolders listed on the left. You can drag and drop your images into the proper categories.

CREATING KEYWORDS FOR EACH IMAGE

Now that you have organized all your photos, you need to assign them keywords so that if you need a particular image or a series of images, you can plug in a search word such as "people," and all of the appropriate photos will be listed in the thumbnail view. The following steps explain the procedure:

1. Choose the Keywords tab above the preview window. By default, you are given some predefined categories. At this stage, you will want to create your own categories, so right-click in the empty space of the keyword window and click New Keyword Set, as shown in Figure 1.51.
2. Make sure the title of the Keyword Set reflects the main category of the parent folder that each of the subfolders is located in. In this example, it is titled *Death Valley* (see Figure 1.52A). Right-click the Texture Keyword Set and select New Keyword (see Figure 1.52B). Make as many keywords as you can that will define the images associated with Texture, as shown in Figure 1.52C.
3. If you make a mistake, you always have the option to rename the Keyword Set. Just right-click the Keyword Set and select Rename. Next, type in the new title of the Keyword Set. When you are finished, press Enter; the new set will be viewed and organized alphabetically (see Figure 1.52D).
4. To rename the Keyword Set, just click twice on the title to activate the text-editing mode and then type in the new name (see Figure 1.53). When done, press the Enter key on your keyboard.

FIGURE 1.51 Create a New Keyword Set.

FIGURE 1.52 Create a new name for the Keyword Set.

5. Now, notice that after renaming the Keyword Set, it was automatically reorganized alphabetically, as shown in Figure 1.54. This is helpful to identify your categories quickly.

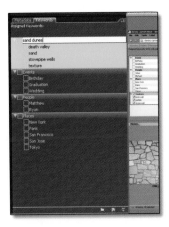

FIGURE 1.53 Rename your Keyword.

FIGURE 1.54 Renamed Keyword is automatically alphabetized.

6. Next, highlight a series of images by Shift+clicking between the first and the final image or Ctrl+clicking on individual thumbnails (see Figure 1.55). In the Keywords panel, click the check box to associate the proper Keywords with their image or images. Note that if you select the sand dune Keyword Set, all of the Keywords in this category will be applied to your chosen thumbnails.

FIGURE 1.55 Apply Keywords to multiple images.

7. Now let's test your search engine. Press Ctrl+F (PC) or Cmd+F (Mac) to bring up the Find panel. In the Source section, navigate to the folder or the sub-folders that you want to search (see Figure 1.56).

8. Under the Criteria section, select how you want Find to search for your images. Choose Keywords.

9. Define the parameters that the search engine will use to identify the images. In this case, choose Contains. Finally, enter the Keyword that you want to use. "Sand" is used here (see Figure 1.57).

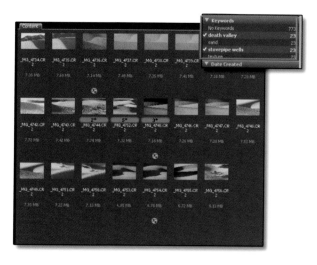

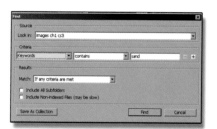

FIGURE 1.56 Choose Keywords Search Parameters dialog box.

FIGURE 1.57 View of the Search Parameters' results.

That's all there is to it. If you take a look at the thumbnails, you will now see the particular images that were associated with the "sand" search. You can also use the filters to search for images and display the thumbnails. Figure 1.58 shows check marks next to dates in December and January. Any files with these dates included in their metadata will be displayed as thumbnails.

In addition, you can preview images according to their rank or color designation. Figure 1.59 shows examples of all images that have the color designation of red.

Finally, you can organize images as groups or stacks to save space, as well as to apply properties to multiple images as a group. To do this, select two or more images, right-click, and select Stack (see Figure 1.60).

This command has just organized all of the selected images into a stack, as shown in Figures 1.61 and 1.62. The number of images in the stack is prominently displayed on the upper-left corner of each stack, so you can easily see the volume of images that you have organized in your folder.

FIGURE 1.58 Date Created filter is applied.

FIGURE 1.59 Filter applied by color.

FIGURE 1.60 Multiple images selected for a stack.

FIGURE 1.61 Selected images designated as a stack.

FIGURE 1.62 Display of multiple stacks.

THE ADOBE CAMERA RAW (ACR) INTERFACE

Figure 1.63 shows an overview of the Adobe Camera Raw (ACR) interface. It shows the basic preview pane that takes up the bulk of the interface. The tonal, color, and effects controls are on the right, and the workflow and resizing options are on the lower left. Note the histogram in the top-right corner, which displays the tonal information representing the red, green, and blue channels independently. Any information from the center to the left of the graph represents the middle to lower tonalities until it reaches black. Inversely, the center of the graph all the way to the right represents the middle to brighter tonalities toward white.

A higher vertical mound indicates a greater amount of those particular tones and colors in your image. It is important to note that the new ACR will not just open raw formats. It will now open TIFF and JPEG as well, which you'll see later.

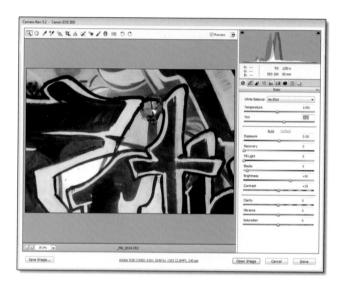

FIGURE 1.63 Raw interface.

You may use your own raw files, or you can use the one provided in Tutorials/ch 1 original images/sanddune.crw. Use Bridge to navigate to the file, right-click, and select Open in Camera Raw.

You are now going to gain some familiarity with the power of the new ACR 5.3 (Adobe Camera Raw) interface. You'll immediately see some improvements to the ACR interface. These changes will not only allow you to gain a better handle on correcting contrast, white balance, or sharpening, but they will also give you the ability to clean up any imperfections having to do with the dust on your sensor, correct red eye, and use new improved tonal and color correction tools. Bridge gives you the most effective way to open your images in ACR. Just right-click the thumbnail and select Open in Camera Raw from the list. You can open TIFF and JPEG images in ACR this way as well.

If you want your raw, JPEG, and TIFF files to open automatically in ACR, then you can specify this in two places. One is in the Photoshop preferences (Ctrl+K/CMD+K). Under the File Handling menu, you will see a section titled File Compatibility. Under that heading, click the button called Camera Raw Preferences. On the bottom, you will see a section titled JPEG and TIFF Handling. Make sure that you select Automatically Open All Supported JPEGs for the JPEG option and Automatically Open All Supported TIFFs for the TIFF option.

The second area where you can locate the ACR options is in Bridge. Just go to Edit > Camera Raw Preferences.

Let's explore the new interface.

1. Click each of the drop-down menus in the Workflow Options area to preview your options for color space(A), bit depth(B), and sizing and resolution(C), as shown in Figure 1.64.

2. White balance is simply the process of making your whites in your photograph as close to a neutral white as possible. In other words, proper white balance is the process of removing any color cast in the highlight areas. ACR gives you presets that relate directly to the white balance settings in your digital camera (see Figure 1.65). So you can choose one that will give you the best result.

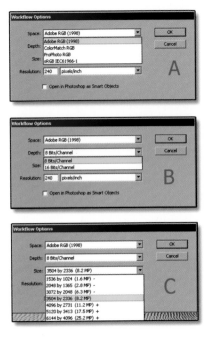

FIGURE 1.64 Raw interface color space, bit depth, and sizing and resolution options.

FIGURE 1.65 The White Balance options.

3. Take a look at the color Temperature slider under the White Balance menu. Slide it to the right and then to the left. Notice that as you slide to the right, your image becomes warmer (yellow), and as you drag in the opposite direction, your image becomes cooler (blue). The histogram in the top right gives you an update as to how all of the colors are responding to any and all adjustments in the Raw interface (see Figures 1.66 and 1.67).

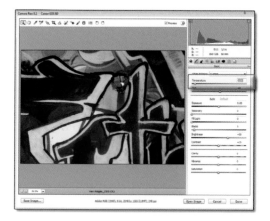 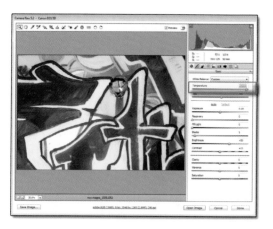

FIGURE 1.66 Raw interface color Temperature cooling options.

FIGURE 1.67 Raw interface color Temperature warming options.

4. Experiment with the Tint slider and see how you can control magenta and green. This is great for situations where textures are photographed near fluorescent lighting. Note how your histogram displays a dominant magenta or yellow, moving higher as you adjust the Tint slider to the right or left (see Figures 1.68 and 1.69).

5. The Exposure slider will help you make adjustments to any overexposed or underexposed images. In Photoshop CS3, you had to click the Preview button for both the Shadows and the Highlights at the top of the interface to observe which areas were losing detail due to underexposure or overexposure. This

FIGURE 1.68 Raw interface color tinting toward magenta.

FIGURE 1.69 Raw interface color tinting toward green.

capability was invaluable to photographers. However, the way ACR communicates which areas are losing detail due to underexposure or overexposure is through color mapping. Any shadow regions losing detail are designated with a blue tint, and any highlight areas losing detail have a red tint. If you look at the histogram in the top-right corner, you will see two arrows above the black point and the white point. Click these arrows to toggle the blue and red out of gamut preview (see Figure 1.70).

6. In a continuing effort to allow the photographer to have more control of detail in the shadow, midrange, and highlight areas of the image, Adobe has added Recovery. Experiment with the Recovery slider (see Figure 1.71) and notice that the midtone range information is becoming denser. This slider deals with the process of bringing back the midtone information by adding density in those areas.

FIGURE 1.70 Preview of where detail is being lost.

FIGURE 1.71 The Recovery slider.

7. As recovery increases the middle range total detail, the Fill Light slider allows you to brighten the middle range tonal detail (see Figure 1.72). Often in a photographic image, the shuttle and highlight information are acceptable, but the midrange of information is too dark because of the environment's extreme contrast. Adjust this slider to make changes to those areas.

8. Click the HSL/Grayscale tab and select the Convert to Grayscale button located at the top (see Figure 1.73). This is a convenient addition that will likely be very popular because it gives the photographer the ability to create black-and-white photos straight from camera raw files. You can even control the tonal values by selecting a color and shifting it toward dark or light.

FIGURE 1.72 The Fill Light slider.

FIGURE 1.73 Results of the Convert to Grayscale option.

CUSTOMIZING ACR 5 THROUGH THE OPTIONS PANEL

Let's take a look at how to customize ACR 5.2 to assist you in preparing your photographic images to be imported into Photoshop. Take a look at the icons in the top-left corner of the interface. If you look from right to left, you'll notice two circular arrows that rotate 90 degrees clockwise to the right and 90 degrees counterclockwise. To the left of those two commands, you will see the Preferences Panel icon for ACR. Figure 1.74 shows some of the options that are available. For example, you can update your JPEG previews to be medium quality or high quality, you can control the cache size, you can make some default changes to your image settings, and you can determine where you want to save the XMP data from the raw files. After you make adjustments to the settings, they will stay as default settings until you go back and alter the changes.

The next icon to the left of the Preferences icon is the Red Eye icon (Figure 1.75G). Another convenient addition to ACR is the ability to correct red eye. CS4 makes it very easy to apply this command. Just select the Red Eye icon and click the red eye in the portrait to remove the red color automatically. You will also have the option to brighten or darken the tonality to make the pupil more prominent.

Figure 1.75F shows the parameters for the Spot Removal brush that allow you to apply the Stamp tool to your raw images to remove blemishes or dust problems from the camera's sensor.

Figures 1.75E and 1.75D show the options for the Alignment and the Crop tools. The Alignment tool corrects a rotating or offset photograph. The Crop tool does exactly as the name implies—it crops the image.

FIGURE 1.74 The Preferences panel.

FIGURE 1.75 ACR options.

Figure 1.75C shows the parameters for the Parametric Curve. This is a wonderful feature that lets you apply color and tonal changes just to the areas that you select. In other words, by clicking on a local color, you can drag the slider to alter the Hue, Saturation, Luminance, and Grayscale mix of your selection.

Figure 1.75B displays the icon for the Sampler tool option to assist you with white balance or tonal correction by laying down reference points to select localized areas and adjust the white balance. Figure 1.75A is the White Balance tool icon.

Take a look at Figure 1.76. It displays an example of how the white balance can be adjusted by clicking various areas of the print. When you click a particular tonal range, the White Balance Eye Dropper will neutralize the highlights in your scene toward more of a neutral white balanced look. In this example, a color sampler was placed on the highlight, shadow and midtone region to assist in locating where to click when applying white balance. It is designated with circular markers, which are numbered 1 thru 3.

Maximum Color Samplers Allowed

Take note that the Color Sampler tool only allows up to a maximum of four targets.

FIGURE 1.76 White Balance applied to local areas of the image.

THE RETOUCH TOOL

Let's focus our attention on Figure 1.77 (A and B), which displays a facial blemish that you can eliminate with the new Retouch tool using these steps:

1. Define the area where you need to utilize the good texture and replace it all over the blemish by making sure Heal is selected under the Type menu.
2. Click and drag your mouse to define the circumference of the brush over the area that you consider as the clean texture to cover your blemish (Figure 1.77A).
3. After the brush size is set, click the Lasso and drag your mouse toward the area that you need to repair. Notice that a second circle has been created, which is designated with a red color and is in connection with the green circle. The green circle determines the good texture, and the red circle determines where you're going to place that texture.

FIGURE 1.77 Applying the Retouch tool to eliminate blemishes.

4. Drag the red circle on top of the blemish and watch the imperfection disappear, as shown in Figure 1.77B.

The Subtle Differences Between the Healing and Clone Tools

Observe the differences between the Heal and Clone options. Go to the Type menu and switch from Heal to Clone (see Figure 1.78). Healing blends the two textures, whereas Clone just applies 100% of the texture on top of the blemish, thus giving it the darker shading of that selected area in this example.

FIGURE 1.78 Using Clone as an option.

Raw File Function

You are working with a raw file so you have the ability to make several adjustments that are automatically saved with the file. You can never edit the raw file directly so you do have the option to remove and reapply any of the Retouch tool settings.

You can also define multiple areas to retouch in the photograph. Figure 1.79A shows the use of several areas being added in one sitting since the figure displays several Spot Removal circular highlights throughout the face. As you probably have already noticed, the blemishes are not the only aspect that needs to be corrected with this portrait. The red eye needs to be taken out as well, which is very common in most snapshots taken with a built-in flash.

Another great convenience included in the new ACR interface is the ability to correct red eye. We are going to use the same photo used for the Retouch tool because it has red eye issues as well. You start by dragging the selection rectangle around the area that is affected with the reddish hue (Figure 1.79B). Immediately, the red is dramatically reduced. Figure 1.79C shows the options that you have to eliminate the reddish color. Use the Pupil Size to adjust the tool's sensitivity as to the amount of reduction that is required When red eye occurs, the darker tonalities in the eye are often sacrificed, so use darken to place density back into the pupils.

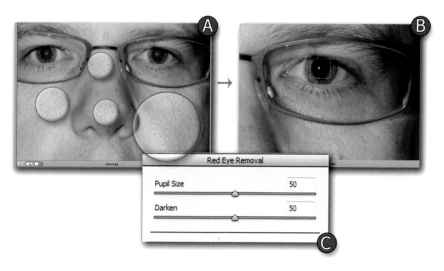

FIGURE 1.79 View of red eye and multiple placements of Retouch/Nodes.

OTHER FEATURES IN ACR 5

Next, let's look at the Curves feature. Click the Tone Curve tab to access the standard Curves command to control the contrast in the scene. You have two options. The Point option (see Figure 1.80) basically gives you the standard Curves dialog box. Notice that it has a slightly different look and that the histogram is included in the background to help you assess visually where the tones are on the graph.

The second option, Parametric, not only gives you the standard Curves, but it also gives you the sliders for adjusting the shadows, midtones, and highlight information (see Figure 1.81). You adjust these sliders just as you do in Levels.

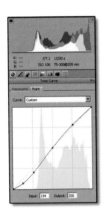

FIGURE 1.80 The Point option for Tone Curve.

FIGURE 1.81 The Parametric option for Tone Curve.

Now, take a look at the Hue (A), Saturation (B), and Luminance (C) options in Figure 1.82. Each has its own set of sliders to apply changes to primary and secondary colors. Dividing up all these colors for each aspect gives you incredible control over the color balance, white balance, and the overall color scheme.

FIGURE 1.82 The Hue (A), Saturation (B), and Luminance (C) options.

The Hue gives you access to both the primary and secondary colors in your image. If your intention is to isolate a particular color in your photograph and alter that color, then you would choose the designated slider and make your changes to that color only. For example, if you would like to have green leaves take on a warmer appearance, then you would select the slider for the Green Hues and pull that slider to the left toward a yellowish, green look.

The Saturation option increases or decreases the saturation of each individual color that is present in your image. Finally, the Luminance option selects a certain color that is present in the photograph and alters that color toward white or black.

Let's take a look at a few other nice features in the new ACR. For instance, the Detail feature applies an unsharp mask to sharpen your imagery (see Figure 1.83).

Next, Split Toning allows you to create images that are dominated by two colors (see Figure 1.84). Traditionally, this was a common technique created by using two types of toner baths to add color to black-and-white prints.

FIGURE 1.83 The Detail panel.

FIGURE 1.84 The Split Toning panel.

Finally, options are available for chromatic aberrations (Figure 1.85A) and color corrections for your camera profile (Figure 1.85B), as shown in Figure 1.85. You can also apply any presets (Figure 1.85C) that were created in ACR.

When you have applied the settings and are satisfied with the results, you can save them as XMP data presets. In this example, a new preset is titled *High Key Dunes* (see Figure 1.86).

When you save your new preset, you'll be asked what subsets to save with the file. From this list, you can simply check the options to be included and uncheck any options that you do not want attached (see Figure 1.87).

Now, if you open any other file in ACR and access the Presets tab, as shown in Figure 1.88, you can select any preset that you have created.

FIGURE 1.85 Lens Correction, Camera Calibration, and Presets.

FIGURE 1.86 Saving your XMP data. **FIGURE 1.87** Select your subset options.

FIGURE 1.88 Apply preset.

Since you are dealing with the raw file data, you have more information to experiment with than if it were formatted. In other words, you have at your command the raw 1s and 0s that the camera originally captured. After your adjustments are applied and you save the file, it is formatted as a TIFF, JPEG, or PSD of your choice. In addition, the new ACR can open not only raw format but also both TIFF and JPEG file formats. To locate a thumbnail in Bridge, right-click it and select Open in Adobe Camera Raw or just click the shortcut icon listed below the menus on the top left side of the interface (see Figure 1.89).

FIGURE 1.89 Right-click the thumbnail and select Open in Camera Raw.

FLOATING POINT CAPABILITIES

Previous versions of Photoshop have made use of the 16-bit capabilities of digital images. But technology keeps getting faster and better, and photographers demand the capability to record greater amounts of information than ever before. Now, Adobe has given you the capability to edit 32-bit images. This is, sometimes referred to as *images with floating point designations*. Let's experiment.

1. Open a new file that is a 5×5 square inch image with a resolution of 150 PPI.
2. Change it to a 32-bit file (Image > Mode > 32 Bit).
3. Take your mouse and single-click your foreground color on the bottom of your Tools palette and take a look at the Color Picker (see Figure 1.90). You have added content to the interface. Focus your attention on the top portion of the interface. The 32-bit version of the color picker displays the selected color in the center of the graph. To the left and right are one-stop increment adjustments. The right adjustments are overexposures and the left are underexposures.

4. You can adjust the preview in Stop Size increments. Take a look at Figure 1.91A–C. Each one shows the results of selecting one, two, or three Stop increments. Randomly click each color box and observe the changes in color.

FIGURE 1.90 View of 32-bit color picker.

FIGURE 1.91 View of the changes to the Preview Stop Size.

5. Take a look at the numerical equivalents and notice that you no longer have tonal designation in numerical increments of 0 to 255. Since we are working in floating point mode, we have designations from zero to one. Zero represents the absence of color and 1 represents the absolute saturation of that color. Figures 1.92 through 1.97 show the numerical representation of black, white, medium gray, red, green, and blue.

FIGURE 1.92 View of the numerical representation for black as being 0,0,0.

FIGURE 1.93 View of the numerical representation for white as being 1,1,1.

FIGURE 1.94 View of the numerical representation for medium gray as being .5, .5, .5.

FIGURE 1.95 View of the numerical representation for red as being 1,0,0.

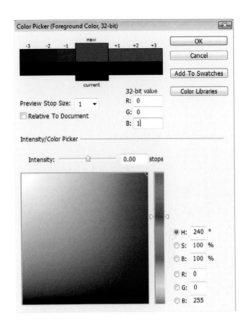

FIGURE 1.96 View of the numerical representation for green as being 0,1,0.

FIGURE 1.97 View of the numerical representation for blue as being 0,0,1.

The floating point system works in fractions where before we were working with whole numbers such as 0, 128, 255, and so on. In 32-bit mode, you are working with decimals (thus floating points), which allow you to capture subtler shades of color and tone if your digital camera or scanner has the capability to record this amount of information.

PHOTO DOWNLOADER

To assist you with better workflow, Adobe has included the Photo Downloader. This is a feature that has been part of Photoshop Elements and has found its way into Photoshop. The concept is that when you insert your storage card into your card reader, it will immediately recognize the files on the card and download them to a location of your choice. In addition, you can rename your photos or convert them into Adobe's new raw file designation called *DNG*.

1. Access the photo downloader through Bridge (File > Get Photos from Camera).
2. Take a look at Figure 1.98, which shows the basic interface of the photo downloader. Here, you can tell the program where to retrieve the photos, where to download them, or how to name the photos.

3. Click the Settings tab for Convert to DNG to view your options. In this example, the JPEG preview is set to medium. The compression box is checked in an effort to save space on the hard drive. Also check Preserve Camera Raw to preserve the original data. Finally, you have the option to embed the original raw file and the DNG file during the conversion. When done, click OK.

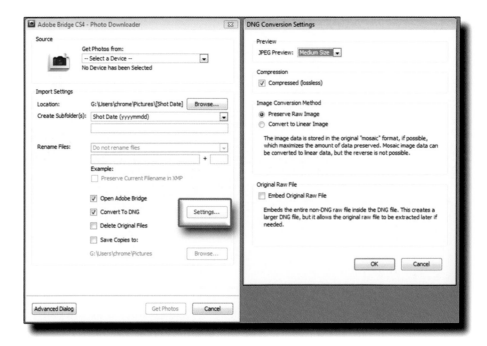

FIGURE 1.98 View of the Photo Downloader dialog box.

4. On the bottom left-hand corner of the dialog box, you'll see a button titled Advanced Dialog. Click this to customize how the photos are downloaded. When you access your card to preview your images, you can select the photos to be processed by clicking the check box.
5. Figure 1.99A gives you the location of where Photo Downloader will retrieve the photos. Figure 1.99B gives you the option to create a subfolder, as well as to rename your photos. Figure 1.99C converts the photos to DNG in the process of downloading, and Figure 1.99D gives you the choice of adding metadata while downloading.

What are the advantages of converting a file to DNG? When you make changes through ACR 5.2, the data is often saved in a sidecar in a form of XMP data. With DNG, all ACR data, including metadata, are embedded within the file itself, which is a more organized way to work.

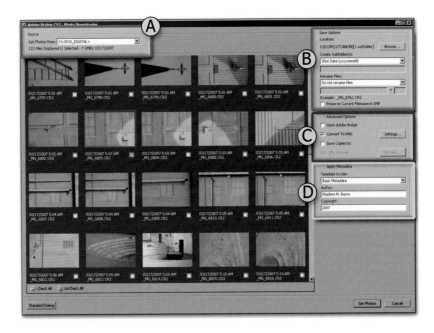

FIGURE 1.99 Photo Downloader options.

WHAT YOU HAVE LEARNED

- To use the Wacom tablet to improve workflow.
- How the CS4 interface is organized.
- The interface has only three sections to access all your commands.
- How to use the Tools palette.
- How to use cascading menus.
- The command palettes are shortcuts to what can be accessed in the cascading menus.
- The floating point is a decimal-based system.
- The new features in Bridge.
- ACR is an invaluable tool for editing raw files.
- ACR and Bridge work together.

INSIGHTS INTO LAYER BLEND MODES, MASKING, AND ADVANCED SELECTION TECHNIQUES

IN THIS CHAPTER

- How Layer Blend modes work
- How an 8-bit environment functions
- The importance of selections and how to create them
- Save selections
- Make the connection between masks and channels
- Create and edit Alpha channels
- Apply layer masks
- The new Masks panel

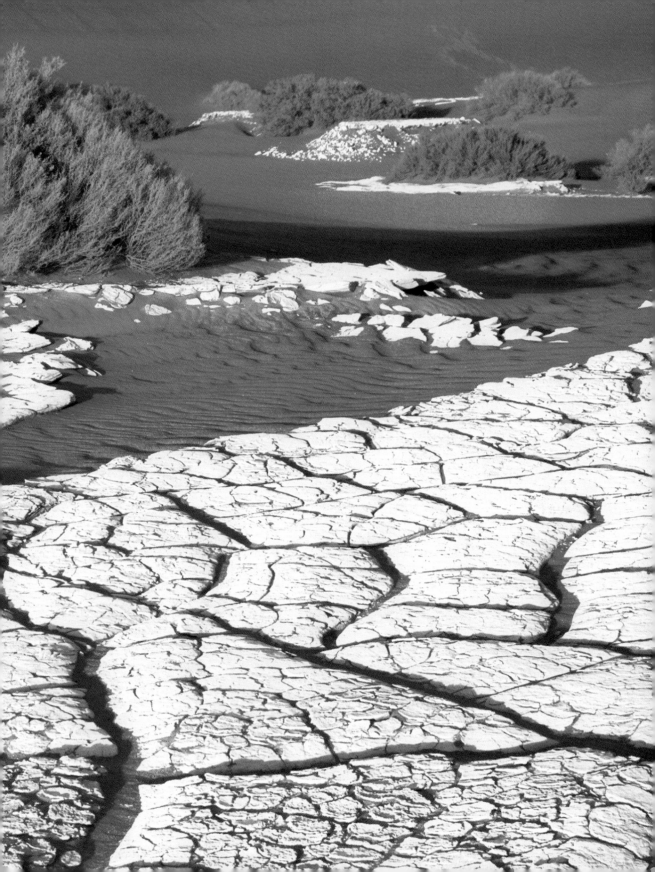

LAYER BLEND MODES

You can use the Blend modes to take advantage of ways to blend layers to produce dynamic and creative results. The Layer Blend modes reside in a drop-down menu at the top-left corner of the Layers palette. By default, it reads Normal. We will take a closer look at three of the Blend mode sections and discover what they can do and how they do it.

Since you have to have a layer to apply a Layer Blend mode, duplicate your background (Ctrl+J/Cmd+J) so that Photoshop creates that image onto its own layer. Now that you have access to your Blend modes, let's experiment.

In Figure 2.1, notice that by default your Blend mode will be set to Normal. The Normal Blend mode displays the red, green, and blue strips next to the gradient on a layer above the texture and as its namesake implies, it displays the colors normally. This Blend mode is shared with Dissolved. Dissolve simply takes anything that gradates on a layer and alters it into one-bit pixel information. Visually, it looks like little dots. Also in Figure 2.1, you will see three large sections represented by three values: black, white, and medium gray. The first section blends the highlighted layer with the layer underneath so that all of the blacks are maintained and the whites go completely transparent.

The second section blends the highlighted layer with the layer underneath so that all of the whites are maintained and the blacks go completely transparent.

The third section blends the highlighted layer with the layer underneath so that all of the blacks and whites are maintained and the medium grays (midtones) go completely transparent.

The fourth and fifth sections affect how color is displayed against the underlying layer. Let's take a look at both.

Notice what happens in the fourth section that represents Difference and Exclusion Blend modes and how it treats color and black-and-white information. The color strip will invert to its opposite hue in the area that has a brighter white on the black-and-white gradient strip while leaving the black areas unaffected. As for the RGB color strips, the Difference and Exclusion Blend mode will invert the colors to their opposite hues in the areas that show shadow detail on the texture. The areas of the texture that have highlights will simply be tinted with the original hue.

The fifth section simply blends the color with the layer underneath applying more or less saturation. The purer the hue, the more it will intensify the color. The less pure the color or colors that have black, white, or medium gray mixed with it, the more the Blend mode will desaturate that color. Notice that the Hue and Color Blend modes do the same thing; however, Color allows for a more saturated look. Saturation gives the same effect as the other two except that the hues are more intense in saturation. Finally, Luminosity simply maintains the luminous values (black-and-white information) and allows those to dominate the image. Let's look at these concepts visually for the Blend modes that affect black-and-white values.

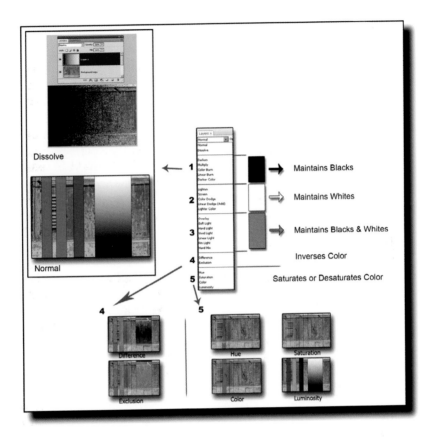

FIGURE 2.1 Blend the different layers.

LAYER BLEND MODES AND VALUES

The next exercise shows two images that illustrate how the Blend mode works. The first is an example of how the gradient is affected, and the second shows how the duplicate layer responds.

To use the Blend mode to affect the gradient, follow these steps:

1. Open the textures.jpg in the Tutorials/ch 2 folder in Photoshop and create a new layer. Press the D key to set the foreground and background color to black and white.

2. Select your Gradient tool. Starting from left to right, click and drag on your canvas while holding down the Shift key. The Shift key will constrain the flow to one direction. You have just created a fill made up of 256 shades of gray. The Blend mode is at normal, so the integrity of the gradient is maintained (see Figure 2.2).

Now let's see the effects of each gradient as we apply the Blend modes.

In the next steps, you will see two examples. One will show the effects of the Blend mode applied to the gradient, and the other will show the results of the Blend mode applied to a duplicate layer. This will give you both an understanding of how tonal information is altered and a practical view of how photographic images are affected. The modes in the first section of our example include the following:

Darken: Whites go transparent, but some residual of midtones still persists (see Figure 2.3).

Multiply: Whites go transparent, but all midtones are nonexistent (see Figure 2.4).

Color Burn: Whites go transparent, but greater saturation occurs where midtones were present (see Figure 2.5).

Linear Burn: Whites go transparent with a truer representation of the gradient (see Figure 2.6).

Darker Color: This has the same result as Darken. The difference is where Darken utilizes one channel chosen by the program to blend color, Darker Color utilizes a composite of all the channels (see Figure 2.7). So whichever one is the lighter color, that one will dominate.

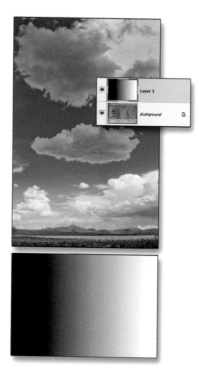

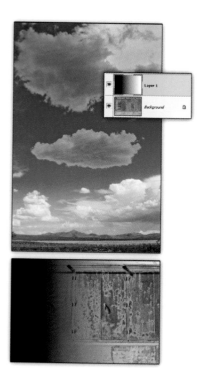

FIGURE 2.2 Effects of the Normal Blend mode on a duplicate layer.

FIGURE 2.3 The result of applying Darken.

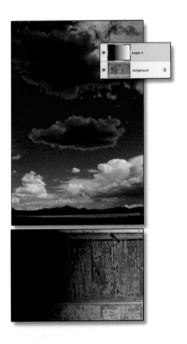

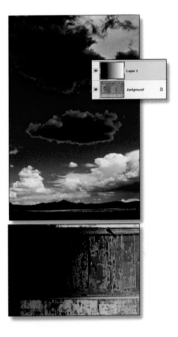

FIGURE 2.4 The result of applying Multiply. **FIGURE 2.5** The result of applying Color Burn.

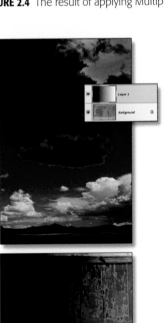

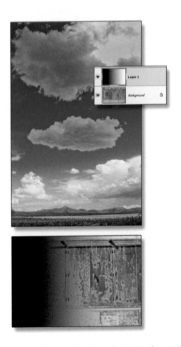

FIGURE 2.6 The result of applying Linear Burn. **FIGURE 2.7** The result of applying Darker Color.

The second section has the following modes:

- **Lighten:** Blacks go transparent, but some residual midtone persists (see Figure 2.8).
- **Screen:** Blacks go transparent, but all midtones are nonexistent (see Figure 2.9).
- **Color Dodge:** Blacks go transparent, but greater brightness occurs where midtones were present (see Figure 2.10).
- **Linear Dodge:** Blacks go transparent with a truer representation of the gradient (see Figure 2.11).
- **Lighter Color:** Blacks go transparent with a truer representation of the gradient (see Figure 2.12). This has the same result as Lighten. The difference is where Lighten utilizes one channel chosen by the program to blend color, Lighter Color utilizes a composite of all the channels. With this mode, whichever color is lighter, that color will dominate.

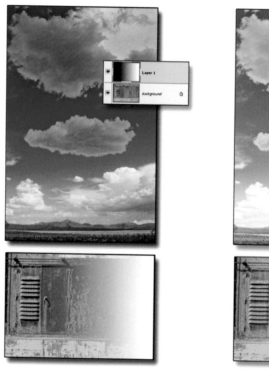

FIGURE 2.8 The result of applying Lighten.

FIGURE 2.9 The result of applying Screen.

FIGURE 2.10 The result of applying Color Dodge. **FIGURE 2.11** The result of applying Linear Dodge.

FIGURE 2.12 The result of applying Lighter Color.

The modes in the third section of the Layer Blend modes include the following:

Overlay: Midtones go transparent with some increased saturation in the low tones and higher brightness in the high tones (see Figure 2.13).

Soft Light: Midtones go transparent with subtle saturation in the low tones and subtle increased brightness in the high tones (see Figure 2.14).

Hard Light: Midtones go transparent with a higher dominance of black and white (see Figure 2.15).

Vivid Light: Midtones go transparent with drastic dominance of black and white (see Figure 2.16).

Linear Light: Midtones go transparent with purer representation of the whites and blacks (see Figure 2.17).

Pin Light: Midtones go transparent with truer representation of the gradient (see Figure 2.18).

Hard Mix: Midtones go transparent with a posterizing effect (see Figure 2.19).

FIGURE 2.13 The result of applying Overlay. **FIGURE 2.14** The result of applying Soft Light.

FIGURE 2.15 The result of applying Hard Light.

FIGURE 2.16 The result of applying Vivid Light.

FIGURE 2.17 The result of applying Linear Light.

FIGURE 2.18 The result of applying Pin Light.

FIGURE 2.19 The result of applying Hard Mix.

As you work through the tutorials, you will be given some practical applications of the use of Blend modes. There are no rules about creativity. Just set your mind to achieving more dynamic results.

PHOTOSHOP'S NATIVE 8-BIT ENVIRONMENT

To master Photoshop, you must understand selections. They are connected to masks and channels.

The image shown in Figure 2.20 is the key as to how Photoshop manages image editing. What you are looking at is a gradient that is made up of 256 steps of gray. All of the channels for RGB, CMYK, and LAB color space in Photoshop are made up of the tones in this gradient.

That's right. We are working in an 8-bit environment composed of 256 shades of gray. Let's explore this concept further.

1. At the base of your toolbar, single-click the foreground color to access the Color Picker dialog box, as shown in Figure 2.21.

FIGURE 2.20 Gradient of 256 shades of gray.

FIGURE 2.21 View absolute white with the mouse along the top-left edge.

2. As you click and drag the Color palette mouse, the top preview swatch changes to reflect the color you select. This gives you a comparison to the original foreground color shown underneath it.

3. Place your mouse pointer on the top-left corner of the Color Picker dialog box and slowly drag down the mouse vertically, making sure it remains on the left edge. What happens to the preview swatch?

4. The colors should show the range of 256 shades of gray from absolute white or luminance at the top-left corner until you reach absolute black or density, as shown in Figures 2.21 to 2.23. In essence, this is where all of the grays reside devoid of hue or color.

5. Now place your mouse on the top-left corner of the Color Picker dialog box and slowly drag the mouse horizontally, making sure it remains on the top edge. What happens this time?

FIGURE 2.22 View medium gray with the mouse along the center of the left edge.

FIGURE 2.23 View absolute black with the mouse along the bottom-left edge.

6. The colors should show the range of 256 shades of hue from absolute white or luminance at the top-left corner until you reach absolute saturation of the single hue that is selected on the top-right corner. In this case, the hue is red. In essence, this is where your luminance and pure hue reside devoid of density. Figures 2.24 through 2.26 show a sample of this progression.

FIGURE 2.24 View absolute white with the mouse along the top-left edge.

FIGURE 2.25 Progression of luminance and hue along the top horizontal edge.

7. Now place your mouse on the top-right corner of the Color Picker dialog box to get your total saturation of hue and slowly drag your mouse down, making sure it remains along the right edge.
8. The colors should show the range of absolute saturation blended with 256 shades of density until it ends at black. Figures 2.27 and 2.28 show a sample of this progression.

FIGURE 2.26 Resulting view of luminance and hue along the top horizontal edge.

FIGURE 2.27 View of saturation to density.

9. Drag your mouse anywhere inside the Color Picker dialog box and notice that you are accessing a combination of hue, density, and luminance (see Figure 2.29).

FIGURE 2.28 Resulting view of saturation to density.

FIGURE 2.29 View of hue, density, and luminance combinations.

DEMYSTIFYING THE 8-BIT ENVIRONMENT

Photoshop CS4 enables you to view 8-, 16- and 32-bit images. The functions and tools are completely available to you in the 8-bit mode; 16- and 32-bit images will have limited capabilities.

Now, let's make the connections between the numerical equivalents of color and the colors themselves.

1. Look at the numerical equivalents on the right in the Color Picker dialog box: 0 for red, green, and blue represents absolute black. So type 0 in each box next to the R, G, and B boxes, as shown in Figure 2.30A. Notice that the small selection circle jumps to the bottom left.
2. If 0 for the RGB values is absolute black, and if there are only 256 shades of gray, then the numerical equivalent of absolute white is 255. Type 255 into the R, G, and B boxes (refer to Figure 2.30B). Notice that the small selection circle jumps to the top left.
3. Now let's establish what the midtone will be. This is the tone that photographers worship because it gives them accurate light meter readings when they record their imagery. It is normally referred to as the 18% gray value. This value is in the middle of your absolute white and black values.
4. Type 128 in the R, G, and B boxes (refer to Figure 2.30C).
5. Now let's get a white that is brighter than 255 white. Type 256 in the R, G, and B boxes.

We have an error. What happened?

We just proved that Photoshop does not understand anything beyond 256 steps of gray because it's an 8-bit environment. Mathematically, that is 2 to the power of 8; 2 multiplied by itself 8 times is 256. It is base 2 because the computer only understands 2 variables: 1s and 0s (see Figure 2.31).

FIGURE 2.30 Numerical equivalents for black, white, and gray.

FIGURE 2.31 Error dialog box.

UNDERSTANDING SELECTIONS

Remember, selections, masks, and channels are identical.

Keep in mind that Photoshop does not know what you are trying to achieve. You must tell it what, when, where, and how to apply its effects. This is done through selections. Let's prove this concept.

By accessing the Magic Wand tool, a selection is made around the foreground stone, as shown in Figure 2.32. Adjust your tolerance as needed. The higher the tolerance number, the greater the range of color or tone it will select. The lower the number, the less sensitive it will be in selecting tones.

As you may notice, you now have what is affectionately called *marching ants,* which represents your selection. The program is communicating that any areas outside the borders of these marching ants will not respond to any of Photoshop's commands or tools.

As an example, if you apply the Hue/Saturation command while the selection is still active, all of its effects will be applied within the selected area only. In fact, all areas outside of the selection have been masked off, which supports the concept that masks and selections are the same. This approach gives you flexibility when choosing localized areas to apply Photoshop's commands or tools.

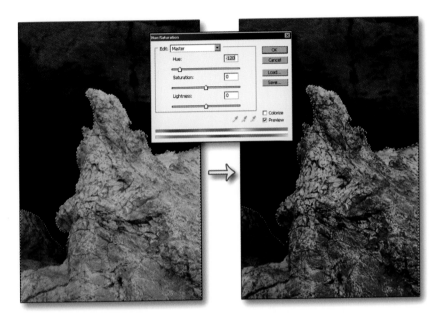

FIGURE 2.32 Apply Hue/Saturation to a selected area.

SAVING SELECTIONS

Because you work diligently to create your selections, it's a good idea to save them. Because you are about to modify a selection, access the Select menu to save it to the file (Select > Save Selection). Notice that the dialog box gives you the option to name the marching ants. If you want to gain access to your selection again, you need to know where you can retrieve it.

This is where you make the connection to an often intimidating area of Photoshop called the *Channels palette*. Make sure that your channels are visible (Windows > Channels) and look at the thumbnail at the bottom, as shown in Figure 2.33. Does it look familiar?

Your selection has become an additional channel called an *Alpha channel* to your original RGB color channels. So it is important to understand that when selections are saved, they go straight to channels. Now let's look a bit further.

To bring the selection back again, you activate the Load Selection command (Select > Load Selection). When you select the Channel drop-down menu, you will see a list of the Alpha channels, as shown in Figure 2.34.

In this case, you have only one. Notice that the marching ants are once again loaded into the document. The shortcut for loading the channels as a selection is simply to Ctrl+click/Cmd+click on the channel itself.

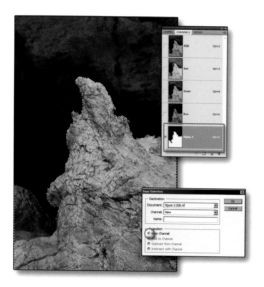

FIGURE 2.33 Save the selection to create an Alpha channel.

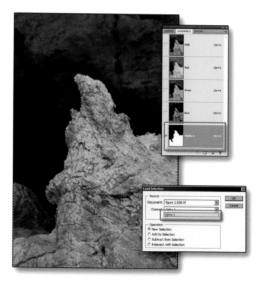

FIGURE 2.34 Load the selection from an Alpha channel.

EDITING THE ALPHA CHANNEL

This mask is nothing more than an image made up of 256 shades of gray. In fact, you can create selections that will have 256 levels of effects. That means you should also be able to paint directly on the mask for altering its form. Let's try it.

If you access the Paint Brush tool and make sure that the foreground color is white, you can alter the image by painting directly on the Alpha channel itself, as shown in Figure 2.35. After the channel has been edited, you can load it back as a selection. To do this, access the Select menu and choose Load Selection. Now you will see the marching ants version of your mask, as shown in Figure 2.36.

You can also load this as a selection with a Ctrl+click/Cmd+click on the mask.

Just as before, you can apply Photoshop's commands and tools to this selected area (see Figure 2.37). Take note that you have a new button on the bottom-left corner of the Hue/Saturation dialog box. Select this, and you can just click and drag on the image itself to apply various saturations to the image. If, however, you would like to alter the hues using the Hue slider, then hold down the Ctrl/Cmd key and scrub on the image to make the changes.

FIGURE 2.35 Edited Alpha channel.

FIGURE 2.36 Mask loaded into the document as a selection.

FIGURE 2.37 Applying Hue and Saturation to the newly selected area.

LAYER MASKS DEMYSTIFIED

Now that you have gained some insight into the uses of selections, let's look at some of its more important applications. Let's delve into their uses in creating layer masks. To understand layer masks, you must understand the creative necessity of layers.

One of the most widely used aspects of Photoshop is its capability to integrate gracefully almost an unlimited amount of imagery with the use of layers. What are layers? Let's go back before the advent of digital and discover how the concept of layers was originally applied.

Let's say that your artwork was going to be produced for the front cover of a magazine. The publisher's graphic department had to place the title as well as any graphic effects on the artwork. The artists did not apply the graphics to the art directly, but instead they laid a clear sheet of acetate over the artwork and placed the title of the magazine on the acetate. In turn, they placed another sheet of clear acetate on top and created the border graphic effects on that acetate. In registration, they generated the final copy from which they produced the color separations for the magazine cover.

On a creative level, layers are important because you can apply all of Photoshop's commands and tools to each object independently from the entire scene. Placing most of the elements on separate layers gives you control and flexibility. After the layers are established, you can apply layer masking to control how each object blends and integrates into the entire image. Thus, layer masking is an excellent way to control the opacity or transparency of local elements in an image and is ideal for blending multiple images into one cohesive concept. So how does this work? Photoshop is primarily an 8-bit program, and therefore masks are based on editing in 256 values. The darker the value, the more transparent your image will become. In essence, you have the ability to edit your image with 256 levels of transparency.

Traditionally, this process was done by sandwiching a litho negative with a color transparency and placing it underneath the enlarger to be exposed to raw light. Keep in mind that litho negatives are black-and-white film that does not record midtone grays. It only creates black where it is exposed to light, and the areas not exposed to light or slightly exposed to light remain clear after processing.

When sandwiched together in registration, sections of the litho negative that are clear allowed the enlarger to expose the original image. Other sections of the negative that were in registration with black (complete alignment) blocked out the visual aspects on the transparency, as shown in Figure 2.38. The two in registration(see Figure 2.39) were placed into a photographic enlarger so that the image showing through the clear portion of the litho negative was exposed onto the photographic media. Let's explore how you would achieve this in Photoshop.

FIGURE 2.38 The black portions of the negative block our view of the transparency.

FIGURE 2.39 Two images in registration.

CREATING THE LAYER MASKS

To create the layer masks, follow these steps:

1. Open an image in Photoshop, and duplicate the original layer. This example uses an image of a boulder composition on the beach. You can find this image in the Tutorials/ch 2 boulder.jpg. The foreground stone was selected using the Magic Wand selection tool and saved as an Alpha channel (Select > Save Selection).

2. Access your Channel palette (Windows > Channels). To see the Alpha channel in combinations with the image as you edit the channel, press the "\" key, and the areas that represent the black pixels on the channel will go to a transparent red (see Figure 2.40).

3. If you paint with black, the red is added to the mask and if you paint with white, the red is cleared from the mask. After you are done editing the mask, press the "\" key again to get the Alpha channel back to the normal black-and-white mode.

4. Ctrl+click/Cmd+click that channel to convert it to a selection.

5. Make sure that your top layer is selected and associate a Curves Adjustment layer mask by clicking the black-and-white half circle icon located dead center of your icons on the bottom of the Layers palette. Curves can be applied so that you can alter the selected region's tonality. In this example, we are affecting the middle range tones by dragging the center of the curve upward.

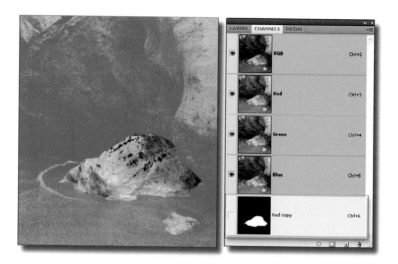

FIGURE 2.40 Edit the mask with a view of the layer's image.

Also, observe that you have a new Adjustment panel that will always be displayed to give you access to all of your Adjustment layers, as shown in Figure 2.41A. If you do not see it open then go to Windows > Adjustments. In combination with the Adjustment layer, use the Mask layer to make any adjustments to the mask only (Figure 2.41B). We will play with this feature in detail in later chapters.

6. Notice that the Curves dialog box has a slightly different look from the previous versions of Photoshop. A convenient feature is the display of the histogram behind the curves. The function of the Curves has not changed, but being able to see the total graph behind it facilitates the process of anticipating where the tones are on the graph. If you click the arrow next to the Curve Dialog Options, you will see check boxes that are selected by default.

- Figure 2.42A show some examples of how to turn off the histogram. This may be convenient for those who are used to working with the previous model of Curves.
- Figure 2.42B gives an example of how to turn off the intersecting line, which is basically a crosshair that helps you keep track of the points as they are repositioned on a curve. If this is annoying to you, you can turn off that option here.
- Figure 2.42C shows you how to turn off the baseline. The Baseline check box gives you a preview as to where the line was located before you started any changes.

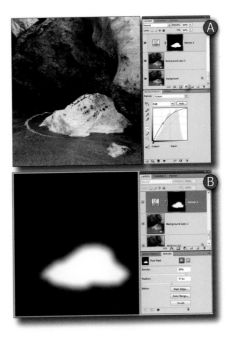

FIGURE 2.41 Associating a Curves Adjustment layer to alter the midtones.

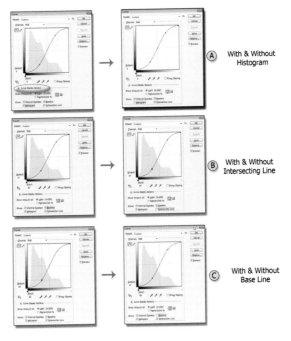

FIGURE 2.42 View of the new Curves dialog and options.

7. You have other options as well. Figure 2.43A gives you an example of reversing the histogram, which is convenient for those who will be printing with the use of an offset printer. If you look at the base of the histogram, you will notice that white starts to the left and ends in black to the right. This represents no saturation of ink to a complete saturation of ink on the paper. This example also shows the use of the larger grid to assist you in placing and moving your points. If you prefer to work with smaller grids, then select the option shown in Figure 2.43B. Also shown is the option to work in the additive Color process where black is located on the left-hand side of the horizontal tonal graph and ends with white on the right. This is representative of the additive process of light where equal amounts of red, green, and blue light will become white.

FIGURE 2.43 You can use pigment or light options in the Curves dialog box. You can also use the shortcut Alt+click/Option+click on the grid itself.

8. One last feature that was included in the Curves dialog box that most users are going to find wonderful is the use of presets (see Figure 2.44A). Figures 2.44B through D show three examples from the list of presets. Scroll to all of them so that you can get familiar with what is listed.
9. Adjust the Curves to see the possibilities of using it as an Adjustment layer. Figures 2.45 and 2.46 show some examples of what can be achieved.

Now take a look at the icons on the bottom right of the Adjustment layer panel, and you will see two icons next to the Garbage Can symbol. Take a look at the one that is the closest to the Garbage Can symbol and notice that the symbol is in the form of a half circle, red arrow (Figure 2.46B). If you made several adjustments already, then this is the symbol that will be displayed, and by clicking it, you can go back in history to the changes that you made with this adjustment.

FIGURE 2.44 Example of additional presets in the new Curves command.

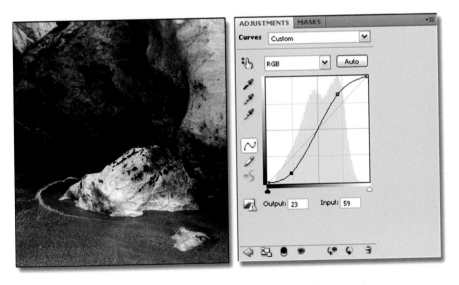

FIGURE 2.45 Increase the contrast using the Curves Adjustment layer.

If, however, you have made only a single adjustment, then the symbol will be displayed as a full circle.

Next, look at the third icon from the left (Figure 2.46C). Clicking this will take you back to the original results before the adjustments.

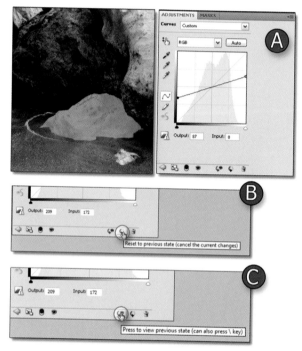

FIGURE 2.46 Decrease the contrast using the Curves Adjustment layer.

As you can see, there is great power in the use of masks and Adjustment layers, and the new addition of the Adjustment and Mask panels will revolutionize your workflow.

FURTHER UNDERSTANDING OF MASKS

Earlier you learned that if you save a selection, it will become an Alpha channel, and from that you can convert the Alpha channel into a selection. The same is true for RGB channels.

1. Open the lone tree.jpg (see Figure 2.47) in Tutorials/ch 2.

2. Look at all the channels to get a better understanding of what they are and the type of information that is included in each one.

3. Click the Red channel to view it on the canvas. If you placed black-and-white film into your camera and placed a red filter over the lens of the camera, the resulting black-and-white print would look like Figure 2.48. Notice that this channel has a greater range of contrast than the other two. This is the one that harbors all of the contrast in your digital image.

FIGURE 2.47 View of lone tree.jpg.

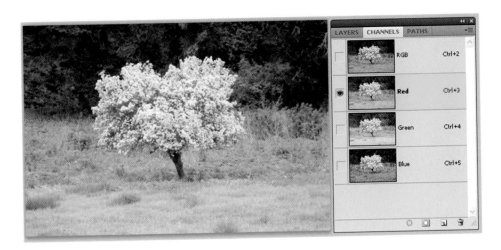

FIGURE 2.48 Red channel view.

4. Click the Green channel. If you placed black-and-white film into your camera and placed a green filter over the lens of the camera, the resulting black-and-white print would look like the Green channel. If you look further, the contrast is the least for this channel because it is the one that contains all of the continuous midtone information (see Figure 2.49).

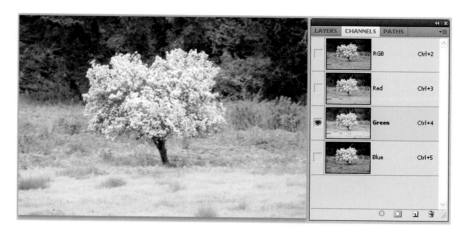

FIGURE 2.49 Green channel view.

5. Click the Blue channel. If you placed black-and-white film into your camera and placed a blue filter over the lens of the camera, the resulting black-and-white print would look like the Blue channel. This is the channel that is most sensitive to the ultraviolet range of light, thus capturing much of the noise in the atmosphere. If you were to produce a black-and-white print, then the Blue channel would usually be the least desirable to use (see Figure 2.50).

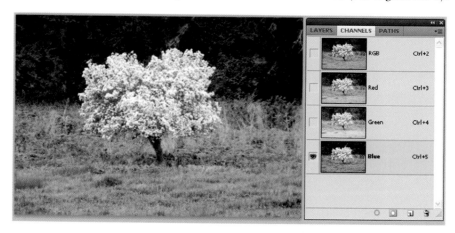

FIGURE 2.50 Blue channel view.

Now let's make the connections between selection and channels:

6. Go to the Layers palette, create a new layer, and fill it with black (Edit > Fill > Fill with Black). When you are done, click the eyeball symbol on the left of the layer to turn it off temporarily so that you can view the channels of the tree.

7. Access the Channels palette and Ctrl+click/Cmd+click the Red channel to produce a selection. With your marching ants still selected, turn on the layer filled with black. You should have something that looks similar to Figure 2.51.

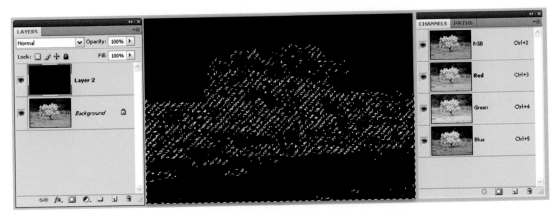

FIGURE 2.51 New layer filled with black with selection from the Red channel.

8. Now fill the layer with white (Edit > Fill > Fill with White) and take a look at what you have (see Figure 2.52 for the result).

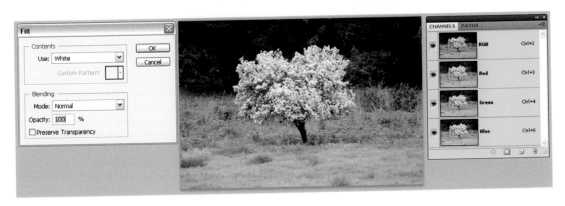

FIGURE 2.52 Fill selection dialog box.

Do you see what has happened? You have just transferred the Red channel into a layer via a selection. As we have noted, the key to mastering Photoshop is mastering selections. Selections, masks, and channels are identical.

Now let's take this one step further and use the results to enhance the image.

9. Change the Blend mode of the top layer to Screen. This will give you a nice fluffy white for the flower petals. Everything else looks fine as is, so restrict the effect to the flower detail.

10. Associate a mask with the layer that you just changed to Screen mode. Notice that you have an extra white thumbnail connected to your image. This is the Layer Mask, as shown in Figure 2.53. You can paint with 256 shades of gray on this, but make sure that you click the mask first to tell the program that you are interested in editing the mask. Photoshop is telling you that if you paint within this area with white, you will be allowed to view the image that it is associated with (in this case, the tree image that you set) to a Screen Blend mode. If you paint with black, you will mask out the object; in effect, it will disappear. Make sure that you click the mask and fill it with black (Edit > Fill > Fill with black).

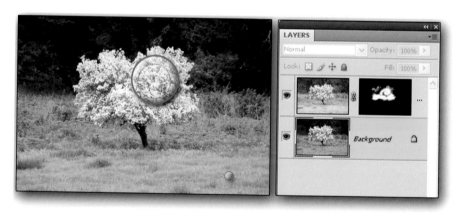

FIGURE 2.53 Edit the Screen mode layer mask.

11. Activate your paint brush and use a low opacity setting to apply white paint to the filled black mask. Apply it only to the white flowers to bring out the creamy luminance that will make this image a little more dynamic, as shown in Figure 2.54.

12. Alt+click/Option+click on the mask to view it in the canvas area (see Figure 2.54).

Now that you have an understanding of selections, mask, and layer blending modes, let's move on to apply this knowledge to some creative applications.

FIGURE 2.54 Mask viewed on canvas.

USING CHANNELS TO MAKE MASKS

Let's look at another option for creating masks. Navigate to Tutorials/ch 2 and open the file desert.jpg. Click each channel to understand its properties.

The Red channel harbors the contrast of your image. Let's relate this to photography before the advent of digital. If you photographed this image using black-and-white film and placed a red filter over the lens and then proceeded to make a black-and-white print, this channel is what the print version would look like (see Figure 2.55).

FIGURE 2.55 View of the Red channel.

The Green channel harbors the continuous midtone grays in your image. If you photographed this image using black-and-white film and placed a green filter over the lens and then proceeded to make a black-and-white print, this channel is what the print would look like (see Figure 2.56).

FIGURE 2.56 View of the Green channel.

The Blue channel harbors the noise from the atmosphere. This is the channel that is more sensitive to ultraviolet radiation. The same comparison pertains to this channel as well, in that if you photographed this image using a blue filter over the lens, the black-and-white print would resemble this channel (see Figure 2.57).

FIGURE 2.57 View of the Blue channel.

We are going to make a mask enhancing the whites of the sand. There is an advantage to creating a mask this way because your channels already contain all of the textural details of your image in shades of gray; therefore, you can create a more accurate mask. In fact, with much practice, you could create masks faster this way.

1. View each of your channels and determine which one will give you the best tonal separation between the sand and everything else. In this case, the Blue channel works the best. You do not want to alter the original channel because this will alter the blue hues in the image, so create a duplicate of it to create an Alpha channel. By default, it will be named Blue copy. You will use this to create your mask (see Figure 2.58).
2. On the toolbar, select the Color Sampler Tool and visually determine the darkest area and the brightest area on your Alpha channel (see Figure 2.59).

FIGURE 2.58 View of the Blue copy channel. **FIGURE 2.59** The Color Sampler tool.

3. Press Ctrl+M/Cmd+M for Curves and Ctrl+click/Cmd+click on the gray grass located next to the blossom to place a point on the section of the graph that represents the selected tonality (see Figure 2.60).
4. Now do the same thing for the crackling mud to place a point on the section of the graph that represents its selected tonality. Now that you have the two tonalities mapped, you can create some extreme contrast to make the crackling mud and the background details black (see Figure 2.61).
5. Take the point that represents the background detail and drag it to the lower extremity to send the selected midrange grays to black. Do the same for the crackling mud and send that point upward to send its tones to pure white (see Figure 2.62).

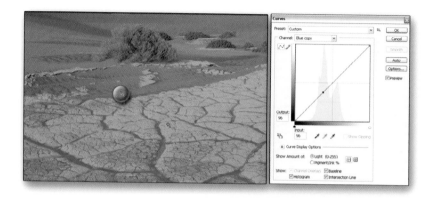

FIGURE 2.60 Place the point of the curve representing the background details.

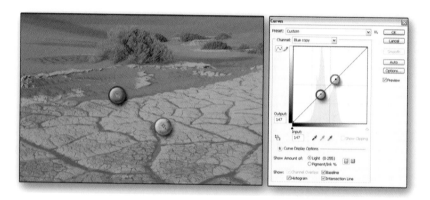

FIGURE 2.61 Place the point of the curve representing the crackling mud.

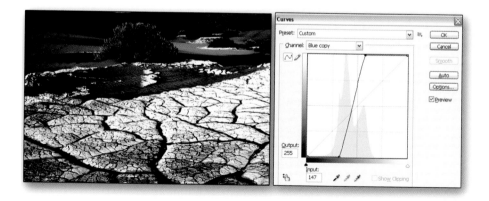

FIGURE 2.62 Create extreme contrast using the mapped points.

6. Use the Burn tool to take out any unwanted details toward black leaving only the crackling mud detail (see Figure 2.63). Make sure that Shadows is selected in the Options bar.

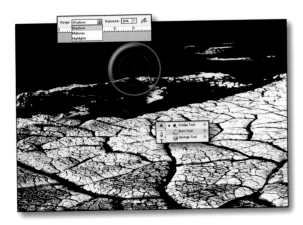

FIGURE 2.63 Edit the mask with the Burn tool.

7. Now that you have the mask, you can apply it to the layer that has the Screen Blend mode. Ctrl+click/Cmd+click on the Blue copy Alpha channel to get your selection. Now add a layer mask and notice that the Alpha channel has been transferred to the mask. In essence, the selections were honored so that the areas selected remain white and everything else is masked out with black, as shown in Figure 2.64.

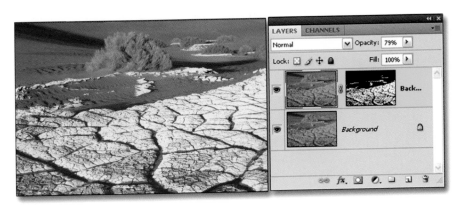

FIGURE 2.64 Apply Alpha channel as a layer mask.

MORE SOPHISTICATED WAYS TO SELECT YOUR OBJECTS

Next, you're going to get a basic course on how to use the Pen tool to outline sophisticated shapes from which you're going to create a selection.

1. Select the Pen tool on the Tools palette or press P (see Figure 2.65). Then go to Tutorials/ch 2 and open pen tool exercise.jpg.

FIGURE 2.65 Activate the Pen tool.

2. Select the Pen tool on the Tools palette or press P. Use Figure 2.66A as a guide and place your first and second point with the single-click between the two locations that make up the straight line of the rusted bar, as shown in Figure 2.66A.

FIGURE 2.66 Use the Pen tool to trace the shape.

3. Next, assess where the curve ends from the location of the last point. Now, place another point at the location where the curve subsides (Figure 2.66 B) and click and drag while tracing the shape going forward, as shown in Figure 2.66C. When you trace the shape after you lay down a point, the curve behind the dragging mouse will naturally fall into position.
4. Continue the same procedure by assessing where the curve ends and then click and drag your mouse while tracing the shape going forward (see Figures 2.67 and 2.68).

FIGURE 2.67 Continue to outline the shape.

FIGURE 2.68 Continue farther along to outline the shape.

5. Now take a look at Figure 2.69 and observe that the handlebars are flowing with the outline of the object. When practicing this exercise, be patient and try not to bite off more than you can chew. Remember to place your first point where the curve begins and one where it ends and simply outline the shape by dragging the mouse. As a result, your Bézier shape will outline your object effortlessly.

6. As you continue to outline your shape, place the point where the two curves meet, as shown in Figure 2.70. In Figure 2.70, your point has been placed at the intersection of two separate curves.

FIGURE 2.69 The handlebars flow with the exterior of the shape.

FIGURE 2.70 Point placed at the intersection of two curves.

7. If you continue normally, as shown in Figure 2.71, the curve will follow in the direction of the handlebar. You do not want it to create another curve, but instead start as a fresh point. To solve this problem, you need to get rid of the handlebar created by the last point. To do this, simply hold down your Alt key/Option key and click the last point. This will allow you to start fresh, as shown in Figure 2.72.

8. Continue to outline your shape and don't forget to trace the line as you move forward on the curve to allow the back end to fall into place (see Figure 2.73).

9. Close your path by clicking the point where you began (see Figure 2.74). Open your Paths palette (Windows > Paths) to view your shape. Make sure that you save the path simply by double-clicking the Path layer and renaming it. This will allow you to save it to the file so that you have the option to edit it later on, and it will automatically be updated.

FIGURE 2.71 Curve is created by the extended handlebar.

FIGURE 2.72 Use your Alt/Option key to take away the handlebar.

FIGURE 2.73 Continue outlining your shape.

FIGURE 2.74 Close the path.

10. Once your path is complete, you can go back and edit the points by moving them, as well as dragging the handlebars and adjusting them to improve the outlining of your shape. In order to do this, you must use your Direct Selection Tool shown in Figure 2.75.

FIGURE 2.75 Close the path.

11. Now that you have your path drawn, hold down your Ctrl/Command key and click the path icon to get a selection from your path (see Figure 2.76).

FIGURE 2.76 Create a selection from your path.

12. Once you have a selection, you can add an Adjustment layer, which in this example is Selective Color (see Figure 2.77). Use this to alter the color of the handle and not affect the rest of the background.

FIGURE 2.77 Create a selection from your path to use with the Selective Color Adjustment layer.

Now that you have an understanding of selections, masks, and layer blending modes, let's move on and apply our knowledge to some creative applications.

WHAT YOU HAVE LEARNED

- How and why Layer Blend modes work the way they do.
- The key to mastering Photoshop: selections.
- Work optimally in 8 bits.
- Create and edit Alpha channels to create layer masks.
- Create masks from Alpha channels.
- Edit the Alpha mask to isolate chosen details.
- Outline sophisticated shapes with the Pen tool.

INTEGRATING 3D CONCEPTS WITH PHOTOGRAPHY

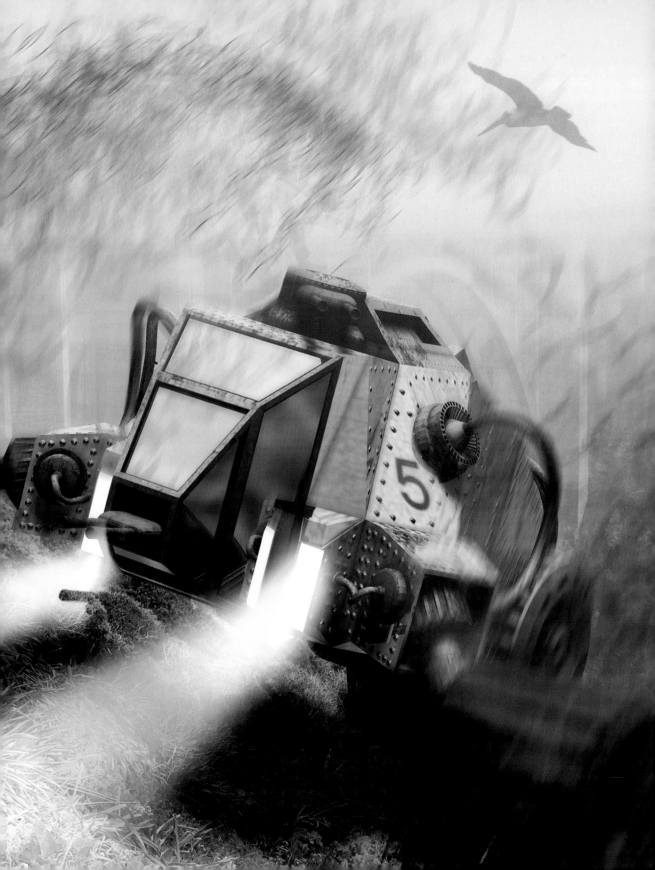

CREATING THE INITIAL LANDSCAPE

In this exercise, you will combine three different landscape-type images to serve as a backdrop for the emerging figure coming forth from beneath the depths. You will start by combining the landscape image. Then you will add custom-created clouds to enhance the scene. Next, you will add the human figure, which you will later clothe in a series of textures. Be patient and take your time with this fun exercise.

1. Create an 8.5×15-inch file with a resolution of 300 ppi. Access the Tutorials/ch 3 folder and open Bridge.jpg.
2. Position the bridge as shown in Figure 3.1, leaving some space for sky along the upper edge and space to the left for extending the foliage. Select a large portion of the hillside to the lower left, which will assist you in rebuilding the hillside.

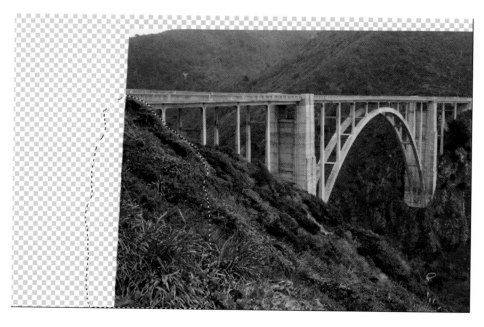

FIGURE 3.1 Position the bridge and the lower-right corner.

3. Copy (Ctrl+C/Cmd+C) and paste (Ctrl+V/Cmd+V) the selected area onto a new layer and apply Free Transform (Ctrl+T/Cmd+T) to produce something that resembles Figure 3.2.

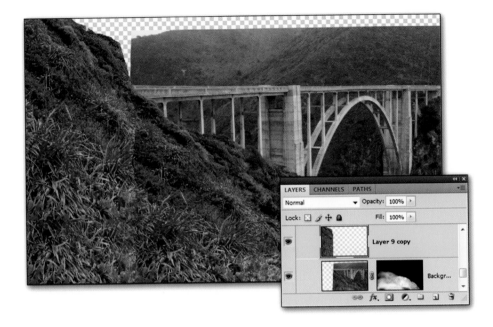

FIGURE 3.2 Transform the foliage to cover the right side of the composition.

4. Create a new layer (Ctrl+Alt+Shift+N/Cmd+Option+Shift+N). Activate the Stamp tool (S). Now you will blend the two layers together so that the entire foreground appears seamless. It is usually a good idea to apply editing techniques that will make it as easy as possible for you to make changes if your client desires them. So apply the clone technique onto a separate layer. Make sure that Aligned is checked, and in the Sample drop-down list, make sure that All Layers is selected. You have now told Photoshop to allow you to apply the Stamp tool onto the blank layer but utilize the visual information of all layers underneath and apply the technique to the current layer selected (see Figure 3.3).
5. In the Tutorials/ch 3 folder, open the sky002.jpg file. Place and position it into the scene, as shown in Figure 3.4.
6. Duplicate the bridge layer and apply a layer mask that isolates the bridge (see Figure 3.5). Place the bridge layer on top of the sky.
7. Now, apply a layer mask to the sky and use your paint brush with your Wacom Pen to isolate its visual aspects to the areas behind the hill and behind the bridge (see Figure 3.6).

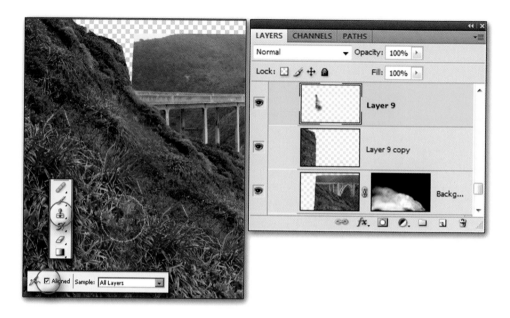

FIGURE 3.3 Use the Stamp tool to blend the grassy areas.

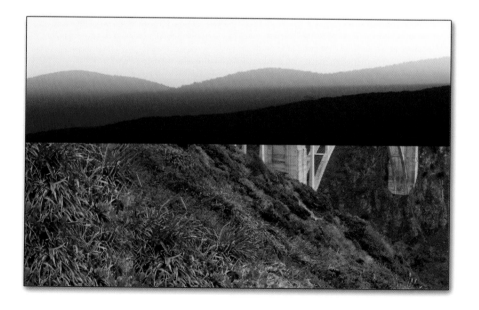

FIGURE 3.4 Add the sky to the scene.

FIGURE 3.5 Duplicate the bridge layer and apply a mask to isolate the bridge.

FIGURE 3.6 Apply a layer mask to the sky.

8. The goal is to apply a hazy atmospheric effect to the background of the scene. That means the bridge will lose detail as it becomes more dominated by haze. Use the technique of applying a layer style of overlay to the bridge and the sky layer. When you select Overlay, make sure that the color you designate for the overlay is a color that already dominates the sky area. Bring down the opacity of the color fill so that the bridge isn't completely devoid of detail (see Figures 3.7 and 3.8).

FIGURE 3.7 Apply a layer style of overlay to the bridge.

FIGURE 3.8 Apply layer styles to the clouds.

9. The bridge is coming toward the foreground at an angle and should reflect less distortion from the fog than the right side. To give this appearance, duplicate the bridge layer and double-click it to open the Layer Style dialog box. Pull the Opacity slider for the Overlay effect to the left to reduce the haze and reveal more texture detail in the bridge overall. Apply the layer mask to restrict the results to the left side of the bridge, leaving the right to maintain its ghostly appearance (see Figure 3.9). Let's now give the image some warmth.

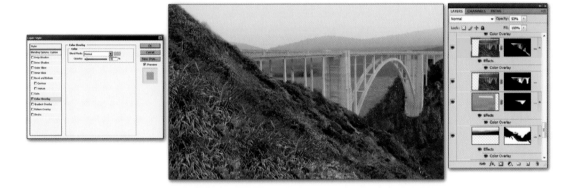

FIGURE 3.9 Duplicate the bridge layer and change the strength of the layer style.

10. So far, the image looks a little blue and drab, so use a Curves Adjustments layer and select blue as the color that you want to alter. If you push the curve upward, it will become dominated by the blue hue to a greater degree. In other words, the Blue channel is being directly affected. To warm up the scene, use yellow, which is the opposite of blue. Pull out some blue near the lower tonal area of the curve, as shown in Figure 3.10.

11. Merge all the layers into a new layer by holding down the Alt/Option key, accessing the Layers submenu, and selecting Merge Visible. Next, commit this new layer to a smart object. Apply Gaussian Blur (Filters > Blur > Gaussian Blur) to the smart object and set the radius to around 21 pixels (see Figure 3.11). The idea is to establish a shallow depth of field, so restrict the blur effect to the upper portion of the image by using a gradient on the mask. Make sure that you apply white to the upper portion of the mask and black in the lower portion.

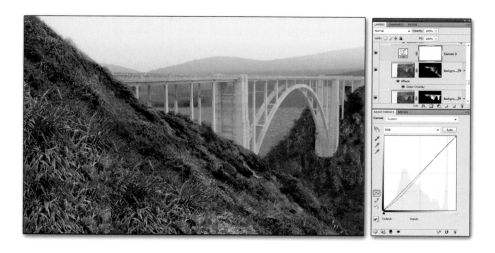

FIGURE 3.10 Apply a Curves Adjustments layer to adjust color.

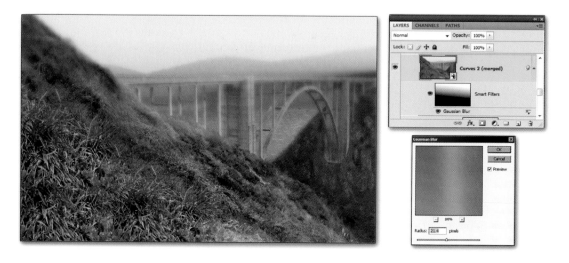

FIGURE 3.11 Create a shallow depth of field.

12. Apply the same technique of adding a Layer Style Color Overlay, but this time, set the Layer Blend mode in the Overlay panel to Luminosity (see Figure 3.12).

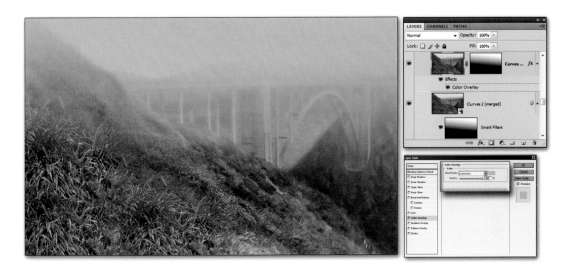

FIGURE 3.12 Apply the Overlay Layer Style and the Luminosity Blend mode.

13. Add some subtlety to the atmospheric fog by using the Gradient Adjustment layer. Apply a Gradient layer that establishes a gray with a slight greenish cast on the left and gradates toward white on the right. This effect gives the appearance of the ambient color being more dominant in the foreground due to the fact that the foreground is closer to the viewer's perspective. The human eye will be able to perceive subtle colors in its immediate vicinity. The farther away you get, the denser the fog will become, which will take on a more neutral effect visually; therefore, any objects in the background will lose their identity and take on the soft luminance of the fog. To duplicate this effect, we have applied a more greenish fill to the areas that are closer to the camera, which are in the left portion of the composition.

14. Use a layer mask to restrict the effects of the gradient to the upper portion of the image. Notice that in Figure 3.13, an initial gradient has been established applying black in the lower half and white in the upper half. The computer often applies clean, predictable results, but this also makes your image easily recognizable as being computer generated. To break up this predictability, edit the mask with your Paint tool by hand to remove the effect from the areas that are closer to the foreground. Use your own creativity to establish the final result.

15. The sky looks a little boring and needs a sense of life, so navigate to the Tutorials/ch 3 folder, and open the birds in flight image. Select one or more of the flying birds and place them into the sky (see Figure 3.14). Now you are ready to add the futuristic land patroller.

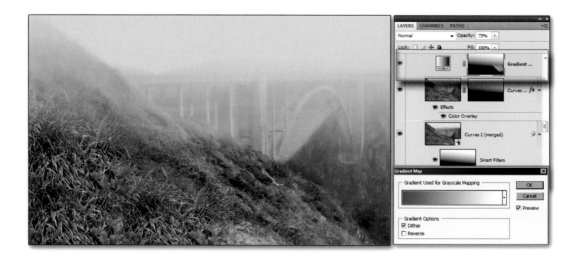

FIGURE 3.13 Edit the Gradient mask.

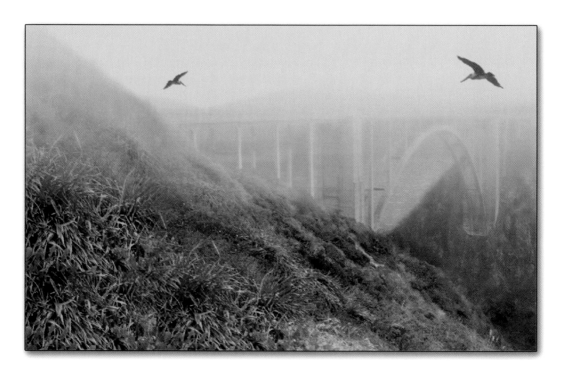

FIGURE 3.14 Apply birds to the sky.

WORKING WITH 3D LAYERS

Before the advent of 3D layers in CS4 Extended, the artists who had the job of creating a 3D model for the mat painter had to render it as a bitmap to be placed into a layer to complete the digital scene. In the event the mat painter needed a different angle or lighting than the one received, the modeler had to make all the necessary adjustments in a 3D program and rerender it again. Now, in CS4 Extended, the ability to import 3D objects into 3D layers will save illustrators quite a bit time from having to rerender their models in the correct position and perspective required to completed the creation.

The creation of the 3D model begins in a 3D program. The 3D objects in this book will be derived from LightWave 3D (www.newtek.com).

Photoshop reads vector- and raster-based graphics extremely well. Vector graphics are based on shapes that utilize algorithmic procedures to produce shades of colors. You can see this effect in Adobe Illustrator or Freehand when they produce shapes with fills or strokes of colors or gradients. Raster-based graphics are pixel-based images such as those produced by digital cameras. Your 3D program produces vector-based imagery in the form of geometry that makes up your 3D object and utilizes raster-based images such as photos to texture the surfaces to give them character. There are five texture types that you can apply to your images: planar, cubic, cylindrical, spherical, and UV. Let's take a brief look at each of them.

Planar will favor mapping a texture along the X, Y, or Z axis. Once you choose an individual axis, the 3D program will ignore the geometry on the other two. Figure 3.15 is an example of an image that is mapped on the Z axis. The X and the Y are ignored for proper image placement.

Cubic will place the image on geometry for all four axes (see Figure 3.16).

FIGURE 3.15 Planar projection on the Z axis.

FIGURE 3.16 Cubic projection.

Cylindrical will wrap an image around the object on a single axis. In this case, it uses the Y axis to texturize a cylinder (see Figure 3.17).

Spherical projection will wrap an image around an object as if it is a ball. Figure 3.18 shows a sphere with an image wrapped around it using all three axes.

FIGURE 3.17 Cylindrical projection.

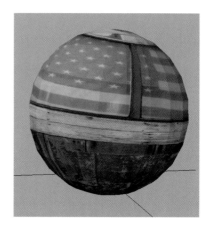

FIGURE 3.18 Spherical projection.

Finally, UV projection will be the map that you should use most often if you plan to use the 3D object in Photoshop's 3D layers. A UV map is actually the most accurate way to apply your textures to your object. Working in this way also gives you the most control. Here is how it works. If you take an object, let's say a paper cube, and unwrap it so that the entire surface is displayed flat, then you can draw or paint on it to give the surface the character that you would like it to have. When finished, you can simply tape the box together again, and you will have your completed artistic cube. Figure 3.19A displays the geometry unfolded. Wherever the geometry sits on the image will be the part of the image that will be mapped onto it, as shown in Figure 3.19B.

All of the surfacing and texturing should be established first in your 3D program so that when you import the object into 3D layers, Photoshop will read the surface textures just as you had originally applied them. It is highly recommended that you use UV Map as your surface type of choice, because this will assist you in placing details exactly where you want them to sit on your model as you are painting your textures.

Figure 3.20 shows the surfaces that are associated with the 3D model in LightWave. Figure 3.20A shows the names of the surfaces that have been applied to the geometry of the land vehicle. This is done through the surface editor (F5) in LightWave. Each of the surfaces has a texture applied to it. As you can see, the texture has been applied using the UV Coordinate Projection (see Figure 3.20B).

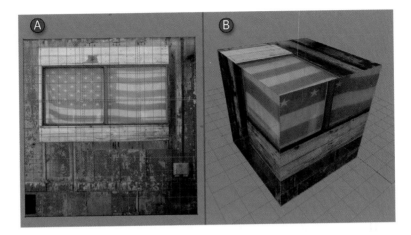

FIGURE 3.19 UV map coordinates placed on an image.

You have three properties applied. One is the Projection type, which is UV in this case; the other is the name associated with that particular UV map; and the final one is the name of the image that will be applied to the UV. The procedures will be the same in all 3D programs.

FIGURE 3.20 Surface details displayed in LightWave's interface.

Also, take notice of how the geometry for the land vehicle has been applied as a UV Map in Figure 3.21. Don't worry about how to actually create the UV for now. We will go over that in a later chapter. Figure 3.21A displays the UV Map of the vehicle and Figure 3.21B displays the texture that will be mapped onto the vehicle.

Figure 3.22 shows the 3D object with the textures applied to its surface in LightWave or the 3D program of your choice.

FIGURE 3.21 UV coordinates displayed with texture.

FIGURE 3.22 View of the 3D vehicle with textures applied.

GET INTO CS4 EXTENDED 3D LAYERS

Let's take a look at the features and capabilities that you have for adding 3D objects to your illustration. Until now, Photoshop has been primarily a two-dimensional program in that it utilizes an X axis (left to right) and a Y axis (up and down). This information is consistently displayed in the information palette (see Figure 3.23).

FIGURE 3.23 The information palette displays the X and Y location of your cursor.

CS4 adds a new dimension to the 3D layers. This dimension displays the Z depth (foreground to background), which now gives you 3D capabilities, where the positive X axis is to the right of 0, and the positive Y direction is heading above 0. Going in the opposite directions of 0 will give you negative numbers. The Z axis is often referred to as Z depth. It has a positive direction going into the scene(see Figure 3.24).

To view 3D objects, CS4 uses a special layer called *3D layers*. To view the objects, follow these steps:

1. Access the Tutorials/ch 3 folder and open land vehicle.psd (see Figure 3.25). If you have applied textures to your model, they will be displayed as 3D layers, which are all listed below the layer thumbnail. The land vehicle has the Diffuse, Bump, and Self-Illumination textures displayed. The Diffuse simply represents the color image, the Bump displays the rivet and linear indentations, and the Self-Illumination is used to add brightness to the image map.

FIGURE 3.24 The information palette displays X, Y, and Z vectors.

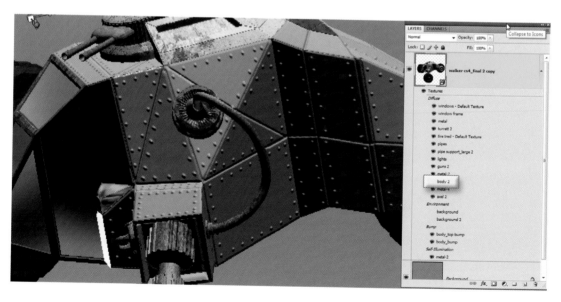

FIGURE 3.25 Open the 3D file.

To the left of the texture name body 2, locate the black-colored eye and click it. Notice that the image map associated with the geometry that creates the body of the vehicle has been turned off and displays only the base color of the surface (see Figure 3.26).

FIGURE 3.26 Turn off the body 2 texture.

2. Click one of the 3D tools on your Tools bar (K). You will see the Option bar displaying the 3D options. There are two different ways to view your 3D scene. One way is by viewing the object as you move it around in 3D space to resize or reposition it. You can access all 3D Object navigational tools from the Tools bar and the Options bar. You will see the choices to pan, rotate, roll, slide, or adjust the scale of the 3D object (see Figure 3.27A).

3. Another option for navigating through your scene is by using your Camera. On the Tools bar, click the Camera icon, which is next to the 3D Objects option button (see Figure 3.27B). These tools give you options for navigating the camera throughout your scene by using, pan, rotate, roll, slide, or adjust the focal length of the lens.

FIGURE 3.27 Viewing the Camera and Object options.

4. Look at the navigational commands for your 3D model. Start by selecting the Rotation command and navigate 360° around the model (see Figure 3.28).

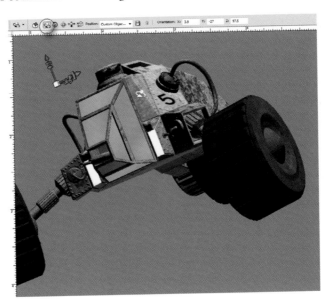

FIGURE 3.28 Rotate the model.

5. Select the Roll command and roll the model on its pitch (see Figure 3.29).

FIGURE 3.29 Roll the model.

6. Use the Slide command to move the model closer or farther away from the camera (see Figure 3.30). The object distorts as it gets closer to the camera. This is similar to using a wide-angle lens on a photographic camera.
7. Select the Drag command to move your object anywhere in your frame (see Figure 3.31).

FIGURE 3.30 Slide the model.

FIGURE 3.31 Drag the model.

8. Finally, you can scale your object so that it takes on a larger or smaller size (see Figure 3.32). In addition, you can position the object. Use this for placing your object throughout the scene without getting lens distortion.

FIGURE 3.32 Scale the model.

ORTHOGRAPHIC VIEWS

You also can use orthographic views, which are views from a single perspective. They are as follows:

- Custom 3D view (Figure 3.33) is the default view of your model from a position that you set.
- Left view (Figure 3.34) previews the model from its left side.

FIGURE 3.33 Custom view.

FIGURE 3.34 Left view.

- Right view (Figure 3.35) previews the model from its right side.
- Top view (Figure 3.36) allows you to look down at the model.
- Bottom view (Figure 3.37) gives you a perspective from directly below.
- Back view (Figure 3.38) gives you the details of the rear of the 3D object.
- Front view (Figure 3.39) shows you the front end of the 3D object.

FIGURE 3.35 Right view.

FIGURE 3.36 Top view.

FIGURE 3.37 Bottom view.

FIGURE 3.38 Back view.

FIGURE 3.39 Front view.

3D Panel Options

CS4 Extended has made some great strides in improving the capabilities of its 3D engine, and the ability to add lights to a scene is one of the best additions.

Open the 3D panel (Windows > 3D) and take a look at some of the other controls that you have for 3D in CS4 Extended.

You will see three icons along the top edge of the panel that represent the 3D Scene, 3D Mesh, 3D Materials, and 3D Lights consecutively (see Figure 3.40).

You can access each of these options by clicking its corresponding button, or you can access them all from one location in the 3D Scene panel (first button on the left). Let's explore this further.

In the 3D panel, you will see a listing called *Photoshop Meshes*. Click this layer. Take note that the name of the panel on the top left-hand corner is titled 3D (Mesh), as shown in Figure 3.41. On the bottom, you will see the options for all of the meshes in this scene. You will see a preview of your mesh (in this case, the land vehicle). To the left of the preview, you will see the navigational tools that are the same as the ones listed on your Tools bar. On the very bottom, there are options listed for how shadows will react with the 3D object. You can allow the object to Cast Shadows or Catch Shadows. Finally, you can decide to view the object or make it invisible in the scene. This option would be handy if you were using multiple objects in your scene.

FIGURE 3.40 View of the 3D Scene panel.

FIGURE 3.41 View of the 3D Mesh panel.

Next, click one of the meshes listed below the Photoshop Mesh subfolder, as shown in Figure 3.42. The title of the panel now becomes 3D (Materials). Each one represents the geometry and the surface applied to that geometry. You can alter the surface properties or the image applied to it at any time. We will explore the creative uses of these settings beginning in Chapter 5.

Click one of the 3D Lights and notice the panel will now be titled 3D (Lights). You have several light types, which are Point, Spot, and Infinite (see Figure 3.43). Each one will have its own settings. We will cover each one in more detail in the chapters that follow.

FIGURE 3.42 View of the individual 3D meshes.

FIGURE 3.43 Rendering options.

Another new advance to the 3D engine is its ability to render a variety of styles.

Click Scene in the 3D panel. Look at its options on the lower panel and click the arrow next to Presets. By default, Solid is listed, as shown in Figure 3.44. But let's take a look at a few of the other options.

Click the Ray Traced option in Figure 3.45, which is the one you will use as the final renderer for your scene. Ray Trace will render all surfaces accurately with shadows, reflections, specularity, and ambient light properties that you set in your scene.

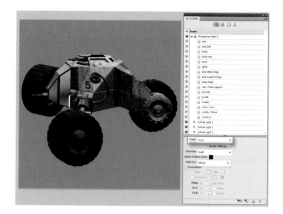

FIGURE 3.44 By default, Solid is the preferred render option.

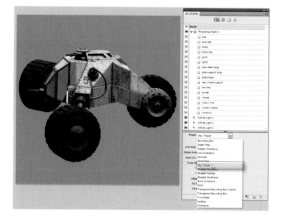

FIGURE 3.45 Results of the Ray Traced option.

Select Normals and Wireframe to see how they are displayed in CS4 (see Figures 3.46 and 3.47). Make sure that you preview all of them to get more familiar as to how they can assist you in creating your illustrations.

Below the Preset, you will see a drop-down menu for Paint On (see Figure 3.48). With CS4 you can paint directly onto your 3D models using any surface. The Paint On list lets you choose the surface on which you are interested in painting. This too will be covered in later chapters.

FIGURE 3.46 Results of the Normals option.

FIGURE 3.47 Results of the Wireframe option.

Let's take a peek at some of the surface properties.

Select the Body material and change the ambient light to a light blue by clicking the Ambient color swatch (see Figure 3.49). The ambient light represents the atmospheric tints that show up in the shadow regions, so pay attention to the areas where shadows are cast to see the effect.

FIGURE 3.48 Display of the Paint On option.

FIGURE 3.49 Change the color of the ambient light.

Now, click the color swatch for Self Illumination (see Figure 3.50). If black is the color selected, there will be no effect. The closer to white that you get, the brighter the surface will become.

FIGURE 3.50 Change the color of Self Illumination.

Take a look at the image map applied as the bump for the object in Figure 3.51. The bump map used shades of gray to apply texture to the model where black has no effect and white creates a raised surface.

FIGURE 3.51 You can add images to the Bump channel.

FIGURE 3.52 Play with the Light Intensity to view its effects on the 3D object.

Explore the lighting properties and increase the intensity of the current to see the effects to the object, as shown in Figure 3.52. Also, change the color of the light source to view its effect as well (see Figure 3.53).

FIGURE 3.53 Play with the Light Color to view its effects on the 3D object.

Set your Render options to Ray Trace to view the shadows. Make sure that the Create Shadows check box is selected and use the slider for Softness to adjust the quality of the shadows (see Figures 3.54 and 3.55). Keep in mind that when you are in the Ray Tracing render mode every change will cause Photoshop to render a new scene, so be patient because depending on your graphics card and processor, it could take a few seconds to complete its effect.

FIGURE 3.54 View of the shadows Softness slider set at 0.

FIGURE 3.55 View of the shadows Softness slider at 37%.

On the left side of the Softness slider, you will see a button with the symbol of a camera on it. This button is called Move to Current View (see Figure 3.56). Click this button to see the light source illuminating your object from the current viewing position, which is similar to using a camera flash.

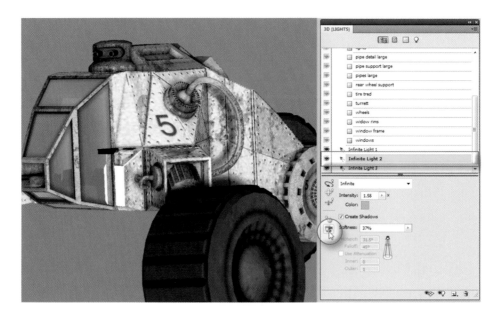

FIGURE 3.56 Change the position to Current View.

CROSS SECTION FEATURE

For artists who do mechanical illustrations, the Cross Section feature is a god-send. On the Options bar, select the downward triangle next to the Cross Section button to take a look at this feature's capabilities. Cross Section allows you to slice your model to view its interior, add other features and details to illustrate the function of a mechanical instrument, or apply slices to give an inside look at the architectural interior. The possibilities are endless.

As you can see, you can isolate the slice along the X, Y, or Z axis. You use the sliders to adjust positioning or rotate the slicing plane. You can also flip the cutting plane by checking the Flip check box (see Figure 3.57).

FIGURE 3.57 View of a cross-sectioned image.

A CREATIVE WAY TO INTEGRATE THE 3D MODEL

Over the landscape comes a futuristic military vehicle speeding toward the camera with great determination. As it moves forward, its powerful tires kick grass and dirt skyward.

In this exercise, the 3D object has already been textured and committed to a smart object to facilitate the creation of this tutorial. If you want to try your hand at texturing the model in your own 3D program, the land patroller.obj 3D file has been provided for you on the Web site inside the 3D folder. For now, use a smart object derived from the 3D file to complete the tutorial.

1. Go to the Tutorials/ch 3 folder and open walker solo.psd. Drag this image into the new file and resize and position it similar to what you see in Figure 3.58.
2. Now you need to modify an existing brush in your Brush palette. Select the Grass brush shown in Figure 3.59.
3. Modify the Brush properties to match what you see in Figures 3.60A through D.
4. In essence, you are adjusting the scattering, its rotation, and its shape dynamics to match the grass configuration of the hillside.

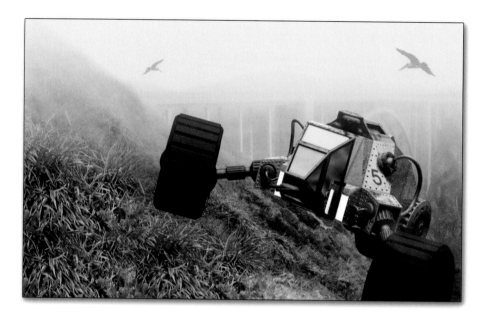

FIGURE 3.58 Place the land patrol into the landscape scene.

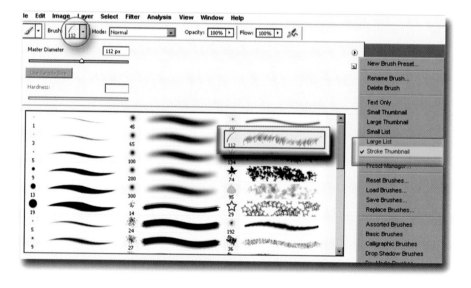

FIGURE 3.59 Select the Grass brush.

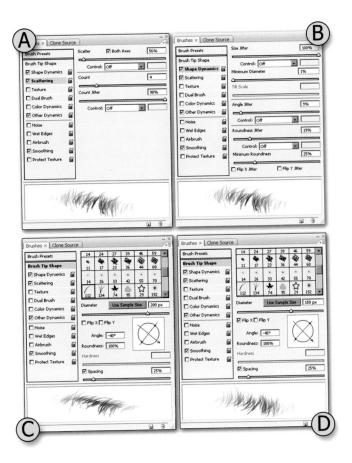

FIGURE 3.60 Modify the existing Brush properties to match the grass.

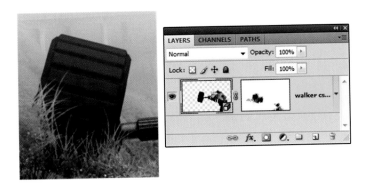

FIGURE 3.61 Edit the mask with the newly created brush.

5. Apply a layer mask to the smart object and use your newly created brush with the foreground color set to black to edit the mask so that the grass shows through (see Figure 3.61). Immediately, you can see the advantages of creating a brush that duplicates the appearance of the grass. Although you could paint the grass on a separate layer, this is a down-and-dirty trick for getting quick results.

6. Use the gradient technique to make a circular flare on a new layer above the vehicle. Resize it if necessary to match what you see in Figure 3.62. This will represent the headlight source for the land vehicle.

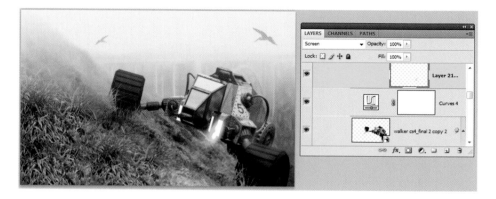

FIGURE 3.62 Create a headlight source.

7. Create a rectangle selection on a new layer and fill it with white. Use Free Transform (Ctrl+T/Cmd+T) to modify the shape that will represent the light beams (see Figure 3.63).

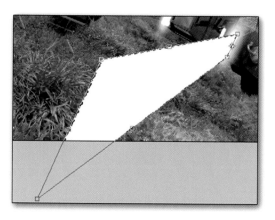

FIGURE 3.63 Create the light beams.

8. Add some Gaussian Blur to the beams and a layer mask to apply transparency to the section that is farther away from the light source (see Figure 3.64).

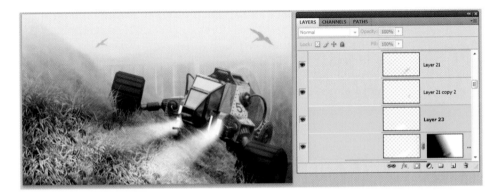

FIGURE 3.64 Apply Gaussian Blur and layer masks.

9. Now you can add a slight vibrating motion to the vehicle. Duplicate the smart object and apply Motion Blur (see Figure 3.65). You now have a Smart Filter that has a mask associated with it. Use your paint brush to apply the blur to the wheels, the axles, and the rear part of the vehicle. This helps establish which parts are vibrating the most.

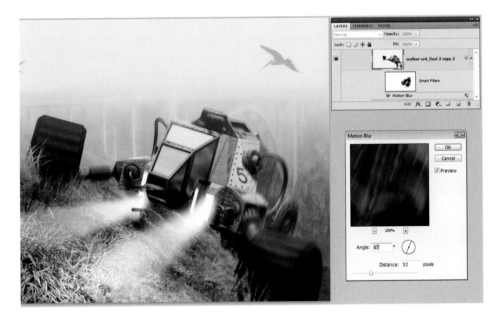

FIGURE 3.65 Apply Motion Blur.

10. Now you have another use for that Grass brush that you created in step 3. Select the Grass brush and make sure that your colors match two extreme greenish hues in the landscape area. Use the Eye Dropper to set the foreground color to a light green and the background color to a darker green. Make sure that you check Color Dynamics in the secondary paint options so that the paint engine will utilize the two colors. Also, give your brush some scattering to represent the grass flying in different directions. Finally, activate Other Dynamics and select Pen Pressure if you are using a pen and tablet. Use your own creativity, but try to get close to what you see in Figure 3.66.

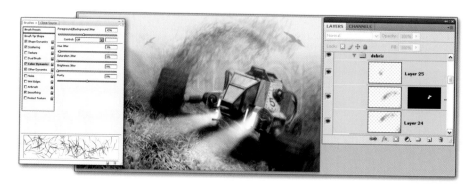

FIGURE 3.66 Paint in the flying grass.

Figure 3.67 shows the final results of this tutorial.

WHAT YOU HAVE LEARNED

- The establishing depth can be a combination of shallow depth of field, tonal control, and atmospheric haze.
- Blend 3D objects with photographic imagery.
- With lighting, you can use Adjustment layers to apply the effects directly to the model.
- Edit the texture on 3D layers.
- Use creative approaches for reflections.
- Apply various Render modes.
- Edit the 3D lights so that the model matches the scene.
- Ambient light affects mostly the shadow areas of a model.
- Your final 3D output should be in Ray Tracing render mode.

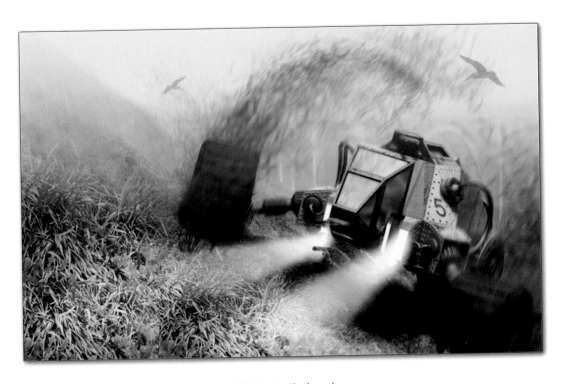

FIGURE 3.67 Final results.

SMART FILTERS TO AID ARTISTIC VISION

IN THIS CHAPTER

- Powerful approaches to compositing photographic imagery

- New Smart Objects

- How to organize your work with layer sets

- Layer Blending modes to assist with composition

- The power of the Free Transform and Distort tools for localized areas

- Practical applications for using layer masks

- How to create masks from channels

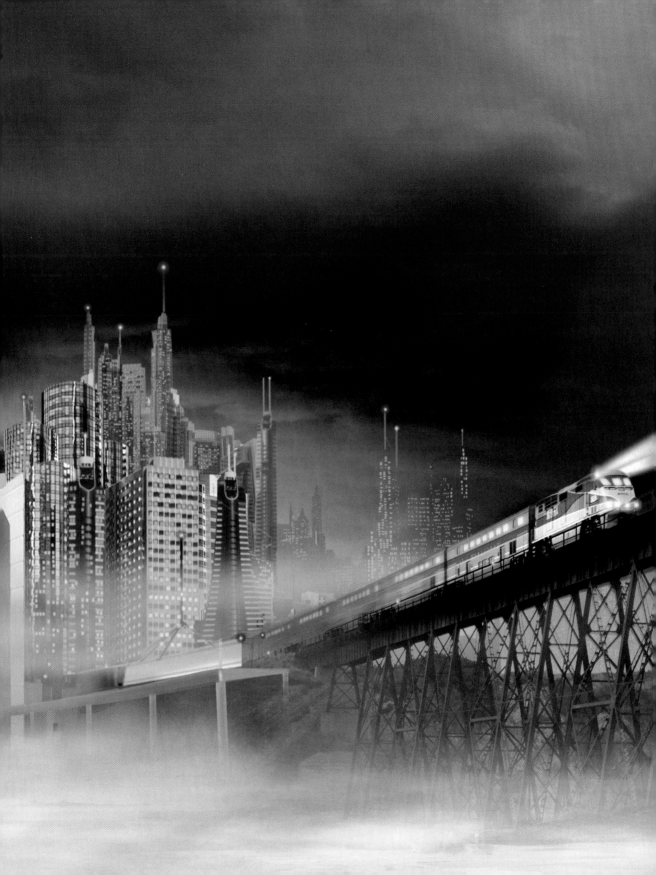

USING PHOTOGRAPHS AS A CREATIVE MEDIUM

The purpose of this exercise is to give you insight into the possibilities of what one photographic image can do if you allow your mind to be open to alternative ways of seeing. Why honor the single shot if you can show something with a more interesting twist?

Most photographers compose for a single expressive image. This technique has been widely used because of the level of difficulty of achieving successful image blends in the traditional darkroom. It could be done in the darkroom, but not without the aid of a series of enlargers with an impeccable registration system to ensure that the images were exposed and placed properly for a seamless integration. Now we have the advantage of Photoshop CS4—the digital darkroom.

With the digital darkroom, your vision is never limited to a single composition. In this exercise, you will learn how to alter the original imagery using compositing and painting techniques. You will also get an introduction to the possibilities of using Smart Filters.

1. Open a file (Ctrl+O/Cmd+O). Access Tutorials/ch 4 and select Cloud001.jpeg. You are going to use this as the base image (see Figure 4.1).

FIGURE 4.1 View of Cloud001.jpeg.

2. In the same folder, open (Ctrl+O/Cmd+O) train001.jpg and use the Magic Wand to select your sky. On the Options bar, make sure that you have Contiguous unselected. This will select all of the particular color that you have clicked to become highlighted with marching ants everywhere in the photograph (see Figure 4.2). Basically, this works globally.

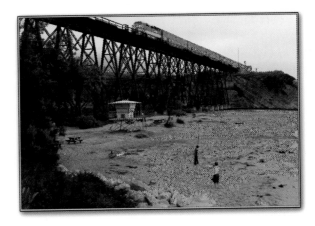

FIGURE 4.2 Magic Wand applied to train001.jpeg.

3. The idea is to select the sky and mask out everything else. To facilitate this process, press the Q key on your keyboard to activate the Quick Mask (see Figure 4.3). Immediately, the areas that are selected will remain clear, and the areas that have not been selected will be highlighted red. Press P to select the paint brush and select black as the foreground color to add to your mask, which in this case is a reddish color. To discard from the mask, paint with white as the foreground color.

If the original red color for the mask conflicts with colors in your photograph, you can change the color that the Quick Mask uses by double-clicking the Quick Mask icon. Then click the color swatch to open the Color dialog box. Simply select a color that you want to work with.

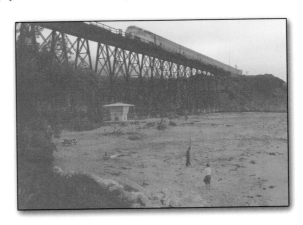

FIGURE 4.3 Apply Quick Mask to the image.

4. Place the train into the Cloud001 base image and flip the image horizontally (Edit > Transform > Flip Horizontal) to position it similarly to what is shown in Figure 4.4.
5. Activate the rectangular marquee and draw a selection around the train. Access the Warp command (Edit > Transform > Warp) and give the nose of the train a little more height, as shown in Figure 4.5.

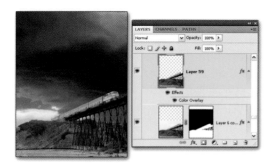

FIGURE 4.4 Place the train image. **FIGURE 4.5** Warp applied to train.

6. Access Tutorials/ch 4 and select beach001.jpeg. Select a portion of the water with the Rectangular Marquee tool (see Figures 4.6A and B). Place this into your train image and flip the water horizontally (Edit > Transform > Flip Horizontal) so that the beach is facing the right-hand side. Apply a layer mask so that the beach detail is isolated to the base of the hill underneath the train (see Figure 4.6C).
7. Create a new layer and make sure that it is located on the very top of your scene. Make sure that your foreground and background colors are medium gray and white. Access the Filter menu and apply clouds (Filter > Render > Clouds). We will use this as the beginning step in creating a low-level fog bank. Then apply perspective (Edit > Transform > Perspective) so that the area closest to the base of the photograph will be larger to give a sense of the fog getting closer to the viewer (see Figure 4.7).

FIGURE 4.6 Steps for creating the beach scene.

FIGURE 4.7 Create fog and apply the transform.

8. Now you need to be able to see through the fog so that the white remains and the gray disappears. To do this, you will use the power of Layer Blend modes. Select Hard Light so that the medium gray will disappear and the white will remain. Apply a layer mask while holding down the Alt/Option key. This will give you a mask that is filled with black by default. Now paint on the mask with a soft-edge paint brush using white as the foreground color. Paint the areas above and to the left of the train to create the effect of the fog lifting up and over the hill. You should have something that looks like Figure 4.8.

9. Let's apply an effect that will help the fog look as if it is part of the color balance of the entire scene. The overall scene is going to reflect a grayish-bluish hue, and the fog needs to be integrated into that color scheme. Double-click on the fog layer that you have just created the mask for. The Layer Style dialog box appears. Select Color Overlay and click the color swatch on the top-right

corner to open your color picker. The idea is to give the fog the grayish tinge with a hint of blue, so select something similar to what is shown in Figure 4.9. In this example, the Opacity is set at 80% so that the entire image will not become one solid color. Experiment with this to find the result that you favor best (see Figure 4.10).

FIGURE 4.8 Layer Blend mode applied to the fog layer.

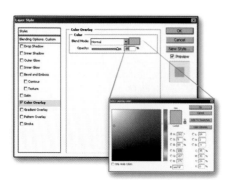

FIGURE 4.9 Apply the Layer Style effect of Color Overlay.

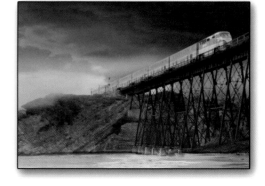

FIGURE 4.10 Results of Color Overlay.

10. Apply the same effect to get the fog on the ground level below the train. Duplicate the fog layer and fill the mask with black (Edit > Fill > Fill with Black). Paint with white on the areas where you want to see the fog exposed. Don't be afraid to duplicate the layers to build the fog effect in various portions of the image. This will assist you in breaking up any obvious consistency in the texture. Use Figure 4.11 as a guide.

11. This is a good time to organize your fog layers into their own layer groups. Select all of the fog layers and place them into a layer group by accessing the layers submenu and selecting New Group from Layers.

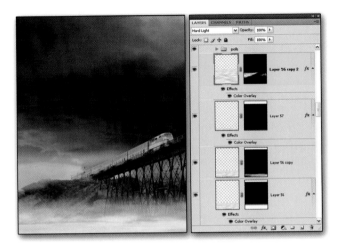

FIGURE 4.11 Apply the fog to lower areas.

12. The intention of the fog technique in step 10 was to give you a way to lay down a quick foundation of texture. Now create a blank layer above your fog and use a soft-edge paint brush to paint the effect in various areas surrounding the train. Figure 4.12 shows an example of the Paint Brush properties and the areas that the technique was applied to. (We will not discuss brushes at this time because they are covered in Chapter 6.)

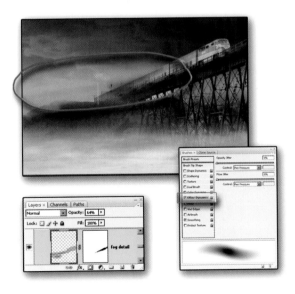

FIGURE 4.12 Reflection created.

13. The train and bridge area should also reflect the color scheme of the surrounding areas, so apply the same Layer Style Overlay technique that was applied to the fog by holding down the Alt/Option key and dragging the layer style from the fog layer onto the train layer (see Figure 4.13).

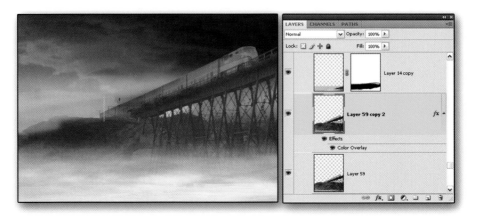

FIGURE 4.13 Add layer style to the train image.

14. For a more dynamic composition, limit the layer style to the rear portion of the train to mimic any areas that will receive more of the atmospheric effect in areas that are farther away. So the front portion of the train will have its original appearance without the effect of the Overlay layer, and the rear portion will have a greater effect with the Overlay layer applied. Duplicate the original train image and place it above the one that you just applied layer styles to. Add a layer mask to that layer and apply a gradient to the mask using the Gradient tool with white for the front portion of the train and ending with black on the rear portion of the train. Use Figure 4.14 as an example.

15. Let's add some detail to the train that will help guide the viewer's eye toward the train composition. Since the background is going to take on a less saturated effect, let's add some detail to the train in the form of a red pinstripe that will lead the viewer's eye farther back into the composition and vice versa.

16. Select the Pen tool (see Figure 4.15A), and create the red decal, as shown in Figure 4.15. On the Options bar, make sure that the Fill with the Foreground Color (see Figure 4.15B) capabilities are selected when you create the path. When the path is completed, you will notice a colored icon to the left side of the actual shape that you've created (see Figure 4.15C). You have just created a vector shape with the advantage that you can double-click on the Color icon to change the color to any shade of hue that you want the decal to be.

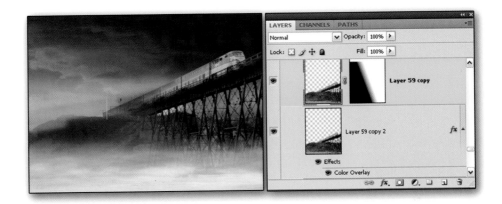

FIGURE 4.14 Apply a gradient mask to the duplicated train layer.

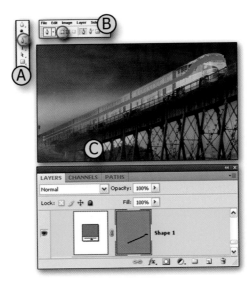

FIGURE 4.15 Apply a vector shape to the train.

17. Now, let's integrate the red stripe more accurately to the side of the train. With your vector-shaped layer selected, change the Blend mode to Soft Light to allow the details of the train to integrate well with the vector shape. Finally, give the vector shape a layer style by double-clicking the blank portion of the layer to bring up the Layer Style dialog box. Next, apply a stroke to the vector detail. This example uses a stroke of one pixel (see Figure 4.16), but you can vary it according to your tastes.

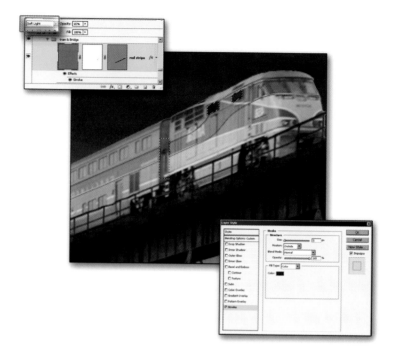

FIGURE 4.16 A stroke of one pixel is applied to the vector shape.

18. To maintain a sense of depth, apply the gradient mask to the vector shape so that the red detail is more prominent toward the front portion of the train (see Figure 4.17).

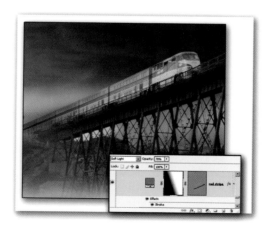

FIGURE 4.17 Apply the gradient mask to the shape layer.

APPLYING MOTION BLUR TO ACCENTUATE MOVEMENT WITH SMART FILTERS

One of the most recent additions to Photoshop CS4 is Smart Filters. This addition represents the continuing effort of Adobe to allow the artists to work in a destructiveless mode of creation. The advantage is that you now have more flexibility to apply the layer effects in any manner that you deem necessary, and you can go back and undo changes or add them to accentuate your texturing without the destruction of the original image. We will get more into the concept of Smart Filters later, but for now, let's apply a simple effect to give the train a sense of motion.

1. Select the layers that make up your bridge, train, and the red decal. While holding the Alt/Option key on your keyboard, access the Layer submenu and select Merge Layers (see Figures 4.18A and B). The Alt/Option modifier merges the selected layers into a new layer without affecting the originals. Next, go to the Layers submenu again and select Merge into Smart Object. The Smart Object command allows you to resize your image without losing the quality that was originally present.

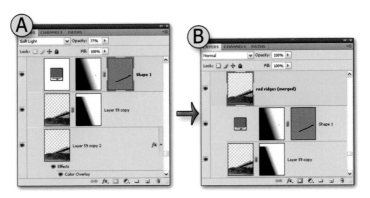

FIGURE 4.18 Merge layers without affecting the originals and then create a Smart Object.

2. Now apply Motion Blur. Adjust the angle to the direction of the train and play with the distance to apply the Motion Blur (see Figure 4.19).

3. Notice that you now have an additional layer beneath your Smart Object. This layer contains the Filter commands that can be altered independently of the entire scene. You also have a mask attached to the Smart Filter so that you can apply the effect to localized areas of the image. On the right side of the title "Motion Blur," double-click to open the Motion Blur dialog so that you can make adjustments to the original Motion Blur settings at any time (see Figure 4.20A and B). In addition, you can apply Layer Blend modes to the effect (see Figure 4.20C).

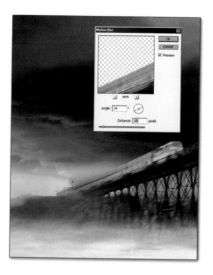

FIGURE 4.19 Apply Motion Blur.

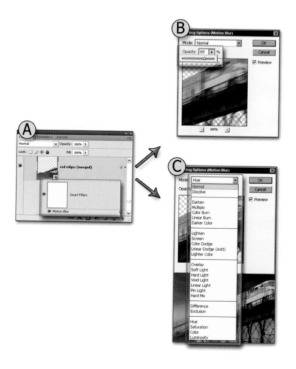

FIGURE 4.20 Make any additional changes to your Motion Blur.

4. Since the mask is associated with the filter, apply a gradient so that the fore-ground is unaffected and the background takes on more of the effect (see Figure 4.21).

FIGURE 4.21 Apply the gradient mask to the Smart Filter.

ADDING DETAIL TO THE BACKGROUND

As the train is coming forward to the foreground, let's make it appear as if it is coming from a platform from the background of the composition. This added detail will help anchor the viewer's eye to the rear of the composition because the train gives the illusion that it is traveling forward. Afterward, you'll add some sunset effects that will push the foreground objects visually toward the viewer.

1. Create a new layer group above the train and bridge, and title it "Bridge Platform." Create a basic shape with the use of the rectangular marquee and fill it with the gradient from medium gray to a lighter gray on a separate layer (see Figure 4.22).
2. Place this shape vertically to represent pillars that will hold up the platform to the rear and slightly below the train, as shown in Figure 4.23A. Make sure that you use Free Transform to make the pillars that are farther away from the foreground smaller and thinner to simulate depth.

FIGURE 4.22 Basic colors shape created.

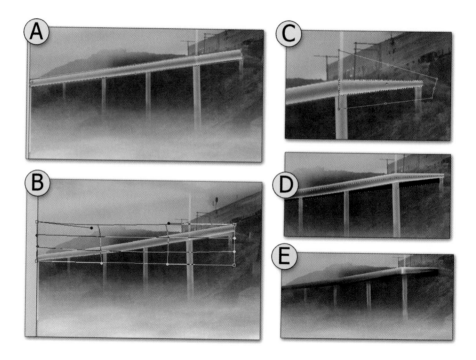

FIGURE 4.23 Custom create your platform.

3. Use the Warp tool to bend the horizontal platform slightly. This will give the effect that there are weighty objects sitting on the platform (see Figure 4.23B). Select the first fifth of the platform with the rectangular marquee and apply Distort to angle it so that it appears that the viewer is looking at the front section of the pier (see Figure 4.23C). Press Shift+O until you select

the Burn tool. In the Options bar, make sure Midtones is selected. This option tells the Burn tool to favor the middle range of grays to become darker in tonality. Now, apply the darkening effect underneath the bridge (see Figure 4.23D). Burn down the rear portion of the platform so that it has a feeling that it is receding farther into the background (see Figure 4.23E).

4. Create a new layer beneath the platform and create a triangular selection similar to what is shown in Figure 4.24A. This is going to become a shadow underneath the bridge. Press Ctrl/Cmd+D to deselect the selection and apply the Gaussian Blur to soften the shadow effect. Figure 4.24B gives the final result.

FIGURE 4.24 Create the platform shadow detail.

5. Create another layer group titled "sunset effects." In this layer group, create a new layer where the gradient starts from red and ends as a transparency (see Figure 4.25). Position the red gradient layer so that the hue fades off slightly above the head of the train. Next, duplicate this layer and move it so that the lower portion of the original sunset takes on a slightly stronger reddish hue. Use Figure 4.25 as an example. In Figure 4.26, add additional gradient layers to enhance the effect and place them in their own layer group. Next, add a mask to the layer group so that the sunset is applied to localized areas in the lower sky.

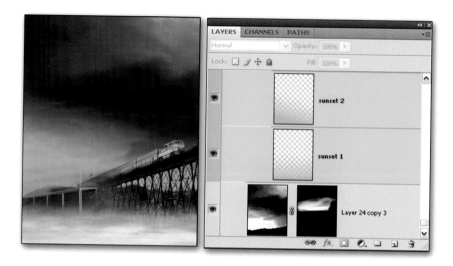

FIGURE 4.25 Apply your sunset.

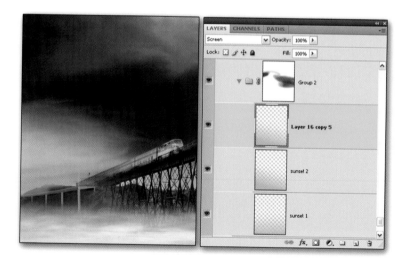

FIGURE 4.26 Apply the layer group mask to your sunset.

APPLYING THE FOREGROUND CITY SHAPES

You're going to create the city landscape with the use of photographic imagery from several sources. You will enhance the results with painting and special effects techniques to make them more dynamic.

1. Open Adobe Bridge (File > Browse), navigate to Tutorials/ch 4, and select building 001.jpg. Figure 4.27A shows the original image.
2. Select a portion of this image (see Figure 4.27B) and place it on its own layer (see Figure 4.27C).

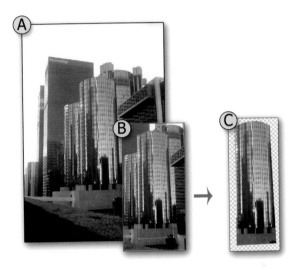

FIGURE 4.27 Selected portion of the architecture.

3. To make things a little easier to work with, turn off the bridge platform layer group. Create a new layer group titled "foreground building." Position this layer group behind the bridge platform group. Duplicate the selected architecture and position it as shown in Figure 4.28.

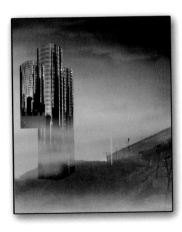

FIGURE 4.28 Position the duplicated architecture.

4. In the same folder, also open building 002.jpg and select the architecture shown in Figure 4.29.
5. As shown in Figure 4.30, place the new building in front of the circular shapes that you created in steps 1 and 2.

FIGURE 4.29 Isolate the architecture onto its own layer.

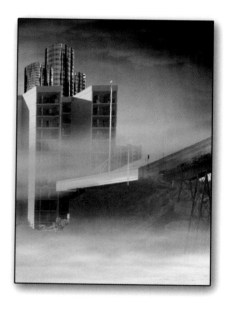

FIGURE 4.30 Place the new building in front of the circular shapes you created earlier.

6. Turn on the bridge platform layer group and, if needed, apply the layer masks to get rid of any extraneous details (see Figure 4.31).
7. Once again, navigate to the Tutorials/ch 4 folder, and select building 003. jpg. Select the skyscrapers shown in Figure 4.32 and use the Warp tool to alter the shapes.
8. Place your new shapes in front of your foreground architectural detail. Play around with their positioning (see Figure 4.33).
9. You can create a lot of detail from just a few images. By selecting portions of other skyscrapers in the building 003.jpg (see Figure 4.34), you can reposition them (see Figure 4.35) on top of other elements to reshape the vision beyond the original photographic imagery. Experiment with this concept by taking details from existing architecture and placing them on other areas of your composition using your layers (see Figure 4.36).

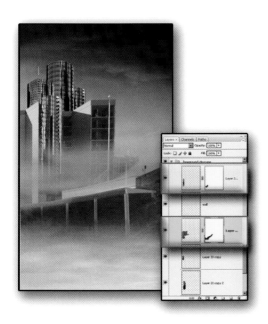

FIGURE 4.31 Edit the architectural details using layer masks.

FIGURE 4.32 Edit the architectural details using the Warp tool.

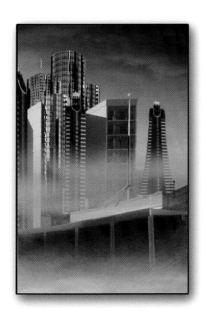

FIGURE 4.33 Add new shapes to the foreground architecture.

FIGURE 4.34 Redefine the foreground architecture.

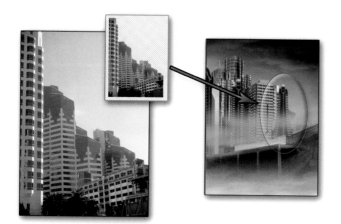

FIGURE 4.35 Add more foreground architecture.

FIGURE 4.36 This an example of the final results organized in their respective layers.

CREATING THE BACKGROUND CITYSCAPE

Next, you will create the cityscape that serves as the background to the foreground city and train. This image has already been created for you and is available in the Tutorials/ch 4 folder. Just open city composite.psd and use this for the background cityscape detail. However, if you prefer to try your hand at creating your own city, follow these steps.

1. In the Tutorials/ch 4 folder, select the building 004.jpg image (see Figure 4.37A). Select a portion of the architecture, as shown in Figure 4.37B, and then duplicate and flip it horizontally using Free Transform (see Figure 4.37C). Place these layers inside a layer group titled "mid-distant city" beneath the Train and Bridge layer group.
2. Add more detail by opening up another image titled building 005.jpg and selecting a portion of its architecture (see Figure 4.38). Place it on its own layer, apply the Difference Blend mode, and then resize it to make it tall and thin (see Figure 4.39). Move this on top of the initial building detail and watch how the effects blend the two details.

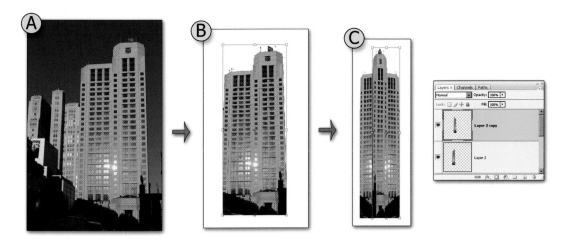

FIGURE 4.37 Select architectural details.

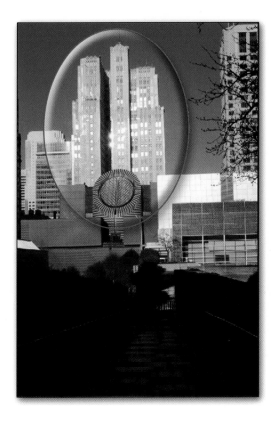

FIGURE 4.38 Select new texture details.

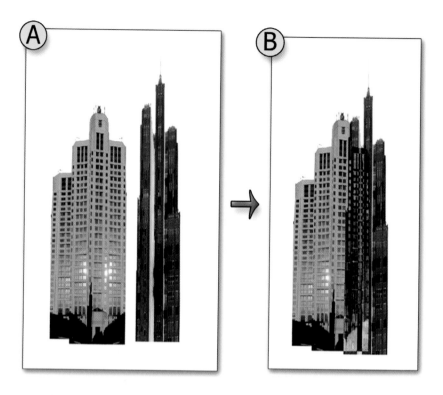

FIGURE 4.39 Allow the Layer Blend modes to alter the texture details.

3. The intention of the final result is to get architectural detail that is going to fade into the background, so you're going to use Multiply, Darken, Overlay, and Difference modes to blend various textural shapes to create the background cityscape.
4. Add more detail by using building 006.jpg to continue building on the cityscape structure. Figure 4.40A thru C shows the progression of removing the background to isolate the architecture.
5. Try to create something close to Figure 4.41.
6. If you create your own version of the cityscape, select all of the layers that make up the background city and merge them. The background cityscape is going to be surrounded by haze and fog, so visually you will not be able to see much detail; instead, you will see mostly a colored outline of the skyline. So double-click the background cityscape layers and apply an Overlay effect that reflects the color of the surrounding atmosphere. Adjust the Opacity slider to feed the detail into the chosen color overlay (see Figure 4.42).

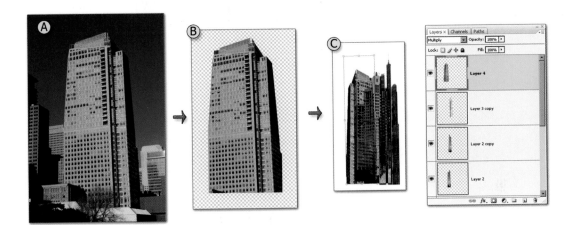

FIGURE 4.40 Continue adding more texture details.

FIGURE 4.41 The final cityscape.

7. Duplicate the cityscape layer. To help the scene not look too redundant with the use of similar shapes repeating themselves, flip the layer horizontally so that it will help add some visual diversity in the composition (see Figure 4.43). Place this object lower in the horizon and directly behind the train and toward the center scene located in between the two larger structures. Now edit its layer style to have a higher opacity in the setting for the Overlay effect. Since we want this cityscape to be farther into the horizon, the detail will be more obscure than its predecessor.

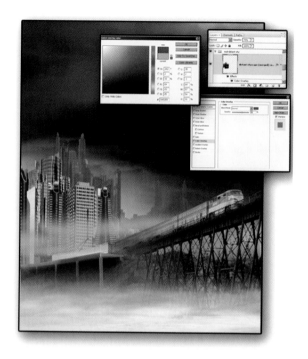

FIGURE 4.42 Continue adding more texture details.

FIGURE 4.43 Duplicate and flip the cityscape horizontally.

ADDING LIGHT DETAILS

Adding light effects to the window region is the easiest step of all. It entails using the Polygonal Lasso tool to select the basic rectangular shape and filling the shape with the color of your light source. In this example, yellow and white are used.

1. Focus on a single building and select one of the windows using the Polygonal Lasso tool or the Rectangular Marquee tool. Create a new layer group titled "light effects" and fill the selection on a new layer. After the layer has been filled, use the Move tool to duplicate that layer by holding down the modifier Alt/Option key while you move the shape to the new location. If this selection is still active, it will move your highlight to the new location while still on the current layer. If the highlight is not surrounded by a selection, then the layer will be duplicated. Use Figure 4.44 as an example.

FIGURE 4.44 Create the lighting effects on the cityscape to add believability.

2. When you're finished, change the Blend mode to Screen, and give the light source a slight Gaussian Blur to create a slight glow. Figure 4.45 shows the final result.
3. Finally, apply the same technique to the windows of the train. This gives the moving vehicle life, as shown in Figure 4.46.

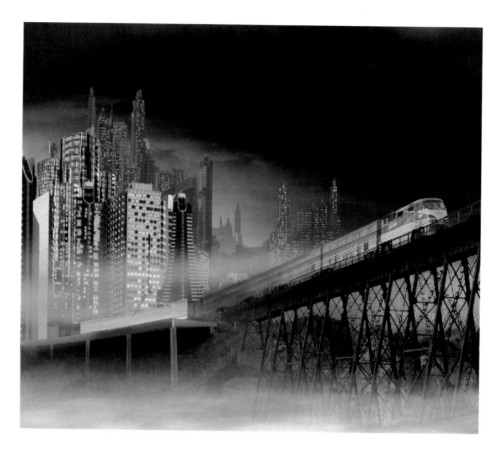

FIGURE 4.45 Final result of light technique.

4. Select the Gradient tool on the toolbar and activate the Gradient Editor on the Options bar. You're going to custom create point lights to use as headlights on the front of the train, as well as light sources on the architecture itself. Take a look at Figure 4.47A. A custom gradient has been established to the presets by clicking the New button. This gradient will start from a white highlight, gradate toward a red hue, and then taper to transparency to create the effect of a glowing ball of light.

5. Figure 4.47B shows the upper portion of the gradient that finds the opacity of the color. The first point is given an opacity of 100%. Start the transparency falloff at the second point in Figure 4.47C, which shows the Opacity point at 91%. Figure 4.47D displays the last point to the right has been given a designation of 0% opacity or complete transparency.

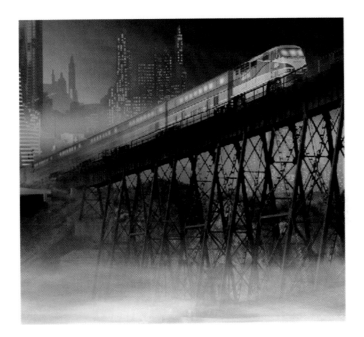

FIGURE 4.46 Create the lighting effects on the train.

FIGURE 4.47 The Gradient tool options.

6. With the Gradient tool still selected, select the Circular Gradient option from the Options bar. Now apply the gradient by clicking and dragging a new transparent layer. You should have something similar to Figure 4.48.

FIGURE 4.48 Create a circular gradient.

7. Take the gradient, transform it (Ctrl+T/Cmd+T), and place it over the areas of the train that will represent the different headlights. Use Hue and Saturation to alter the color of the gradient from red to yellow or orange. Create one large light on either side of the train and four smaller orange lights below the train's nose (see Figure 4.49).

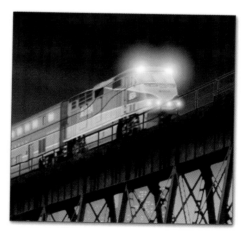

FIGURE 4.49 Create the headlight flair.

8. Figure 4.50 shows several steps for creating the light beam from the main two light sources. Simply create a rectangular selection on a new layer so that the light source expands as it gets farther away from its source.

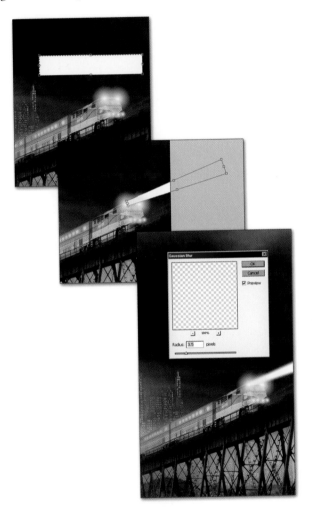

FIGURE 4.50 Create the headlights.

9. The light beam should have a feathered edge, so apply Gaussian Blur to give this effect. Also, as the beam gets farther away from the source, its intensity will dissipate, so apply a gradient mask to achieve this, as shown in Figure 4.51.

10. To add more intensity to the source of the beams, select the paint brush and paint on a blank layer with the Blend mode set to Screen (see Figure 4.52).

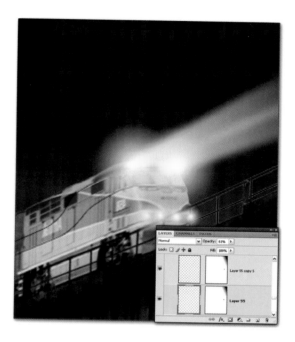

FIGURE 4.51 Gradient mask applied to the light beams.

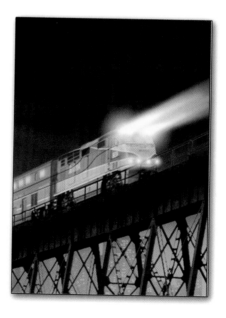

FIGURE 4.52 Add additional flare effects to the light beams.

11. Create a new layer group titled "poles." In this group, create two layers. The top layer will be for the foreground buildings and the bottom layer will be designated as the background buildings. Using the paint brush, create a fine brush and paint some poles on the top of some of the skyscrapers (see Figure 4.53). To constrain the technique to move only on one axis to create a straight line, hold down the Shift key while you paint.

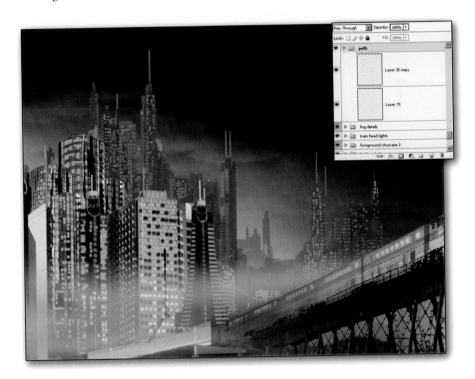

FIGURE 4.53 Add light poles to architecture.

12. Use one of the point lights used for the headlights of the train for placement on the tips of the poles (see Figure 4.54). Remember to use Free Transform to make them small enough to appear as if the light sources are farther in the background. In addition, use the Hue and Saturation command (Ctrl+U/ Cmd+U) to change the colors.

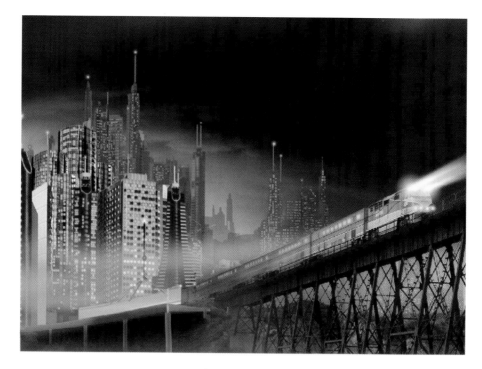

FIGURE 4.54 Place lights on top of the poles.

ADDING FINISHING TOUCHES TO THE ATMOSPHERE

Too many of the colors in the image are too independent, which fights against the homogenous characteristic of the final image. Let's give the image some color effects to further accentuate the atmosphere.

1. Create a new layer and fill it with grayish red. Bring down the Opacity setting to around 28% and leave the Layer Blend mode at Normal (see Figure 4.55).
2. Apply a layer mask to the new color layer and edit the mask so that the effects are greatest in the areas around the train (see Figure 4.56).
3. Add a Color Balance Adjustment layer and alter the settings in favor of Cyan (see Figure 4.57).
4. Create a gradient with blue as a foreground color and 100% transparency as the ending color (see Figure 4.58). Duplicate and position the gradient in the lower and upper portion of the composition. This technique helps focus the viewer's attention toward the moving train.

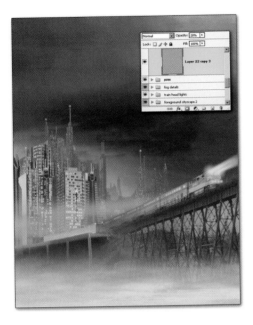

FIGURE 4.55 Create a color layer.

FIGURE 4.56 Apply the mask to the color layer.

FIGURE 4.57 Create a Color Balance Adjustment layer.

FIGURE 4.58 Apply a bluish gradient.

5. The train needs extra contrasts, so apply a Curve Adjustment layer to increase the contrast and then apply the technique only to the train by filling the mask with black and painting the effects with white (see Figure 4.59).

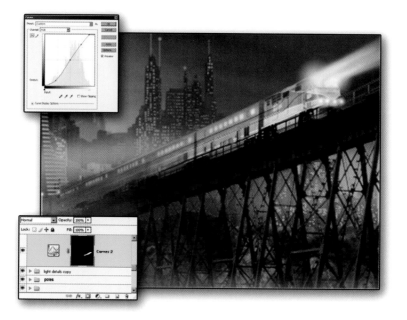

FIGURE 4.59 Add the contrast to train.

6. To add a little more drama to the sky, create the Levels Adjustment layer to intensify the contrast and giver richness to the middle tone detail (see Figure 4.60).

7. The reddish hue of the sunset could use a little more pop. Apply the Selective Color Adjustment layer and select reds from the Colors drop-down menu, as shown in Figure 4.61. Intensify the red by bringing down the cyan and increasing magenta, yellow, and black. Experiment with these settings to find something satisfactory to you.

8. The reddish background of the sunset will spill some reddish highlights on the edges of the building, so apply a Curves Adjustment layer and select Red from the Channel drop-down list (see Figure 4.62). Place a point in the center line and pull it up toward the top left to throw the image into a reddish hue.

9. Fill the mask with black to block out the Curves Adjustment layer effect. Use the paint brush to paint in the effects on the edges of the skyscraper, as shown in Figure 4.63.

FIGURE 4.60 Apply the Levels Adjustment layer.

FIGURE 4.61 Apply the Selective Color Adjustment layer.

FIGURE 4.62 Apply Curves Adjustment for the red hues.

FIGURE 4.63 Apply the Curves Adjustment layer to the edges of the skyscraper buildings.

WHAT YOU HAVE LEARNED

- How to composite photographic imagery.
- How to use smart objects.
- How to use layer sets.
- How to use Layer Blending modes.
- How to use Free Transform and Distort for localized areas.

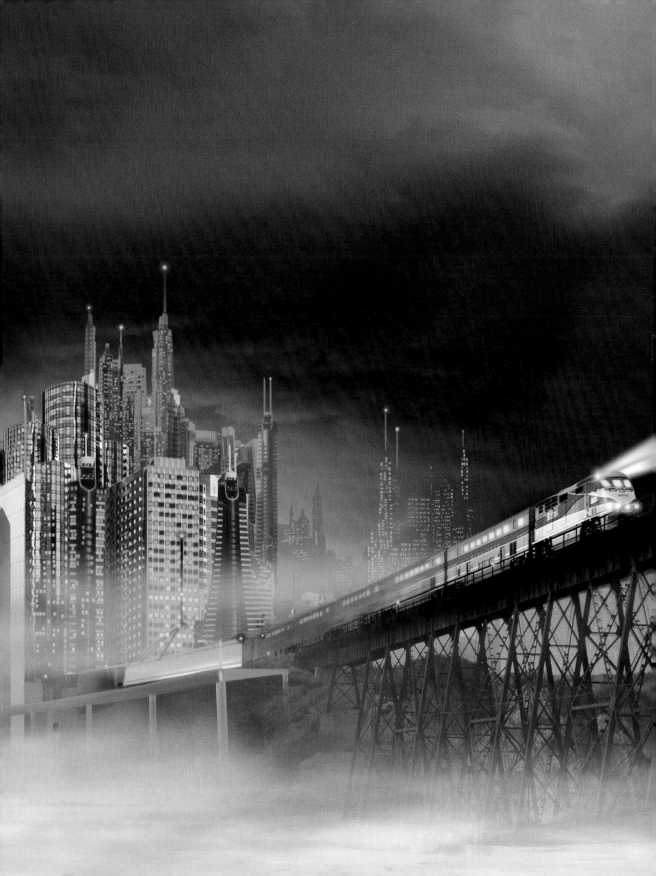

INTEGRATING PHOTOGRAPHY AND 3D OBJECTS

IN THIS CHAPTER

- About integrating 3D objects with photography
- Using the Auto Blend mode
- FX tricks for creating lighting
- Brief overview of UV maps
- Editing surface materials
- Applying 3D lighting

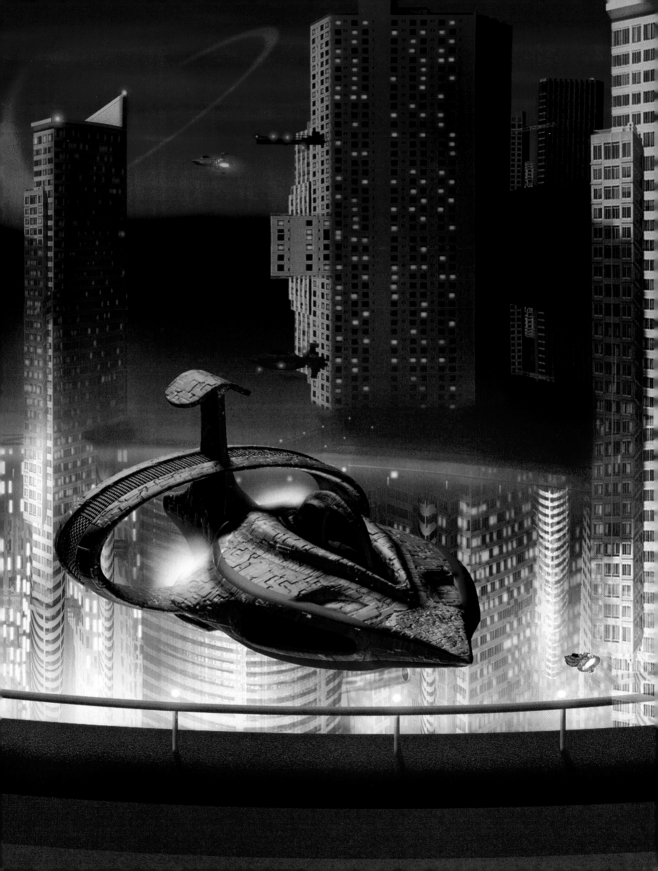

CREATING THE INITIAL LANDSCAPE USING AUTO ALIGN LAYERS

In this chapter, we're going to explore two different approaches to integrate 3D objects into your Photoshop environment. First, we'll use the new 3D layers and then progress toward using bitmaps in the next exercise. We will not go into great depth as to all of the capabilities and features of 3D layers in this chapter primarily so that we can just have fun creating. We will cover those features in greater depth in Chapter 6.

You'll start with a panoramic-formatted image consisting of three images, and you'll apply Auto-Align Layers and Auto-Blend Layers to create a landscape.

This landscape will be the backdrop for a futuristic scene where you will create an underground city within a desert-like landscape. After creating the city, you will then apply the light source emanating from beneath and provide ambient lighting derived from the sunset.

You will also learn about the wonderful new Photoshop CS4 Extended feature called 3D layers. The new 3D layers allow you to import 3D objects created from third-party programs into Photoshop to integrate into your digital workflow.

1. Create a new file that is 8.5×15 inches wide (see Figure 5.1). We will place the end result of the merged panoramic landscape into this file.
2. Access the Tutorials/ch 5 folder and open desert1.jpg, desert2.jpg, and desert3.jpg. Place these three images into your new file (see Figure 5.2).

FIGURE 5.1 View of the 8.5×15 inch format.

FIGURE 5.2 Place the three desert images into the new file.

3. These three images show a desert expanse taken in three separate shots. They are basically the left side, the midsection, and the right side of the composition. These images were not shot with a tripod but rather a handheld to test how well the new Auto-Align Layers feature worked in Photoshop CS4. Auto-Align Layers is basically Photomerge, and it allows you to merge images on selected layers.

4. Select the three desert layers and go to the Auto-Align Layers command (Edit > Auto-Align Layers). A dialog box appears with six options for you to choose how you would like your layers to be aligned (see Figure 5.3). They are the following:

Auto. Tells a program to make all of the important decisions for you and give you the best results. The Warp Transform command will be utilized as needed here.

Perspective. Applies the Perspective transform techniques toward the end of the merged image. This is a good one to use when the perspective causes the imagery to shorten toward the end of the image. Distortion of this type is a common problem with wide-angle lenses.

Collage. Allows the user to manually position the images.

Cylindrical. Tapers left in the right portion of the image but rounds the horizontal. Applies distortion to favor wrapping images around cylindrical shapes. This is ideal for the new 3D features in CS4 Extended.

Spherical. Applies distortion in favor of wrapping images around spherical shapes. This too is ideal for the new 3D features in CS4 Extended.

Reposition. Merges photos without using Transform or Warp distortions. This is ideal when you do not want your images to be transformed with stretch or warp.

5. Click OK and take a look at the results in Figure 5.4.

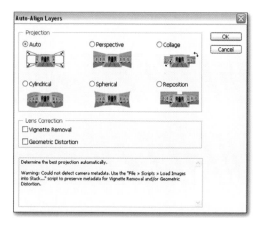

FIGURE 5.3 Apply the Auto-Align Layers command.

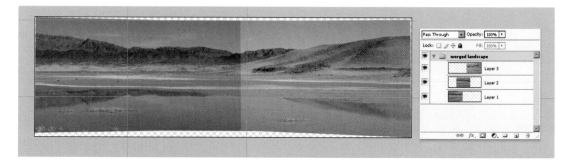

FIGURE 5.4 Results of the Auto-Align Layers command.

6. The landscape has been blended fairly well, and if you take a look at your layers, you can see how each image has been positioned so that the three images are overlapped in such a way that the landscape takes on a continuous flow. But there are a few problems. First, each photograph seems to have a slightly different exposure because the digital camera was set on auto exposure, which means each image has its own exposure settings. Another problem is

that the edges of the images are prominent and need to be removed. You could do that with masking, or Photoshop can do it with the Auto-Blend Layers command (Edit > Auto-Blend Layers), as shown in Figure 5.5.

7. This command blends the edges of your photographs and adjusts the brightness and color balance so that the overall results look consistent, as shown in Figure 5.6.

FIGURE 5.5 Access Auto-Blend Layers in the Edit menu.

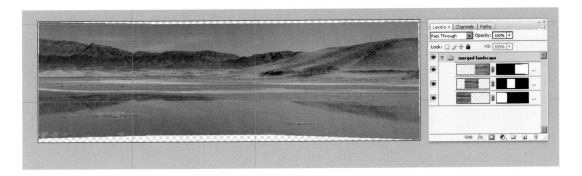

FIGURE 5.6 Results of the Auto-Blend Layers command.

8. When the layers are merged, Photoshop expands the canvas size to fit the three images. Since we want to retain the original dimensions of 8.5×15 inches, merge all three of the layers and place the merged object into the new canvas that you created earlier (see Figure 5.7). Afterward, simply Free Transform (Ctrl+T/Cmd+T) the image to fit within the dimensions of the new file. Place these files into their own layer group titled "merged landscape" (see Figure 5.8).

FIGURE 5.7 Merge all layers.

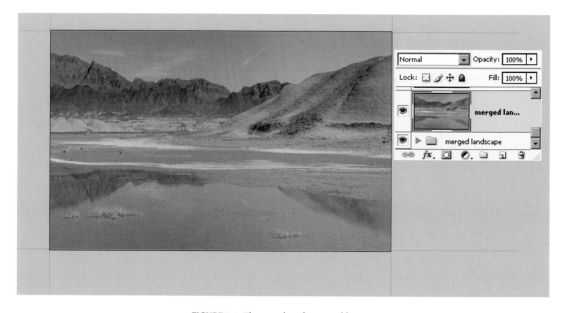

FIGURE 5.8 The results of merged layers.

9. Use the Quick Selection tool to select the sky, as shown in Figure 5.9. When you are finished, press Delete to cut out the sky.

FIGURE 5.9 Apply the Quick Selection tool and remove the sky.

10. Now you will create the location where the underground city will be built. In addition, you will resize the mountain range so the viewer's attention can be focused on the underground city structures. Use the Circular Marquee tool (M) to make a selection similar to what's shown in Figure 5.10A. Select a mountain range with the Rectangular Marquee tool (Shift+M) and use Free Transform to reduce its height toward a more narrow result (see Figure 5.10B).

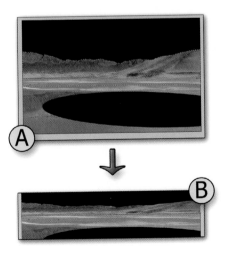

FIGURE 5.10 Apply selections and transform the mountain range.

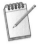

Shortcut Tools

The shortcuts for Photoshop's tools are often designated by a single character; in this case, it is "M" for Marquee. However, there are other options within the same palette. To toggle through these options, hold down the Shift key and press M to access the other hidden tools. This is standard procedure for all tools on the Tools palette.

11. Next, you will create the sunset-dominated sky by using the Gradient tool. Make sure that your foreground color is of a bluish nature and your background color is more of a reddish nature. Use the Gradient tool (G) and apply the blue for the upper portion of the photograph with a gradient toward a red in the lower portion of the photograph, as shown in Figure 5.11.

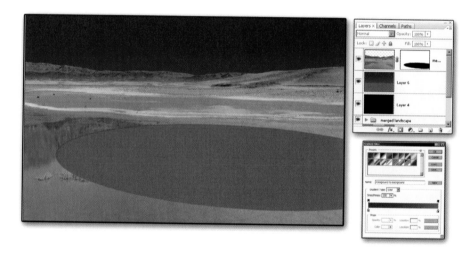

FIGURE 5.11 The results of the applied gradient.

12. Add a new layer and place it above the gradient layer. Create a gradient by making sure that your foreground color is yellow. Select the Gradient Editor and then select the Foreground to Transparency option. Now apply the yellow gradient so that it tapers off to transparency near the upper portion of the mountain range, as shown in Figure 5.11. Figure 5.12 shows the options that were used to create the gradient for the yellow highlight. In addition, add a gradient in a separate layer below the landscape layer where the sides are black to medium gray toward the center. Use the Mirror option in the Options panel, also shown in Figure 5.13. This helps to give a visual that this will be the cavern where the underground city will be placed. The look for now does not have to be fancy. It is just a proxy that will help aid your imagination. The city will replace it.

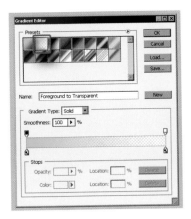

FIGURE 5.12 Gradient options for the yellow highlight.

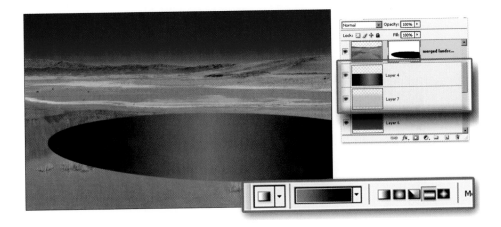

FIGURE 5.13 Add a gradient from blue to red that represents a sunset as well as a gradient for the cavern that the underground city will replace.

13. Double-click the landscape layer to bring up the Layer Style dialog box (see Figure 5.14). Use this to create a gradient where the top one-third portion is darkened and the rest of the image is unaffected. Change the opacity of the gradients to 81%. Now the background appears to recede into the distance.

14. Let's get the landscape to reflect the ambient light coming from the sunset. You use layer styles to do this. Double-click the landscape layer to bring up the Layer Style dialog box. Select a gradient from the menu and use the foreground color that is close to a reddish hue that was used for the sunset (see Figure 5.15). In addition, set the background color to the blue that was

established for the sunset layer (see Figure 5.16). Play with the Opacity slider for this gradient to get a subtle effect. It is important to play with these settings to get the results that you are satisfied with. There is no substitute for pure experimentation.

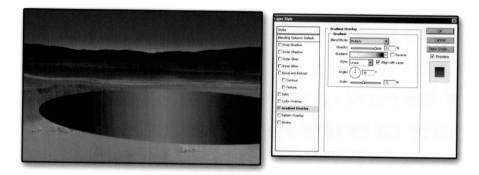

FIGURE 5.14 Apply a gradient using the Layer Style dialog box.

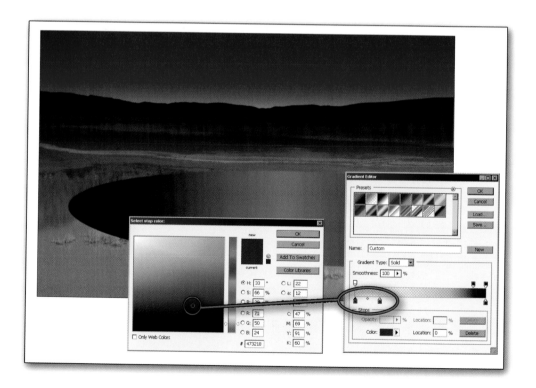

FIGURE 5.15 Establish the red foreground color as the gradient.

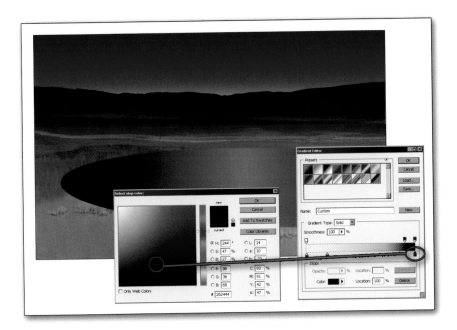

FIGURE 5.16 Establish the blue background color as the gradient.

15. In the Tutorials/ch 5 folder, open the clouds 001.tif file. Place the clouds in the upper portion of the sky (see Figure 5.17). Resize the clouds so they fit into the horizon. Also, reduce the clouds' opacity to about 40% so they blend with the gradient.

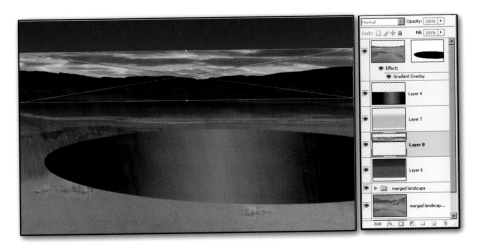

FIGURE 5.17 Commit the clouds as a Smart Object and reposition them into the horizon.

16. Give the clouds a slight Motion Blur. Since the cloud's image is a Smart Object, the filter for Motion Blur will become a Smart Filter (see Figure 5.18).
17. Figure 5.19 displays the settings used for Motion Blur. Experiment with different angles and blur effects to come up with something that you will like better.

FIGURE 5.18 Apply Motion Blur to the clouds.

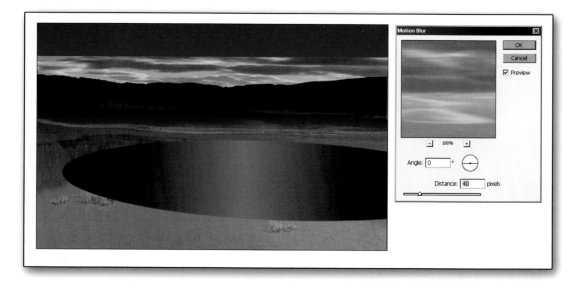

FIGURE 5.19 Settings for Motion Blur applied to the clouds.

18. This is where the real fun begins. Let's start creating the underground city. Go to the Tutorials/ch 5 folder and open architecture 001.tif (see Figure 5.20A).You will apply quite a bit of distortion to these images, so you will not commit them as Smart Objects. Select the sky as you did with the landscape image using the Quick Selection tool (see Figure 5.20B). Then invert it and apply perspective so that the lower portion of the image is slightly shorter than the top. This will make the buildings look as if they're extending downwards.

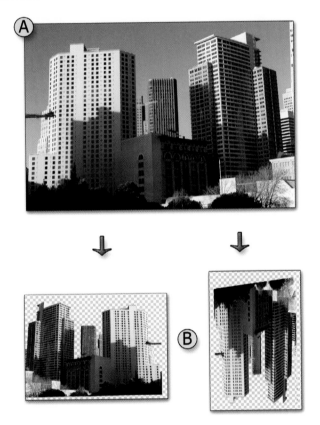

FIGURE 5.20 Modify the architecture.

19. The whole concept of this tutorial is to apply some trickery to the eye. Sometimes working in more of an abstract fashion can help convey a figurative concept. So we will lay out a series of buildings, which will not take on any definite shape until later in the tutorial. To make sure that things don't get too visually busy on the canvas, turn off the landscape layer and work with the visual aspects of the architectural images for the time being.

20. Duplicate the architecture layer several times, resize the layers, and position them so that they look similar to Figure 5.21. Place these layers into a layer group titled "underground city."

FIGURE 5.21 Add a series of buildings for the underground cityscape.

21. Continue to duplicate and add portions of the architecture, but this time, change the Layer Blend mode to Darker Color (see Figure 5.22). This will allow the texture information that is darker to dominate the blend. In effect, the concrete texture and window patterns will become even more prominent throughout the underground cityscape portion of the final object.

FIGURE 5.22 Duplicate the architecture patterns and change the Blend mode to Darker Color.

22. When you're finished, turn on the landscape layer, which should look something like Figure 5.23.

FIGURE 5.23 View the landscape and city together.

23. Create some extra detail by adding a platform supported by a circular-shaped building. Create the platform on top of the landscape layer using the Circular Marquee tool and the Polygonal Lasso tool to get a shape similar to what you see in Figure 5.24.

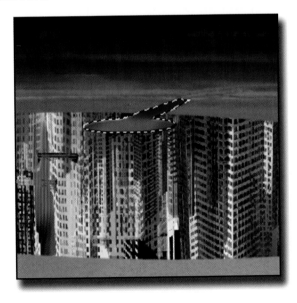

FIGURE 5.24 Create the platform.

24. Go to the Tutorials/ch 5 folder and open the architecture 002.tif file (see Figure 5.25A). You need to make sure that the lines are going to be fairly straight to make it easy to apply the next step. So make sure that the rulers (View > Ruler) are turned on, place your mouse in the left side of the vertical ruler bar, and click and drag to place three guides, as shown in Figure 5.25C. This will assist you in lining up the vertical lines for the new piece you're about to create.

25. Use the Free Transform tool (Ctrl+T/Cmd+T) to narrow the image downward vertically (see Figure 5.25B). While still in Free Transform, hold down the Ctrl/Cmd key, select the middle handlebar on the top portion of the transform box, and move the point to the right so that all of the architecture's vertical lines match up with the guides that you have laid down. Holding down the Ctrl/Cmd key while still in Free Transform is the shortcut for applying Distort.

26. The goal is to give the building some height but maintain the short horizontal grid patterns that you have established when the size of the image is reduced. Duplicate this layer three times and use the Move tool (V) to position the layers on top of one another (see Figure 5.25D). Next, let's give it a rounding effect with the use of the Warp command (see Figure 5.25E).

FIGURE 5.25 Create the rounded architecture.

27. Merge all the layers used to create the rounded architecture; then apply the Layer Styles Gradient. Use this setting as shown in Figure 5.26 as a starting point.

28. Position the completed image below the platform. Use Figure 5.27 as a guide.

FIGURE 5.26 Apply a gradient to the rounded architecture.

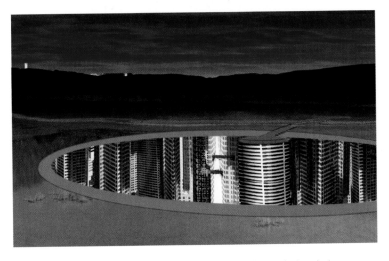

FIGURE 5.27 Position the rounded architecture beneath the platform.

29. Add some warm color to it using the Hue and Saturation command and duplicate the procedures from steps 23 through 28 to create another platform on the left side of the composition (see Figure 5.28).

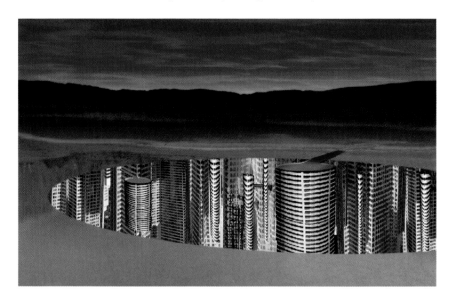

FIGURE 5.28 Re-create the rounded architecture and place it on the left side.

30. In the "mountains" layer group, you will establish a shallow depth of field with a mountain range in the background that blurs out slightly. In addition, you'll establish a slightly stronger atmospheric haze that reflects the ambient color in the environment.
31. Make sure that the mountain layer is committed as a Smart Object. Next, apply Gaussian Blur to effectively blur the entire landscape scene. Since the Gaussian Blur is a Smart Filter, restrict the effects of the blur to the upper portion of the landscape by editing the mask that is associated with the Smart Filter. Create a gradient where black dominates the lower half of the image and gradates toward white in the upper portion of the image. This will restrict the blur effect to the background of the composition, which is the mountain range in this case.
32. Now, let's create the atmospheric haze. Make sure that your foreground color is a similar color to the reddish hue in the sunset area. You can do this by using the Eye Dropper tool to select a color from any area on your image (see Figure 5.29A).
33. Use the Gradient tool (see Figure 5.29B) to apply that color to the mountain range only by using the Reflect a Gradient option on the Options bar (see Figure 5.29C).

FIGURE 5.29 Create atmospheric aids and a shallow depth of field.

34. This is a good time to add the beginnings of a light source to the underground city. Do this by way of a gradient that uses blue for the top portion of the city and yellow on the lower half of the city. To blend these colors in with the architecture, change the Blend Mode to Multiply. Then follow up by adding two more layers using the yellow as the foreground color that will gradate to a complete transparent pixel, as shown in Figure 5.30. Use layer masking to edit the layer to restrict the effects to various locations of the landscape. This breaks up the perfect shading pattern so that you can give the illusion that the lighting is affected by the geometry of the unique shape of each building.

FIGURE 5.30 Add some light source to the architecture.

CREATING THE UPPER ARCHITECTURE

The approach to creating the upper architecture will be more controlled than the previous steps for the underground city. The following techniques are useful when you have a definite idea about how you want your image to look in the final result. You will take portions of a single building to reshape and use textures to create other compositional elements for the concept.

1. Open architecture 003.tif in the Tutorials/ch 5 folder (see Figure 5.31A). Select a portion of the image, as shown in Figure 5.31B, and use Free Transform (Ctrl+T/Cmd+T) to distort the image and make the horizontal lines of the architecture a little more horizontal.
2. To give this building a more straight-on view to the camera, select the left portion that makes up the right face of the building and apply Free Transform to shorten it (see Figure 5.31C). Duplicate the image and flip it vertically (Edit > Transform > Flip Vertically) to create a mirrored image of the original. Use layer masks to blend the two shapes. In this case, the blending does not have to be perfect because much of it will be obscured by the landscape. Try to get your image to look like Figure 5.31D.

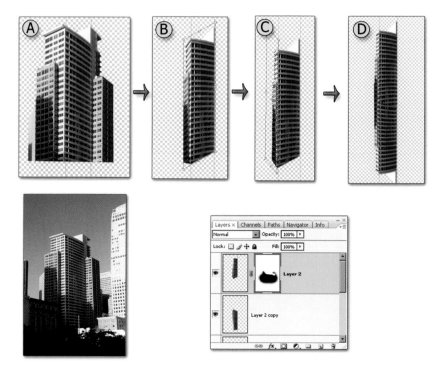

FIGURE 5.31 Select and mirror the architectural shape.

3. Now open the original architecture 001.tif file and apply the same technique to the entire image (see Figure 5.32).

FIGURE 5.32 Select and mirror the complete architectural scene.

4. Position the architectural shapes in the right section of the circular cavern and use layer masks to isolate the buildings in such a way that they look like they are extending through the surface of the landscape and into the under-world of the city (see Figure 5.33).

FIGURE 5.33 Use layer masking to integrate the buildings into the landscape.

5. To add visual interest, add some support around the edges of the cavern. Create a selection around the mouth of the cavern and give it a border (Select > Modify > Border) that reflects what is shown in Figure 5.34A. Fill the border with the brownish color similar to the landscape by using the Eye Dropper tool. Add some noise (Filter > Noise > Add Noise) to give it a sense of texture and then finalize it by applying Crystallize (Filter > Pixelate > Crystallize) to give it some extra character.

6. Use the Pen tool to select a shape that will form the vertical lip of the cavern (see Figure 5.34B). Part of the landscape has a watery feel, so validate the concept that water dominates half of the scene by adding a reflection. Duplicate the lip, place it below the original one, and then bring down its opacity until it takes on a reflective appearance (see Figure 5.34C).

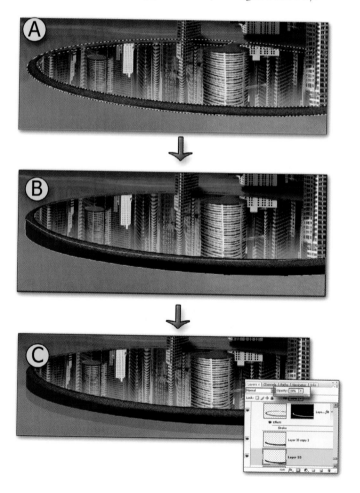

FIGURE 5.34 Creative reflection and the water.

7. Add some extra interest by adding a support rail around the mouth of the cavern (see Figure 5.35). Do this by creating an elliptical marquee and giving it a border. Fill the marquee with medium gray and apply a Bevel and Emboss using layer styles.

8. After creating the support rail, apply the same technique to vertical supports along the rail, as shown in Figure 5.36.

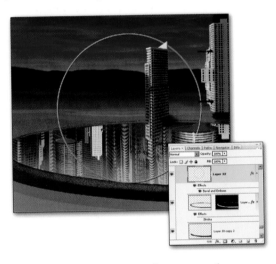

FIGURE 5.35 Create the support rail.

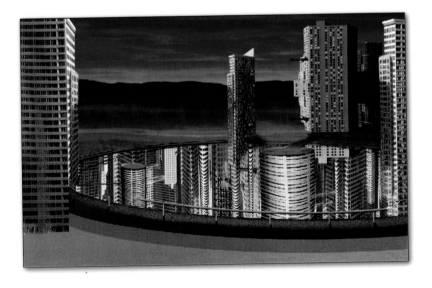

FIGURE 5.36 Create vertical support for the rail.

9. In the next exercise, you'll create additional architecture to meet with the composition. To get a better feel of how well all of the cityscape elements will work together, turn off the highlights for the underground city segment and continue working.

CREATING ADDITIONAL ARCHITECTURE TO FRAME THE COMPOSITION

A powerful compositional technique is to use foreground, middle ground, and background elements to establish a greater sense of depth. The balance should also be created so that the composition is not weighted to favor one side of the frame over the other. Currently, most of the objects are placed on the right-hand side. To add depth as well as a sense of balance, you will create additional architectural elements to the foreground as a framing device to guide the viewer's attention toward the city and the landscape. You will use existing elements to assist in this effort.

1. From the image that you have already opened titled architecture 003.tif, select the front face with the Rectangular Marquee tool and copy the texture onto its own layer (see Figure 5.37). Use Free Transform and Distort to align the horizontal shapes so they are parallel to the horizontal edge of the image frame. You'll come back to this particular texture later on.

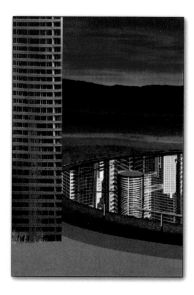

FIGURE 5.37 Create a new texture.

2. Select one of the textures from the right side of the building in architecture 001.tif (see Figure 5.38).
3. It is sometimes very helpful to draw in exactly how you want your shape to look. Create a new layer and paint in a line drawing showing how you want the shape to look (see Figure 5.39). In this example, the color white is used to stand out from the darker colors in the scene.

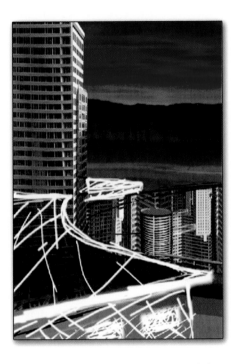

FIGURE 5.38 Add the right side portion of the building.

FIGURE 5.39 Draw in the new compositional element.

4. Use the Pen tool to outline the area that will represent the roof of the building. Then fill it in with a gradient consisting of black for the background and gray for the foreground (see Figure 5.40).
5. Apply the same technique for the front face of the new building where the gradient will be applied vertically with black in the top half and gray in the bottom half (see Figure 5.41).
6. Copy the texture that you used for the new building in step 1 and position it over the roof that you've just created. Using Free Transform and Distort, transform the texture on top of the roof so that the lines fan outward into the foreground. Use a layer mask to isolate it to the shape of the roof (see Figure 5.42).

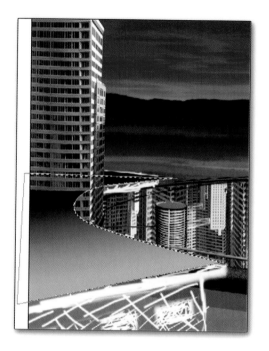

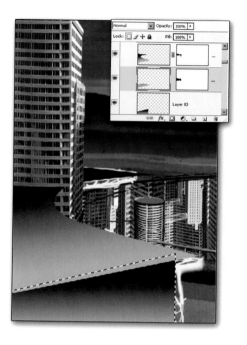

FIGURE 5.40 Utilize the Pen tool to create the roof of foreground architecture.

FIGURE 5.41 Create the front face of the new building.

7. Copy the texture that you used for the new building connecting to the roof that you've just created. Using Free Transform and Distort, place the texture on top of the roof and use a layer mask to isolate it to the shape that you established (see Figure 5.43). Do the same thing for the front face of the new architecture, but resize the texture so that the windows are double the size of the ones in the background.

8. Now let's establish some light sources (see Figure 5.44). Turn on the light source for the underground city, create a new layer, and then apply window highlights just as you did in Chapter 4. Place the window highlights into a layer group titled "Window light source" and place it on top of the underground city layer group.

9. Besides the faces of the buildings, the sides should reflect the reddish orange lighting coming from the sunset. To simulate this effect, create a new layer and change its Blend mode to Hard Light. Select the Paint Brush tool and hold down the Alt/Option key as a shortcut to activate the Eye Dropper tool. Select a reddish orange hue and paint over the side faces of the buildings. Also apply the same technique to the top of the new roof that you've just created (see Figures 5.45 and 5.46).

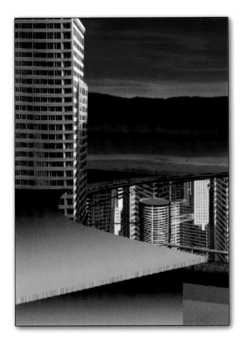

FIGURE 5.42 Create the roof of the new building.

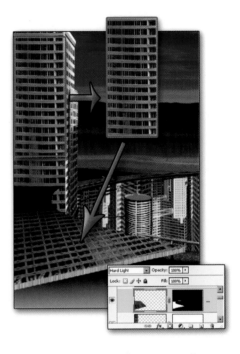

FIGURE 5.43 Create the roof using the photographic textures.

FIGURE 5.44 Create the window light source for the new building.

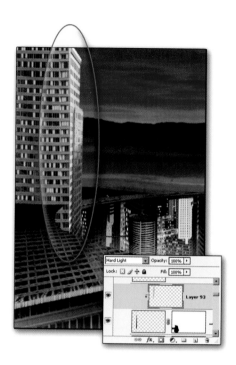

FIGURE 5.45 Apply a reddish highlight to the side of the buildings.

FIGURE 5.46 Apply a reddish highlight to the roof.

10. Continue to use the same texture to apply a curved surface to the rounded portion of the roof. Use Free Transform and Warp to create a curved vertical edge to the new architecture (see Figure 5.47).

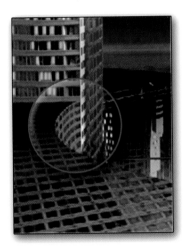

FIGURE 5.47 Apply a curved surface to the new section of the architecture.

11. Now you can add additional light sources to the underground city. Create a new layer group called "city lights detail" and place it above the Window light source layer group. Inside the layer group, create a series of new layers with the Layer Blend mode set to Screen. Use a series of circular gradients on their own layers to be placed within certain areas of the underground city. Use Figure 5.48 as a guide. Also use Free Transform to alter the shape of the light source.

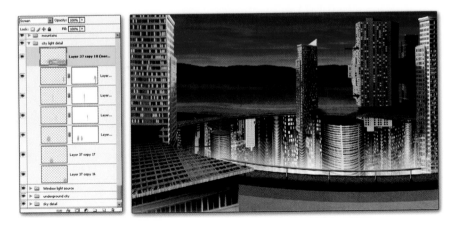

FIGURE 5.48 Apply the light source to the underground city.

12. All of the light sources emanating from underneath the cavern should have a unified glow. Create the glow as a circular gradient based on a bluish color and transform it so that the circular shape sits over the cavern. Use layer masking to isolate the blue color to the edges of the lip. Duplicate the layers if necessary to isolate the effect to the parameter, as shown in Figure 5.49.

13. Create small light flares sitting above the rail supports (see Figure 5.50).

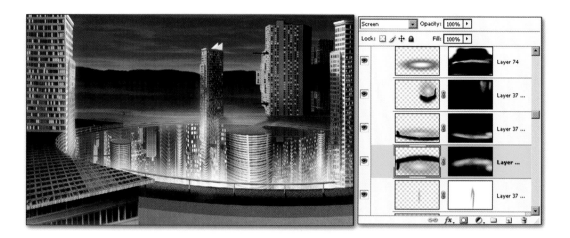

FIGURE 5.49 Apply the light source to the parameter of the cavern.

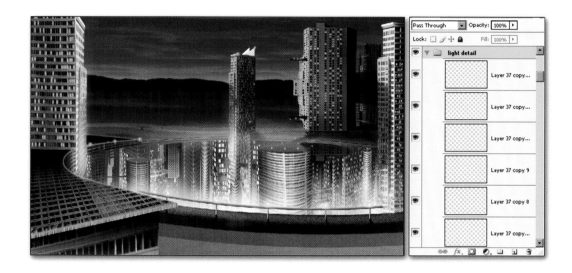

FIGURE 5.50 Apply light flares to rail supports.

ADDING 3D LAYERS TO THE SCENE

The ability to bring in 3D objects from third-party modeling programs is a huge upgrade to CS4 Extended. 3D modelers and animators use a wide variety of formats, but currently the two file formats that are most widely used and supported by CS4 Extended are 3D Studio Max (has a .3ds extension) and Alias Wavefront's Object format (has an .obj extension). Photoshop CS4 will also read Collada, Google Earth 4, and U3D. This book uses NewTek's LightWave 9.5 (www.newtek.com), and in order for Photoshop to read the LWO format, you will need to have the LWO Importer that has been provided for both Mac and PC for you in the root of the tutorials folder (Tutorials/ LightWave Importer). Take note that currently the LightWave Importer works only on the 32-bit version of Photoshop. So you will have to import your LWO objects using the 32-bit version of CS4 Extended. After your object is imported, then you can open the file and manipulate the 3D object in the 64-bit version. For now, install the LightWave Importer plug-in.

Figure 5.51 displays the 3D object in LightWave.

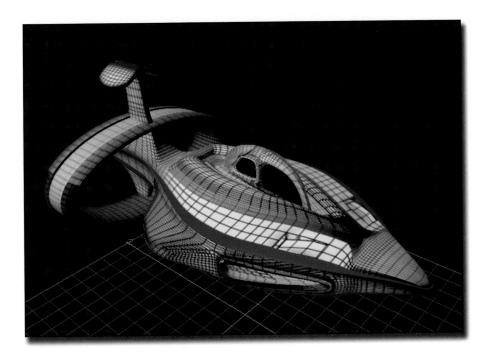

FIGURE 5.51 The 3D object in LightWave.

Several surface maps have been applied to the model called UV maps. UV maps are textures that are in the form of two-dimensional surfaces. In other words, if you peel off the surface of a 3D object and unwrap it so that it lays flat like a sheet of paper, then you can use Photoshop's digital painting tools to apply character to the model and simply wrap the UV map back onto the 3D object when it is completed. So, you are simply painting on the U (horizontal) or V (vertical) coordinates. This is very practical because now you can place any color or details exactly where you want them to appear on the object.

Figure 5.52 displays the 3D object along with the UV map that is designated for the body of the Racer. In addition, notice that LightWave gives you a listing of all the surface maps that are applied to this model. Also, Figure 5.53 shows the location of the Body UV map on the surface of the Racer. Don't worry too much as to the particulars on how they were created because we will cover that in the next chapter. For now, just be aware that several UV surfaces have been applied for you on this model.

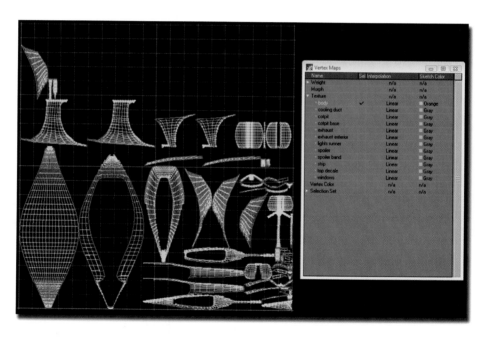

FIGURE 5.52 The 3D object with UV map.

1. Go to Tutorials/ch 5 and open the racer.psd file. You have just opened a file that has a 3D layer with the Racer in it (see Figure 5.54). Take a look at your layers and notice the surface texture layers listed underneath the thumbnails. If you place your mouse on top of the texture, you will see the thumbnail of the UV map used for that particular surface.

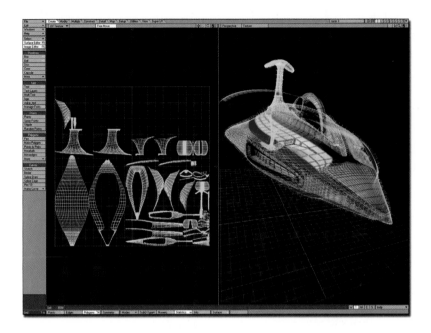

FIGURE 5.53 Display of UV map on the 3D model.

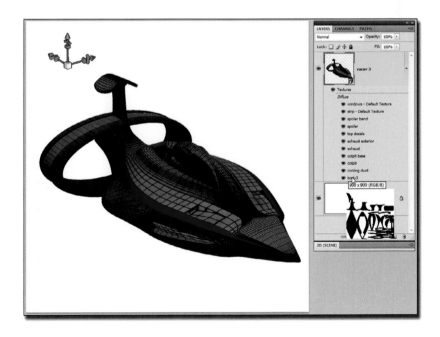

FIGURE 5.54 The 3D file with surface textures.

2. Double-click the surface layer titled "spoiler band." Automatically the UV Map for that surface is opened. Go to the Tutorials/ch 5 folder and open the spoiler strip.tif. Use your Move tool (V) to place the texture underneath the UV map in the spoiler strip file. Inside the borders of the UV map is the only location that you should be concerned with because any areas outside of the map will never be seen on the model. Place the image over the entire map and press Ctrl+S/Cmd+S to save and update the 3D file. Initially, you will see that the texture doesn't quite line up (see Figure 5.55A). This happens because the bottom two strips represent the top and underside portion of the spoiler band, which spans the length of the shape. The top strip, however, represents the side section, and it spans horizontally on the object so you need to duplicate the texture layer and rotate the image by 90 degrees (see Figure 5.55B). Use your Move tool (V) to nudge the texture as needed until you get close to what you see in Figure 5.55C. Save it to update the Racer. Finally, save the texture layers as a JPEG to your computer and call it "spoiler bump.jpg." We will utilize it later in step 4.

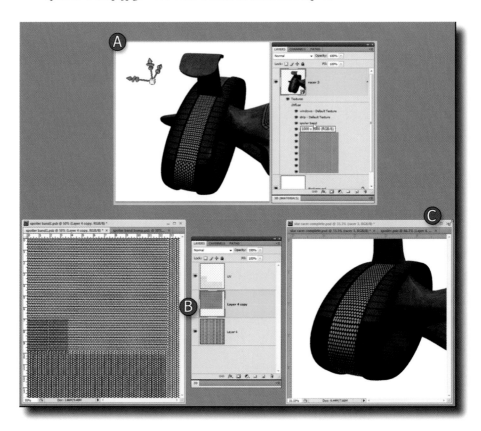

FIGURE 5.55 Add texture to the spoiler strip surface.

3. Sometimes, it's helpful to add some basic surface textures to several surfaces just so you can see how textures will work together to add some character to the 3D object. In this case, apply a texture to the "body" surface, but this time use body.jpg located in the Tutorials/ch 5 folder (see Figure 5.56). Use Ctrl+S/Cmd+S to update the 3D object.

FIGURE 5.56 Add texture to the body surface.

4. Next, go back to the spoiler band material and add some surface bumping to that surface. Make sure that the 3D Panel (Window > 3D) is active to view the 3D options. Click the spoiler band material, and you will see the options for that material in the panel beneath. Look for the Bump Strength. Now, add a new texture by clicking the icon to the right of Bump Strength and selecting Load Texture (Figure 5.57A). Import the spoiler bump.jpg that you saved from step 2 (Figure 5.57B). Automatically, you will see the bump surface applied to the spoiler band (Figure 5.57C).

5. Double-click the spoiler material in the Layers palette to open the texture for that surface. Below the UV map layer add the image called "spoiler" located in the Tutorials/ch 5 folder (see Figure 5.58). This is simply a duplicate image that was used for the "body" surface. Next, place a new texture on a layer above it called spoiler 2.jpg and change the Layer Blend mode to Color. The Color Blend mode uses the colors inherent in the spoiler 2 texture to tint the image below it. Press Ctrl+S/Cmd+S to see the spoiler updated on the 3D model (see Figure 5.59).

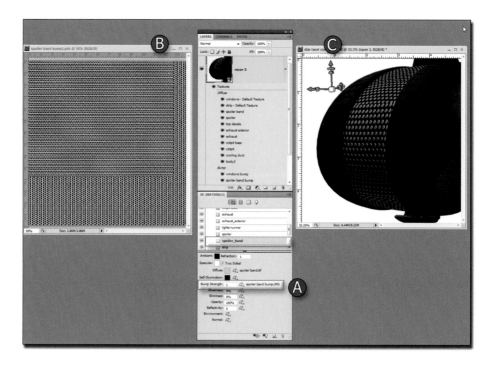

FIGURE 5.57 Apply Bump Strength to spoiler band.

FIGURE 5.58 Open the spoiler material and apply two new textures.

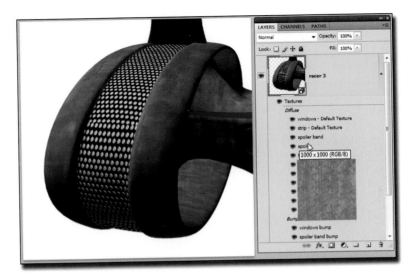

FIGURE 5.59 Updated view of the spoiler.

6. To add more detail to the Racer, open the "Top Decal" materials layer (Figure 5.60A). Go to the Tutorials>ch 5 folder, open the Top Decal.jpg, and add it as a layer underneath the UV layer. Duplicate this layer and transform it (Ctrl+T/Cmd+T) to reduce the size of the texture horizontally (Figure 5.60B). Next, save the texture to see an update on the model (Figure 5.60C).

FIGURE 5.60 Add texture to top decal material.

7. Now that you are proficient at adding bump mapping to the surface, apply the body bump to the surface of the body material. Your model should look something like Figure 5.61.

FIGURE 5.61 Updated view of the spoiler.

ADD LIGHTING TO THE MODEL

Next, you are going to place the model into the Underground City landscape and adjust the light to match the scene that you have established already. We are going to use the new 3D lighting in CS4 Extended to accomplish this task. Keep in mind that by default you are given three lights to illuminate your 3D model. You can add as many as you like, but let's restrict ourselves to the original three to simulate the ambient and the main light source.

1. Place the model into the City Landscape scene. Since this one is going to be the main ship in the foreground, the "top decal" material was given a yellowish texture. Doing so helps to ensure that the view will focus on the ship with the warmer color textures first. You can change it if you'd like or just leave it the same. Access the 3D Lighting panel and turn off all lights except for the center one titled Infinite Light 2. This light represents the main light source illuminating the front portion of the ship. Click the Color swatch to bring up the Color Picker and select a light blue color from the city coloring beneath the ship (see Figure 5.62).

FIGURE 5.62 Place the ship into the cityscape and apply the main lighting source.

2. There are all types of light source temperatures coming from the cityscape, and this includes some of the reddish hues coming from the larger spotlights from deep inside the city. Let's use this as a type of rim light along the rear edge of the racer. Use Infinite Light 1 as the source and select a light source from the scene with a reddish hue (see Figure 5.63). Use the 3D Lights Rotation tool to position the direction from the bottom, right rear of the racer.

FIGURE 5.63 Apply reddish rim light to the racer.

3. Now, do the same thing with Infinite Light 3 and use the 3D Lights Rotation tool to position the direction from the bottom, left rear of the racer. This time give the hue a lighter, reddish hue, as shown in Figure 5.64.

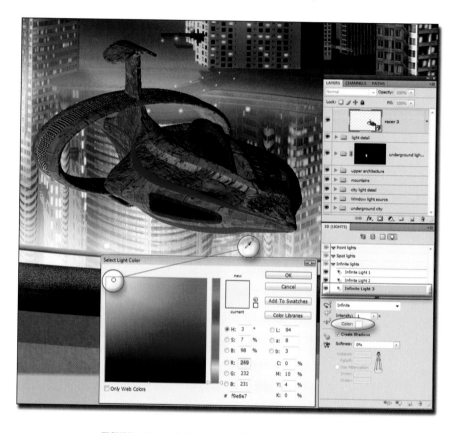

FIGURE 5.64 Apply lighter reddish rim light to the racer.

ADDING THE FINAL DETAILS

Now, we are going to add some finishing touches to the scene by placing more ships throughout the composition and adding some extra lighting details.

1. Duplicate the ship and place it throughout the scene. To add a sense of depth, make sure that the racers positioned to the rear of the scene are scaled smaller. Use the 3D Scale tool on the toolbar to accomplish this. Place all of them in a Layer group by selecting all of the ship layers and then accessing the Layers palette submenu. Select New Group From Layer and name the group 3D. Use Figure 5.65 as a guide.

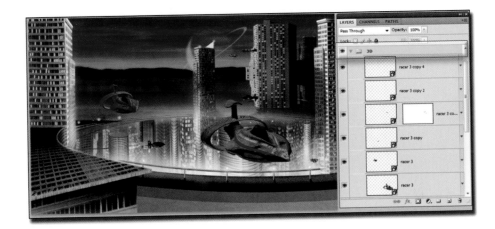

FIGURE 5.65 Duplicate the ship and place it throughout the cityscape.

2. To allow the ship to match the light environment a little better, you can alter the specular highlights of the foreground ship to create a warmer lighting situation. Select the body surface in the 3D Materials palette and use a yellowish hue for the Specular color swatch, as shown in Figure 5.66.

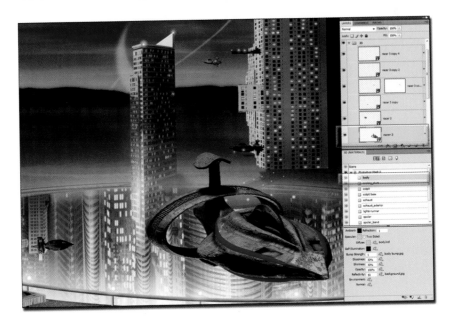

FIGURE 5.66 Change the Specular color to a yellowish hue.
Duplicate the ship and place it throughout the cityscape.

3. On the bottom of the Layers palette, click the symbol that represents a folder to create a new Layer group. Create a new Layer group that is titled "ambient lighting." Within the folder, create a new layer (Ctrl+Alt+Shift+N/Cmd+Opt+Shift+N) and fill it with a purplish color that matches the upper portion of the sunset toward the rear (see Figure 5.67). Use your Eye Dropper tool (I) to select the color from the scene itself to place it as the Foreground Color and then fill the layer with that color (Shift+f5 > Fill with the Foreground Color). Next, change the layer's Blend mode to Softlight.

Since you want the color to be applied mostly to the surroundings and not the foreground racer or the city light source itself, apply layer masks to paint with black to the areas that will not receive the purplish ambient light. In this example, the mask for the ship has been applied to the Layer group itself since it will not receive any of the effects applied with the folder.

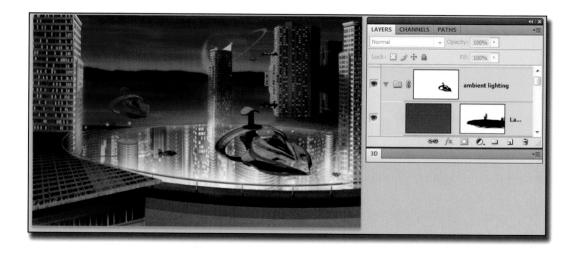

FIGURE 5.67 Add purplish ambient lighting.

4. Add additional layers and apply gradients so that the upper portion of the scene is given a reddish hue and the lower portion a purplish hue. Make sure the Layer Blend mode is set to Soft Light. You may do multiple layers to get the effect that you like best. Also, make sure to apply masks to block out the effect for the city light source coming from the cavern. Use your paint brush to edit the mask and apply the effect as you see fit. Feel free to allow some of the color to spill onto portions of the upper skyscrapers (see Figure 5.68).

5. Next add one more layer with a bluish hue to accentuate the glow around the edge of the cavern (see Figure 5.69). Use your paint brush and paint the color directly onto the layer.

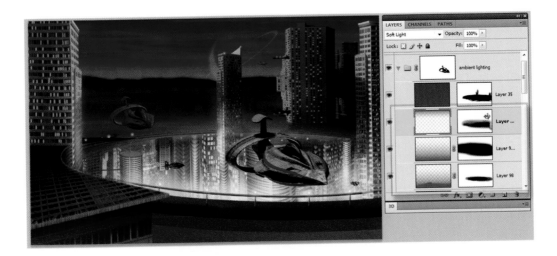

FIGURE 5.68 Add additional ambient lighting.

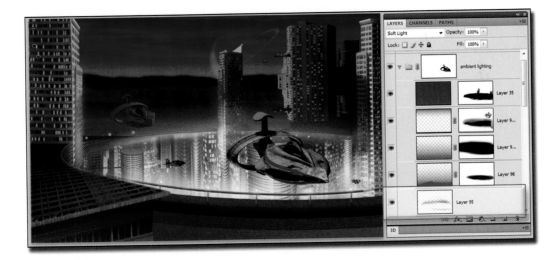

FIGURE 5.69 Add additional bluish lighting along the edge of the cavern.

6. Select the layer for the main foreground layer and add an additional 3D light. Add a spotlight, as shown in Figure 5.70. Use your 3D Light navigational tools to place it behind and to the right of the racer. This will simulate the remaining light coming from the rear sunset. Change its color to a yellowish hue.

7. Finally, set the Render Preset to Ray Trace in the 3D Scene panel (see Figure 5.71). For Anti-Alias, set the option to Better.

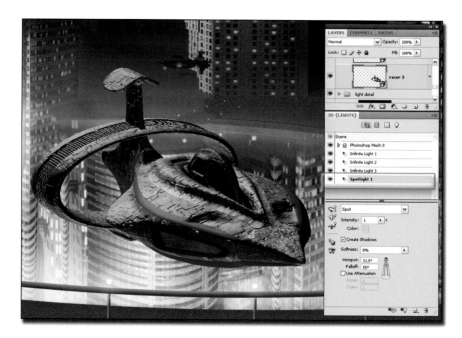

FIGURE 5.70 Add additional lighting with yellowish color along the edge of the cavern.

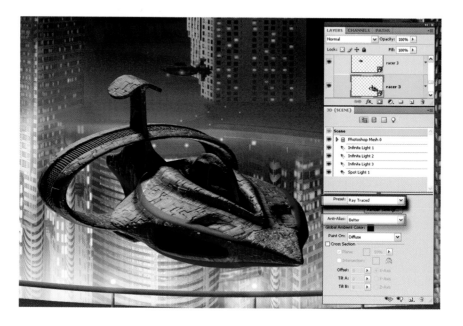

FIGURE 5.71 Set the Rendering intent to Ray Trace.

Figure 5.72 shows the final result of Ray Trace applied. Figure 5.73 shows an example of light flares applied to the propulsion engines.

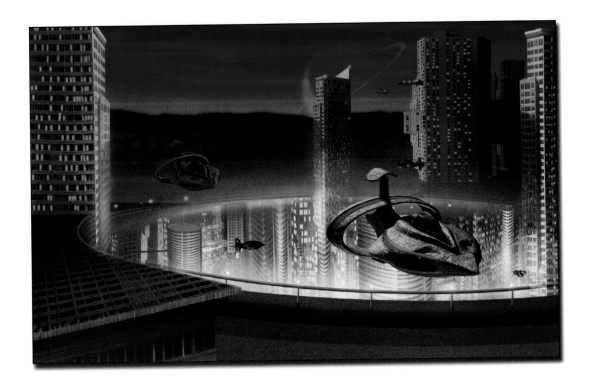

FIGURE 5.72 Ray Trace render.

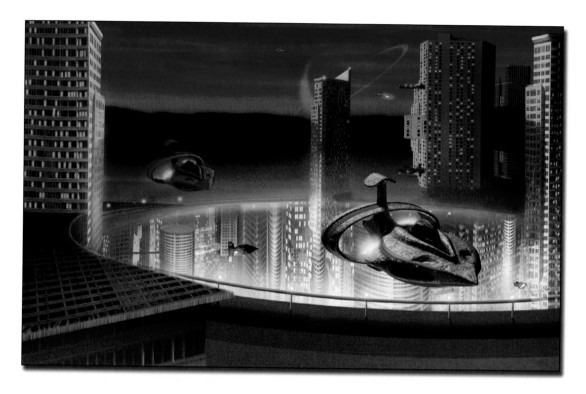

FIGURE 5.73 Final view with engine flares.

WHAT YOU HAVE LEARNED

- 3D layers have limitations.
- How to create textures on a 3D object from bitmaps.
- Creating foreground compositional objects gives the scene greater depth.
- How to create ambient light sources.
- How to create a shallow depth of field.

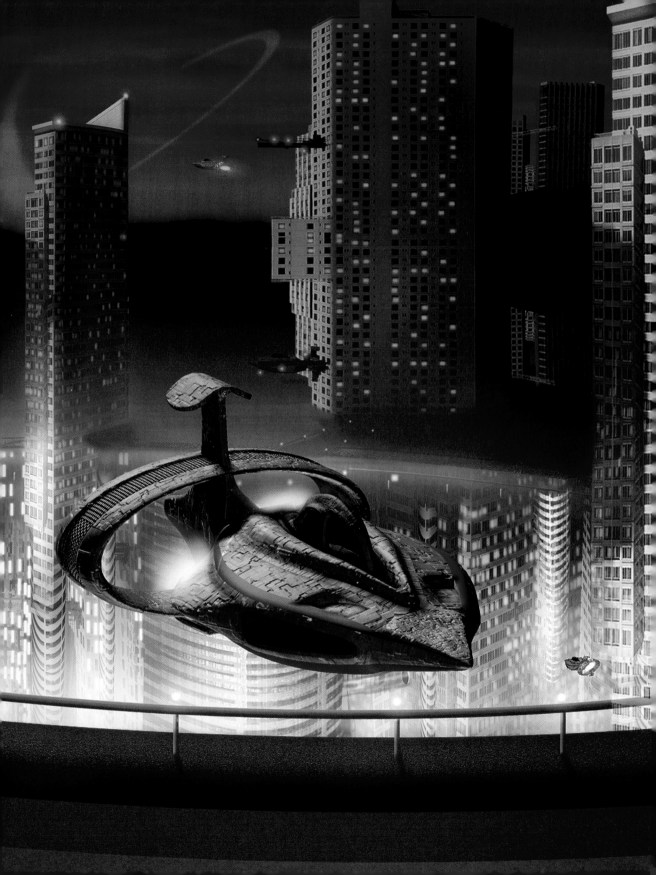

CHAPTER

6

EDITING UV MAPS
ON 3D OBJECTS

IN THIS CHAPTER

- Photomerge to start the composition
- The Auto Blend mode
- Apply Refine Mask
- Apply 3D Lighting
- FX Tricks for Paint Brushes
- Introduction to the Paint Brush for editing surface materials

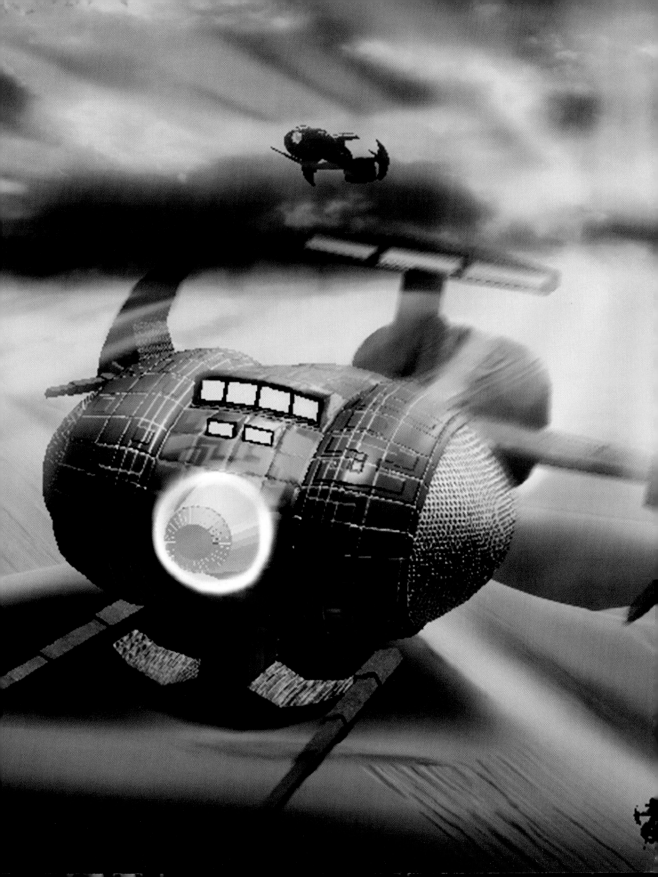

CREATING THE SAND DUNE LANDSCAPE WITH PHOTOMERGE

We are going to use the Photomerge command to create a panoramic scene from a series of sand dune photos that were taken in Death Valley, California. Photographic images are very helpful for establishing a convincing backdrop in little time. So let's move forward.

1. Open Bridge (Ctrl+Shift+O/CMD+Shift+O) and select sand dune_01.jpg through sand dune_04.jpg. Access Photomerge (Tools > Photoshop > Photomerge). For now, uncheck the Auto-Blend Layers option and select Auto as the preferred merging method. You should see something like Figure 6.1.

FIGURE 6.1 Activate Photomerge.

2. In general, Photomerge does a superb job of merging and blending image sequences as long as you have a 30% overlap. But there are rare exceptions, and this is one of them. We chose not to have the program blend the layers so that we could inspect the images and realign them manually if necessary. We have a straggler on the top left so let's place it where it belongs. Then we can merge the image sequence into one single landscape.

We are now going to set up the document dimensions to assist in the alignment of the straggler image. Select your Crop Tool (C) and outline the entire document. Extend the Crop borders past the right just enough to give room to place the straggler image over to the right side. Make sure that you place this image on top of the other layers to facilitate the process and move the image to the right and align the edges using the Distort tool (Edit > Transform > Distort).

In this case, Photoshop was confused by the shape of this image so it did not know exactly what to do with it. We have now given it a little help, and it should have no problem blending the images from this point on. Use Figure 6.2 as a guide.

FIGURE 6.2 Final view of the images layered on top of one another.

3. Now that everything looks well aligned, apply Auto-Blend Layers (Edit > Auto-Blend Layers) and select Panorama as the preferred arrangement (see Figure 6.3).

FIGURE 6.3 Activate Auto-Blend Layers.

4. Figure 6.4 shows the end results of the blend. As you can see, Photoshop did a wonderful job at blending everything seamlessly.
5. For finishing touches use the Warp Command to compose the image to your liking (see Figure 6.5). When done, save your file and let's apply a sky to the scene.

FIGURE 6.4 Final results of Auto-Blend Layers.

FIGURE 6.5 Use the Warp tool to compose the sand dunes.

CREATING THE SKY

In this scene, a starship will be moving forward from the sunset while hovering over the sand dune. Let's create a new sky of our choosing to establish the sunset. While you are working through this exercise, be creative and produce results that are uniquely your own. Your sunset doesn't have to be exactly like the example here, but you can utilize the techniques to accomplish the task.

In addition to the sunset, you will build and insert some skyscrapers above the sand dune. To do this, you will need to extend the canvas upward a bit.

1. Start by duplicating your layer (Ctrl+J/Cmd+J). Activate your Crop tool (C) and drag a Crop box around the entire image. Next, extend the top portion of the crop box upward about 50% higher, as shown in Figure 6.6. When you are satisfied, press Enter on the keyboard to commit the changes. You should have a result similar to Figure 6.7.

FIGURE 6.6 View of the panoramic sand dune.

FIGURE 6.7 View of the panoramic sand dune with extended canvas.

2. Next, you will remove the mountain ranges from the upper portions of the scene. To accomplish this task, activate the Quick Selection Tool (W) and select the sky and mountain areas. Since the Quick Selection Tool will select similar colors or luminance contiguously, it will do the job well here. When everything is selected, press the Delete key to get rid of the mountain range, leaving only the sand dunes (see Figure 6.8).

FIGURE 6.8 Delete the mountain range and sky to leave the sand dunes present.

3. Go to your tutorials folder and open clouds1.tif. Place this image below the sand dune layer. You will notice that the clouds are approximately 50% smaller than the sand dune file due to the panoramic format so let's rectify this creatively. Duplicate the clouds' layer (Ctrl+J/Cmd+J) and place them side by side with a 30% overlap, as shown in Figure 6.9. Remember that the 30% overlap is important for the next step because Photoshop will need some room to make blending adjustments for any panoramic style techniques. It doesn't matter that this was not shot as a panoramic because Photoshop will do its best to blend it anyway, and that is all we want at this point.

FIGURE 6.9 Duplicate the clouds' layer and place them side by side.

4. Use the Auto-Blend Layer Command (Edit > Auto-Blend Layer) to blend both cloud layers together seamlessly. You will see the two layers pieced together with the use of Layer masks (see Figure 6.10).

FIGURE 6.10 Apply Auto-Blend Layer.

5. It would be easier to work on a single layer instead of two, so select the two cloud layers and merge them together. Next, duplicate this single layer and set its Blend mode to Soft Light (see Figure 6.11). This gives the sky a more contrasting look.

FIGURE 6.11 Create cloud layer and apply a Soft Light blend.

6. Apply a Layer mask to paint out the effect of the Soft Light layer from the top portion of the clouds, as shown in Figure 6.12.

FIGURE 6.12 Apply mask to cloud layer and apply its effects selectively.

7. Now, duplicate steps 3 to 5 to create a single merged layer with the clouds 2.tif image (see Figure 6.13).

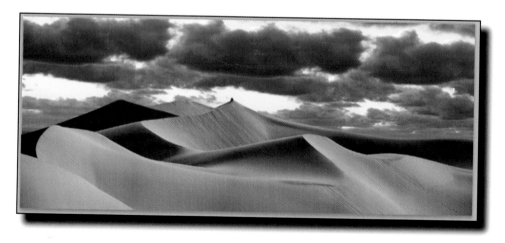

FIGURE 6.13 View of the merged clouds2 image.

8. Apply a Layer mask and paint out all of the cloud details for this layer just as you did in step 6 (see Figure 6.14) to apply them to localized areas of the sky. Use your creative judgment for this. Now you are getting a little more drama in the sky.

FIGURE 6.14 Add more detail to the sky.

9. Finally, let's add some drama to the sand dunes by intensifying the shadow areas. Create a new layer (Ctrl+Alt+Shift+N/Cmd+Opt+Shift+N) and fill it with black. Change its Blend mode to Multiply. Hold down the Alt/Option key on your keyboard and select the Create New Mask icon on the bottom of your Layers palette. This will create a black-filled layer instead of the default white. Now edit the mask using the paint brush and paint with white to reveal the black pixel in the shadow regions. Give the sand dunes as much drama as you like, similar to what you see in Figure 6.15.

 Use a soft-edged brush for this step and be patient. However, if you decide to make a rough go at it, there is another way to fine-tune your mask. Open the Mask palette (Window > Masks). Make sure that the mask that is associated with the black-filled layer is selected by clicking directly on it. The Mask palette has options for fine-tuning the pixel information. Use Figure 6.16 as an example.

FIGURE 6.15 Intensify the shadow areas of the sand dunes.

FIGURE 6.16 Use the Masks palette to modify the Layer mask.

10. Use the Density slider to brighten or darken the mask. The Feather slider will add a blur to the mask to soften the edges (see Figure 6.17).

FIGURE 6.17 Experiment with the Density and Feather sliders.

11. Also, on the very bottom of the dialog box, you will see a button called Invert. Click it and notice that the values on the mask will be inverted, as shown in Figure 6.18.

FIGURE 6.18 Invert the mask.

Now above the Invert button, you will see a button called Mask Edge. Click it and notice that this takes you into the Refine Edge dialog box that gives you even more controls for fine-tuning your mask. Let's explore those.

EXPLORING REFINE EDGE OPTIONS

From the Masks palette, you were able to access the Refine Edge dialog box to further make adjustments to any selected mask. This is very useful when you want to control the hardness or the softness of a masked effect. Let's explore the possibilities.

1. By default, the mask will be previewed against a white background. This will show the mask in its native black-and-white mode (see Figure 6.19).

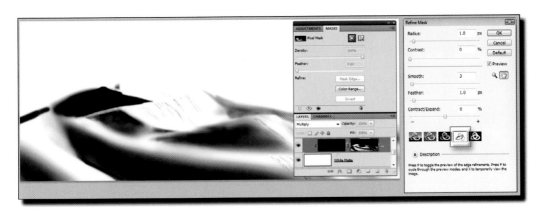

FIGURE 6.19 Default view of the Refine Mask option with mask against a white background.

2. Choose the icon to the far right to view the mask as you created it in Figure 6.20.

3. Choose the center icon to preview the mask against a black background, as shown in Figure 6.21.

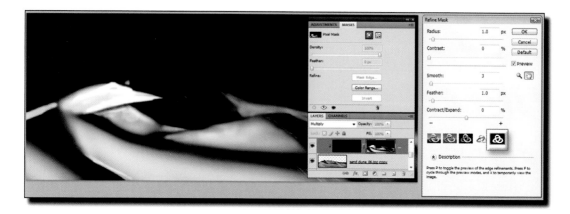

FIGURE 6.20 View the mask as you created it.

FIGURE 6.21 View the mask against a black background.

4. The second icon from the left will show your mask as a Quick mask (see Figure 6.22).

5. Choose the icon to the far left to view the mask as a selection (see Figure 6.23).

6. Play with the Radius slider. This will help determine how drastic the effect will be based on the amount of pixels being affected (see Figure 6.24).

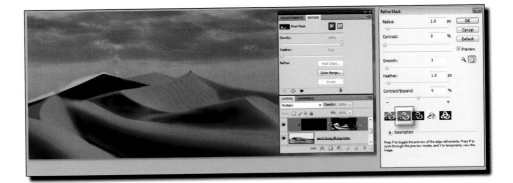

FIGURE 6.22 View mask as a Quick mask.

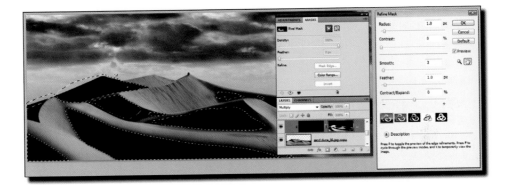

FIGURE 6.23 View mask as a selection.

FIGURE 6.24 The Radius slider will determine the strength of the effect.

7. Shift the Contrast slider in both directions and notice how the contrast intensity can affect the sharpness of the mask edges, as shown in Figure 6.25.

FIGURE 6.25 The Contrast slider will strengthen intensity of the values.

8. Play with the Feather slider to soften the edges of the mask (see Figure 6.26).

FIGURE 6.26 The Feather slider will soften the edges of the mask.

9. The Contract/Expand slider will expand or contract the values. Figure 6.27 shows the mask being expanded and Figure 6.28 displays the mask being contracted.

FIGURE 6.27 Expand the mask.

FIGURE 6.28 Contract the mask.

CREATING THE CITY

Now you are going to create the city that will fit into the landscape using photo-graphic images. You will start by giving the dunes the appearance of the rear portion integrating into the rear lighting atmosphere. We will then use photographic elements to create the skyscrapers emanating from the peaks of the dunes.

1. To help prepare the sand dune for the city details, let's give it the appearance of the sun's rays spilling onto the rear portions of the dunes. You will use the Layer Style option for this. Duplicate the sand dunes layer and place it on top of

the layer that you used to intensify the shadow detail. Double-click the right-most portion of the layer to get the Layer Style dialog box. Select the Gradient option and edit the gradient by clicking the Gradient preview box. Apply the settings that you see in Figure 6.29 by applying a color that will gradate to transparency from a yellowish brown hue.

FIGURE 6.29 Apply gradient to sand dunes.

2. Go to your tutorials folder and open refinery 1.tif (see Figure 6.30).
3. Duplicate the layer and inverse it horizontally (Edit > Transform > Flip Horizontally). Position the second layer and blend it with the other using a Layer mask to achieve a look similar to Figure 6.31.
4. Then implement steps 2 and 3 using skyscraper 1.tif (see Figure 6.32) from the Chapter 6 tutorial folder. The resulting layers should resemble Figure 6.33.
5. Select both of the skyscraper layers and right-click them to bring up a sub-menu. From this menu, select Convert to Smart Object. This will merge both layers into a Smart Object so that you can maintain the original quality of the image as you alter its size with the Free Transform tool. Next, duplicate this layer and transform it (Ctrl+T/Cmd+T) so that it is thinner and longer than the first merged shape. Use Figure 6.34 as an example. Then merge the two layers as a single Smart Object.

FIGURE 6.30 View of refinery 1.tif.

FIGURE 6.31 Create a symmetrical look for the refinery.

FIGURE 6.32 View of skyscraper 1.tif

FIGURE 6.33 Create a symmetrical look
for the skyscraper.

6. Go back and select the skyscraper layer and duplicate it (Ctrl+J/Cmd+J). We will keep one image to place in the foreground of the composition to help establish depth. The other you will use for the following procedure.

7. Position the Refinery layer beneath the skyscraper layer and transform it (Ctrl+T/Cmd+T) to give the appearance of extra detail being added that protrudes above the architecture. Use Figure 6.35 as a guide, but play with the Layer Blend modes to experiment with other possibilities.

FIGURE 6.34 Results of duplicated and transformed skyscraper.

FIGURE 6.35 Transform the refinery.tif image to integrate with the skyscraper.

CREATING THE CITY IN THE SAND

Now that you have the basic building completed to establish your architecture, we will blend this into the sand dune landscape. You are going to create four separate buildings to place into the landscape. You will use several tools to assist with this: Layer masking, Layer Grouping, Paint Brush, and the New Rotation command.

1. Enlarge and place the merged skyscraper into the left edge portion of the composition. Since you are going to create four buildings to place throughout the composition, let's create a new Layer group and call it "architecture."

To do this, click the third icon from the right on the bottom of your Layers palette. Make sure that the "architecture" Layer group is selected. Now add four new Layer groups within it and title them "city 1" thru "city 4." Place a skyscraper into each Layer group where two of them will sit on top of the highlighted peaks located to the left of the composition, and one will sit on top of the shadowy peak. Resize each skyscraper smaller as it gets further into the background, approximately 50% of its original size.

2. Within each Layer group, create two new layers and title them "shadows" and "sand," as shown in Figure 6.36A.

3. Let's start with the enlarged architecture that sits on the left side of the frame. We're going to paint in the sand first with a soft-edge brush, so select that layer and activate your Brush tool (B) (see Figure 6.36B).

4. Hold down your Alt/Opt key on the keyboard to get the Eye Dropper tool. Now select the color of the sand beneath the skyscraper and paint it onto this layer. Make the sand wide at the base to taper into a point as it extends further up the building. Use a soft-edge Paint Brush with the Pen Pressure attributes turned on, as shown in Figure 6.36. Use the Wacom pen's pressure capabilities to facilitate the painting process. Make sure that the Shadows layer is on top and change its Blend mode to Multiply. Ctrl+click/Cmd+Click on the architecture layer to get a selection of the shape on the layer and fill it with black (Shift+F5 > Fill with Black). Since the sunlight is coming from the upper-right rear, let's add a shadow to reflect this. Paint in black on the left side of the rounded contour, leaving the left side mostly lit. Now it starts to look more three-dimensional because it is becoming visually integrated into the scene, as shown in Figure 6.36C.

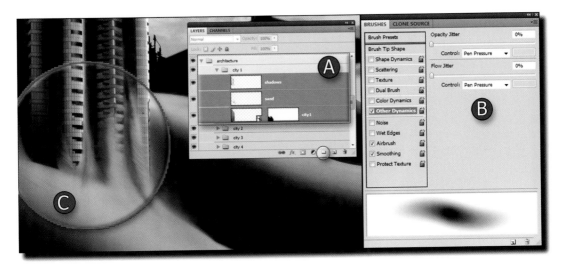

FIGURE 6.36 Enlarge the skyscraper and create new Layer groups.

While you are painting, press the R key to rotate the canvas in any direction that will help you paint more intuitively (see Figure 6.37). Everyone has an ideal angle they like to use, and this is a great new feature in CS4 that I know you will love.

FIGURE 6.37 Apply the Rotate command.

5. Select the Shadow layer. Then add a shadow to the city element by holding down the Ctrl/Cmd key on the keyboard and clicking the architecture layer to get a selection of the building. Fill this selection with black and make it a Smart Object. Place this layer underneath the building and use Free Transform (Ctrl+T/Cmd+T) to flip it onto the left, overlapping the top portion of the sand, as shown in Figure 6.38.

6. Now, give the shadow a soft edge by applying Gaussian Blur (Filter > Blur > Gaussian Blur).
As you can see, by making the shadow layer a Smart Object, it allows you to have nondestructive effects using any of the Filter commands, which is, in this case, Gaussian Blur (see Figure 6.39). This is an advantage because you can go back and edit the blur at any time.

7. You can alter the shape of the shadow to give it the effect of flowing with the shape of the sand dune. Use Warp (Edit > Transform > Warp) to achieve this effect (see Figure 6.40). As a final touch, access the layer for the skyscraper that will sit on the shadowy sand dune. Fill it with black (Shift F5 > Fill with Black). While still in the Fill dialog, make sure that the Preserve Transparency box is checked so only the shape of the architecture will be filled. Click OK, and the rear skyscraper will reflect the shadow of the dune that it sits on.

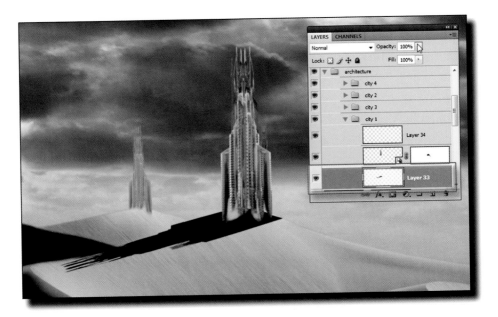

FIGURE 6.38 Create shadow for the skyscraper.

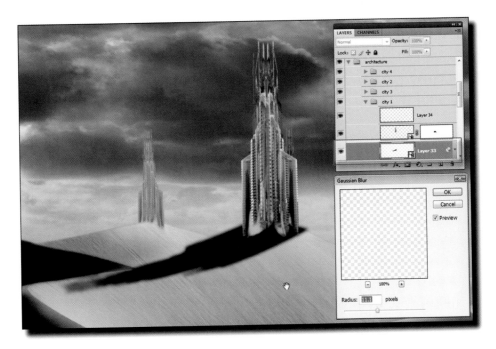

FIGURE 6.39 Apply Gaussian Blur to the shadow layer for the skyscraper.

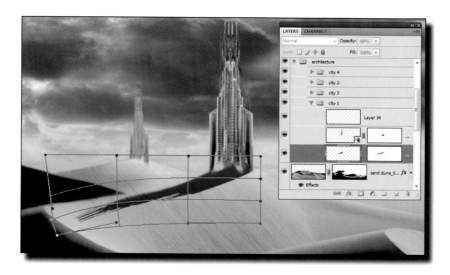

FIGURE 6.40 Apply Warp to the shadow to shape it to the flow of the sand dune.

8. Add some highlights to the sky to give it a more luminous effect (see Figure 6.41). Create two new layers and change their Blend mode to Overlay. Make sure that you have your Paint Brush tool selected. Hold down your Alt/Opt key to get the Eye Dropper tool and select the yellowish hue of the sunlit sky. Now paint this color on the brighter areas and notice how they become even more illuminated. Two layers were created so that you can split up the task of applying one for the overall highlight enhancement and the other to create the central glow coming from the upper-right portion of the sky. However, use as many layers as you feel necessary for this technique.

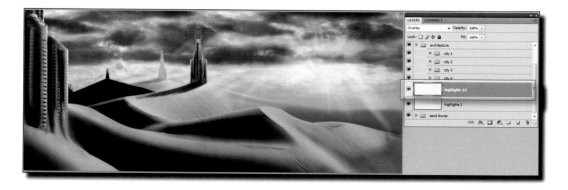

FIGURE 6.41 Accentuate the highlights in the clouds.

9. Create a new Layer group called "light streaks 1" (see Figure 6.42). Within this group, create a new layer and fill it with the yellowish highlight sampled from the scene (I). Give this layer a black-filled Layer mask. Use your Rectangular Marquee tool (M) to make several long vertical rectangles adjacent to one another in your canvas. Now fill these selections with white onto the mask. You are going to transform the Layer masks to get the effect of the lighting coming from the sunlight in the rear. Use Distort (Edit > Transform > Distort) to accomplish something similar to Figure 6.42. Don't forget to utilize your new Mask palette (Window > Masks) to alter the look of the sunlight so that the edges take on a softened look. Next, duplicate this layer and offset it to get a more convincing effect.

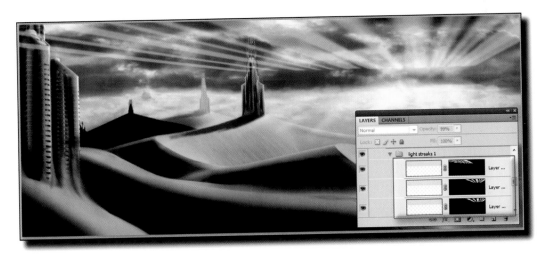

FIGURE 6.42 Create the light streaks.

10. Apply a mask to the Layer group itself and edit it so that the sun rays dissipate as they get further away from the light source (see Figure 6.43). Use a soft-edged paint brush for this.
11. Repeat steps 9 and 10 for the lower portion of the sky, as shown in Figure 6.44.
12. Create a new Layer group and call it "Lighting." Inside this group, add two layers where you will add an orange glow to warm the highlights and blue hue that will cool down the shadow details. Shadow colors are the opposite of their highlights. In other words, sunlit areas provide warmth, which is interpreted with warm colors. Their opposites are cooler colors, which are blue or violet. If you photograph in a shady environment, the dominating color will be blue, which is the opposite of a sunlit environment. So let's add that characteristic here and use Figure 6.45A as an example.

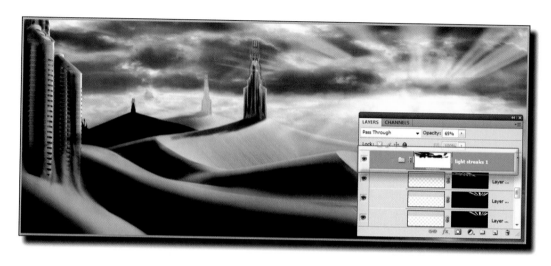

FIGURE 6.43 Create sun rays for the lower portion of the sky.

FIGURE 6.44 Add sun rays to lower portion of the sky.

13. Select your Gradient tool (G) and set your foreground color to an orange hue. In the options, select Foreground to Background Gradient, as shown in Figure 6.45B. Place your mouse on the top portion of the canvas and drag halfway down and release. The yellow hue is placed on the upper portion of the image and gradates toward transparency. Change the Layer Blend mode to Multiply to achieve a more saturated effect.
14. Now do the same thing for the shadow details below the horizon on the shadow side of the sand dunes. Just change the Foreground Color to deep blue and apply the gradient to the other layer, as shown in Figure 6.45C.

FIGURE 6.45 Add an orange glow to the highlights.

15. Continue to accentuate the shadow values by adding more blue-filled layers with a Blend mode of Multiply. Give them a black-filled mask and paint with white to reveal the bluish color in the shady areas only (see Figure 6.46).

FIGURE 6.46 Add deep hues to the shadow areas.

ADDING ATMOSPHERE

Using layers that are filled with color is an ideal way to create atmosphere. To finalize the effect of giving the landscape some atmospheric haze, you will continue to use color-filled layers as well as gradient-filled layers and use them to isolate the haze effect to the areas of your choice.

1. Create a new layer and apply the haze to the sunlit portion of the scene (see Figure 6.47). Add a gradient that creates yellow in the upper portion of the image and blue in the bottom portion. Change its Blend mode to Multiply and add a mask. Editing the mask, apply the effect to mostly the upper and mid portion of the composition, not affecting the skyscraper to the left or the lower portion of the sand dune.

FIGURE 6.47 Apply haze to the sunlit portion of the scene.

2. Let's repeat step 1 for the architecture only, but this time, create an orange-filled layer, keep its Blend mode at Normal, and give it a Layer mask. Edit the mask so that you are applying the haze in the upper one-third portion of the scene where it will appear as if the skyscrapers in the background are fading into this warm glow (see Figure 6.48). Experiment with this and have fun.

FIGURE 6.48 Apply a warm glow to the skyscrapers.

3. Add some contrast adjustments to the entire scene. Start with a Curves Adjustment layer and increase the contrast slightly (see Figure 6.49). Notice that a new functionality has been added. The new Adjustment palette will give you the ability to access all adjustments without the need of a panel that will freeze up your workflow. This is better than the old-style palette that froze your workflow until you committed to the changes.

FIGURE 6.49 Apply a Curves Adjustment layer.

4. Finally, give the scene a slight shallow depth of field. Select the very top layer. Merge visible layers into a new layer (Ctrl+Alt+Shift+E/Cmd+Opt+Shift+E) and make this a Smart Object. Apply Gaussian Blur (see Figure 6.50) and edit the mask so that the rear composition takes on more blur than the foreground. Use your paint brush to control this.

FIGURE 6.50 Create a new merged layer and apply Gaussian Blur to create a shallow depth of field.

PREPARING THE 3D OBJECT

Our next concept is to create a Sci-Fi scene with starships being an integral part of the matte painting. A starship will be positioned as if it is coming forward from the sunset toward the camera. You will learn the benefits of editing multiple UV maps on a single model. You will also apply the paint brush to edit the bump surface of the 3D model.

1. Open the starship.psd file in the Tutorials/ch6 folder. Rotate the model to take a look at the texturing. Figures 6.51 and 6.52 display the top and bottom of the model.

FIGURE 6.51 View of the top portion of the textured starship.

FIGURE 6.52 View of the bottom portion of the textured starship.

2. Let's edit the surface of the star cruiser. Maximize your screen by pressing the F key (full screen mode) once so that it dominates the interface and then displays the object in top view, as shown in Figure 6.53. Zoom in to fill the screen with the wings of the ship. As you can see, the LightWave object has already been imported for you. This was done mostly for your convenience to start the tutorial quickly. If, however, you would like to play around with it by adding textures of your own, then try importing the base model titled "starcruiser.lwo" that has been provided for you in the Tutorials/ch6/3D folder.

FIGURE 6.53 Top view of the star cruiser.

Importing LightWave 3D Objects

Now, for a brief note about importing LightWave objects. CS4 Extended will not natively recognize LWO files so you will need the LightWave Importer to accomplish this. If you do not already have it on your system, go to www.chromeallusion.com and click the Downloads link. You will see the links for both the Windows and the OSX version on the top of the page, so download and install them. They are essentially plug-ins for Photoshop and will be installed into the Plug-ins folder. Depending on the 3D package that you use, you will need to check the company's Web site to find out if they make a Photoshop plug-in that will import their native format into Photoshop.

Now take a look at the texture layers for the star cruiser. You will see all of the textures associated with the 3D object. Double-click the "wing," and let's move forward.

3. By double-clicking the "wing" Texture layer (see Figure 6.54), you have just opened the texture for that particular surface. This model has been designed to have multiple texture surfaces. Place the 3D object and the texture side by side so that you can see the effect instantly as you are working (Windows > Arrange > Tile). You will see the basic image on the bottom layer and the UV map placed on a layer above it. Now let's edit the surface and apply some decals to the wing. You can use any method that you like, but I find it helpful

to use the Vector shapes on the toolbar. Choose a reddish color for your foreground color and apply the rectangular shape to your document by clicking and dragging to make a basic rectangle. Don't worry about the shape too much initially because you will use Free Transform (Ctrl+T/Cmd+T) to shape the decals as you see them in Figure 6.55. Each one will have its own layer, and you can add as much detail as you like. Also, make sure that you change the Layer Blend mode to Soft Light so the color blends with the texture underneath. I highly recommend that you play with these Blend modes to see the variety of effects that you have at your disposal. Now edit each surface using the same procedure and add your own interpretations. When done, save the texture (Ctrl+S/Cmd+S), and you will see your 3D object automatically update.

FIGURE 6.54 Double-click the star cruiser's "wing" Texture layer.

FIGURE 6.55 Use the Shape tool to add decals.

4. Next, you are going to edit the bump surface of the 3D object (see Figure 6.56). Double-click the "Wing Attachment Bump" listed underneath the Bump Map section.

 Bump maps create raised surfaces using tonal values or shades of gray. If you use black, there will be no effect, and if you use white, the surface will appear to elevate upward. You will see the UV map on the top layer and texture grid above that. They both are establishing surface texture so let's add some more bump detail.

5. Duplicate the Grid layer and place it over the back surfaces of the wing attachment. Use Figure 6.57 as an example. Also, to help you visually place your details faster, duplicate the UV map outline and fill it with Red (Shift+ F5 > Fill with Color). Make sure that the Preserve Transparency box is checked in the Fill dialog box.

FIGURE 6.56 Open the "wing attachments bump" side by side with the 3D Object.

FIGURE 6.57 Duplicate the grid patterns to add additional details to the rear of the wing attachments.

6. Follow the same procedures for adding the same bump details to the rest of the surfaces to give the model a consistent look.

7. Let's edit the Glossiness surface to give it the capability to reflect glossy highlights. Access your 3D Materials tab (Windows > 3D). On the panel below, add a new image to the Glossiness channel called "head joiner spec.tif," as displayed in Figure 6.58. This is simply a duplicate of the diffuse (color) surface map. Notice that Figure 6.59. displays how the surface becomes more illuminated.

FIGURE 6.58 Add head joiner spec.tif to the Glossiness surface.

8. We don't want the entire surface to have a glossy effect so we will modify the map using a Curves Adjustment layer. Just like the bump map, black will have no effect and white will display more glossiness, so modify the Curve so that you have a higher amount of contrast. Figures 6.60 and 6.61 show an example of how the model is affected with various contrast ranges.

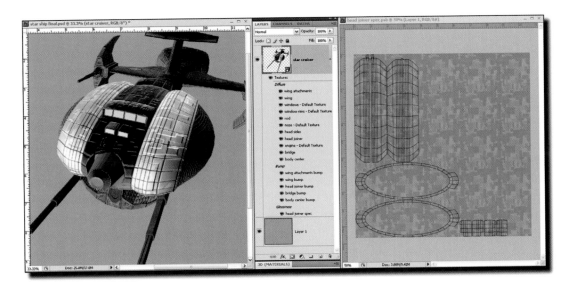

FIGURE 6.59 Results of the Glossiness surface.

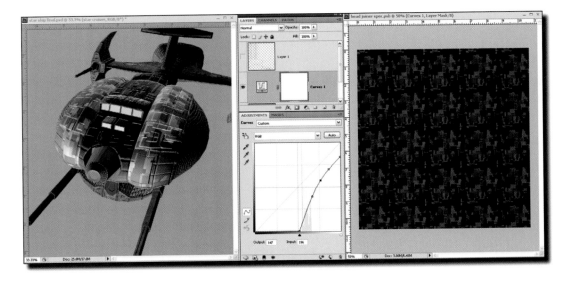

FIGURE 6.60 Add contrast to the Glossiness map.

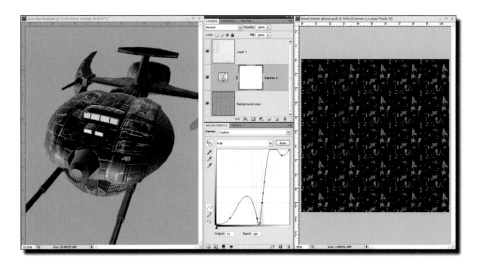

FIGURE 6.61 Increase the contrast to the Glossiness map.

9. Add Glossiness maps to all of the surfaces (see Figure 6.62). Simply duplicate the original color map that is already applied to the color texture layers. Just open it, go to File > Save As, and rename it by placing Gloss at the end to designate it as the one to use for the Glossiness channel.

Now let's add the 3D object to our background and make it part of the scene.

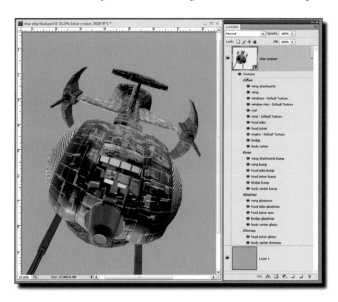

FIGURE 6.62 Edit the Glossiness channels for all of the other surfaces.

INTEGRATING THE **3D** OBJECT AND ADDING LIGHTS

At this stage, we need to add the ship to the background and integrate it by editing the lights so that the star cruiser appears to fit naturally.

1. Make sure that the star cruiser and the background document that consist of the sand dune scene are open side by side. Drag and drop the 3D ship onto the background. You should see something like Figure 6.63.

FIGURE 6.63 Place star cruiser into the sand dune scene.

2. We need to make some adjustments to the camera. The scene was shot using a 100 mm canon lens, so we will match that focal length to the 3D lens in Photoshop. Click the 3D Camera Tool (see Figure 6.64). Play with a variety of focal lengths to discover which gives you the best results.

FIGURE 6.64 Activate the 3D Camera tool.

Take a look at your options bar and notice that the focal length by default is set to 24 mm, as shown in Figure 6.65.

FIGURE 6.65 Default focal length is set to 24 mm.

3. Change the focal length to 100 mm and notice how the perspective of the star cruiser changes (see Figure 6.66).
4. Now, access the 3D Lights panel. By default, you are given three lights. To see them in the scene, press the View Lights icon, as shown in Figure 6.67.

FIGURE 6.66 Change focal length is set to 100 mm.

FIGURE 6.67 Click the View Lights icon to see the lights in the scene.

5. You will see the three lights as layers. Select the middle light because this will be the main light source illuminating the model (see Figure 6.68). Change the color by clicking the color swatch. Use the color picker and click the orange sun rays on the background itself. Now, we have begun to give the object the appearance that it is actually part of the scene.

FIGURE 6.68 Set the color of the main light source to match the lighting quality of the orange sunset.

6. Use the 3D light rotation tool to rotate the direction of the light to illuminate the belly of the ship. We will use this to apply a bluish bounce light coming off the sand dunes (see Figure 6.69). Choose a bluish color from off the dunes.
7. For the rim light, rotate the final light so that it illuminates the back edge of the ship. Give it a hue of orange, as shown in Figure 6.70.

FIGURE 6.69 Light the belly of the ship with a bluish hue.

FIGURE 6.70 Light the back edge of the ship with an orange hue.

8. The windows seem dull and lifeless so let's turn on the lights using the Self Illumination materials option. Make sure that the windows material is selected, as shown in Figure 6.71. Now increase its Self Illumination using an orange hue. Notice that the higher the values, the brighter the surface will become. In addition, the surface will take on the color that you designate.

Finally, apply these same changes to the Nose surface.

FIGURE 6.71 Change the Self Illumination for the windows.

PAINTING ONTO THE 3D OBJECT

CS4 Extended now enables you to paint directly onto the 3D object. You can paint onto any of the surface types, for example, diffuse, bump, glossiness, shininess, reflection, or self illumination. To paint on any of these channels, just choose the channel from the Paint On menu in your 3D Scene panel. We are going to add some hull damage to the ship by painting onto the Bump map of the ship's surface.

1. Start by opening the Bump map of the surface that you would like to edit. Add a new layer (Ctrl+Alt+Shift+N/Cmd+Opt+Shift+N) so that Photoshop will use it to apply all of its effects (see Figure 6.72). Photoshop will paint directly onto this layer, and I find it handy to keep all of my edits on separate layers from my original texture. If you do not create a new layer, Photoshop will apply all of your paint edits directly to your original texture.

2. Go to your 3D Scene panel and notice that Diffuse surface is selected by default for the Paint On option. Change it Bump (see Figure 6.73).

We will create a brush that will paint on the battle damage details. Figures 6.74 and 6.75 show the properties used for the brush.

FIGURE 6.72 Add a new layer to the Bump texture.

FIGURE 6.73 Change the Paint On option from Diffuse to Bump.

FIGURE 6.74 Basic brush with no variables applied.

FIGURE 6.75 Basic brush with Scattering applied.

3. Use your paint brush to paint with black as the foreground color on the surfaces of the ship (see Figure 6.76). Remember black will cut into the ship and white will create raised surfaces, so apply various pressures to get a variety of effects.

Add in the finishing touches.

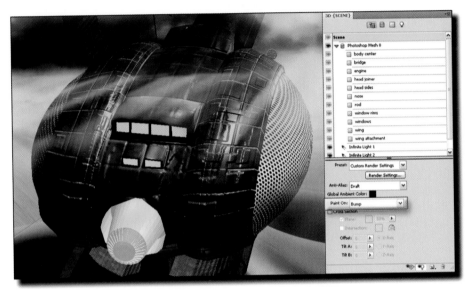

FIGURE 6.76 Paint on the bump details.

FINISHING TOUCHES TO THE SCENE

Let's complete the scene by adding a few more details and effects.

1. Duplicate the ship several times and place the duplicates throughout the composition, as shown in Figure 6.77. Since the energy of the scene emanates from the sunset, it's a good idea to position the ships as if they were originating from that location and flying out toward the viewer. This helps establish some depth. Use your 3D navigational tools to assist you with positioning.

2. The ship in the background will need to reflect the orange hazy environment so double-click the blank portion of the layer for the smaller ship to access the Layer Style dialog box. Select Color Overlay and match the reddish orange color of the background (see Figure 6.78). Next, bring down the opacity until it takes on the same haziness as the surrounding environment. Play with these features and experiment often.

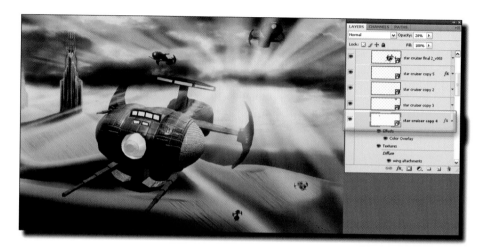

FIGURE 6.77 Duplicate the 3D ship several times and place the duplicates throughout the scene.

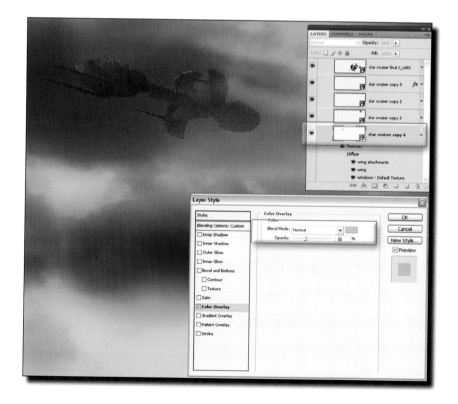

FIGURE 6.78 Apply an orange haze to the rear of the ship.

3. In your 3D Scene panel, change the Preset of Rendering to Ray Traced instead of Solid as in Figures 6.79 and 6.80. This will render all of your surface maps much more accurately, but it takes a lot of memory so I would suggest applying it to your models when you are fairly confident that you have completed the scene.

Figure 6.81 shows what we have accomplished so far.

FIGURE 6.79 View of the 3D object in Solid Render mode.

FIGURE 6.80 Change the Render to Ray Traced.

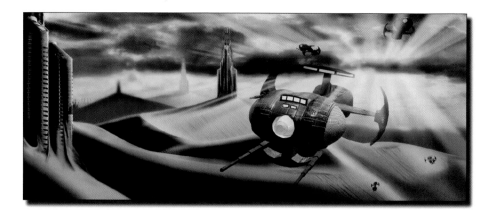

FIGURE 6.81 View of the composition with the ship rendered in Ray Trace mode.

4. You are now ready to add some final effects using Smart Filter. Since the foreground ship is our point of focus, we will add some motion effects to it, so duplicate it and convert it to a Smart Object. (Right-Click the 3D layer and select Convert to Smart Object from the submenu.) Next, apply a Motion Blur (Filters > Motion Blur) with a Distance of 33 (see Figure 6.82). This gives the ship some movement. We need to edit the filter effect using the mask that has been provided so it is not evident on the front portion of the ship and more evident on the areas that are further away. Paint with a soft-edged brush with black on the mask to illuminate the filter effect. To bring back the effect, just paint with white.

FIGURE 6.82 Convert the 3D object into a Smart Object and apply Motion Blur.

5. For some finishing touches, add a new layer above the 3D objects and paint a yellowish white glow using a soft-edged paint brush around the nose entrance of the ship (see Figure 6.83). Change the Layer Blend mode to Color Dodge. This will give the edge a nice glow.

FIGURE 6.83 Add detail to the nose.

CREATING A CUSTOM BRUSH FOR PAINTING FLYING BIRDS

A fun gimmick that often works in images of this sort is to add birds to the sky. Skies by themselves often need a little life in them, and in this case, organic life juxtaposed with the technology adds some interest to the overall feel of the composition. You will create a custom brush that will paint birds into the sky.

1. For this next step, it is a good idea to play with the various pressure sensitivities that are provided for you in the Wacom Tablet Properties. Open the Wacom Tablet Properties (see Figure 6.84). Find the menu that is designated as "Tip Feel." Some artists are a little heavy handed, and if that is the case, then you might want to set the slider closer to Firm. If you like the brush to respond more quickly to your strokes as you apply them, then set the slider toward Soft. Experiment and choose the option that best fits your work style.

2. Open the Brush palette (Windows > Brushes). The palette will display the default Brush that shows tapering at both ends (see Figure 6.85). We will utilize this effect to create the initial Bird brush.

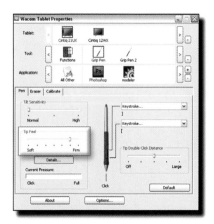

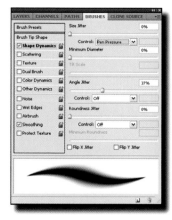

FIGURE 6.84 View of Wacom Tablet properties. **FIGURE 6.85** View of the default Brush properties.

3. Next, open a new document that is 3×3 inches square with a resolution of 150 ppi. Start by pressing down lightly and with continued pressure create two arches that look like the letter "M" with tapering toward the ends and the center. This simulates a bird flying. Use Figure 6.86 as a guide.
4. Use the Rectangular Marquee to select the shape and then create a brush from this shape (Edit > Define Brush). Save this brush, and you can utilize it in the next step (see Figure 6.87). Access the Brush palette submenu and select New Brush Preset and call it "bird."

FIGURE 6.86 Create the initial bird figure.

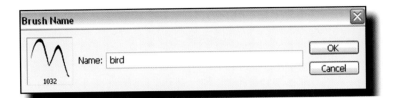

FIGURE 6.87 Save the Bird brush.

5. If we utilize this current Bird brush, it doesn't look like a flock of birds. In fact, the stoke looks more like a centipede, which is an idea for a future tutorial but for now let's stay focused and create flying birds (see Figure 6.88).

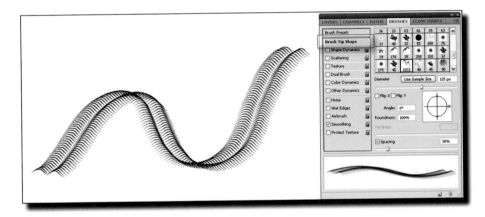

FIGURE 6.88 Results of the initial Bird brush stroke.

6. Access the Shape Dynamics and adjust the Size Jitter and Angle Jitter (see Figure 6.89). These will randomly adjust the size and angle over the length of the stroke. Although this is getting closer, you will need more control over the size of the birds to simulate distance and closeness, so let's make the next adjustment that will give you this control.

7. Instead of setting the Size Jitter, access the menu titled Control and select Pen Pressure (see Figure 6.90). This will allow you to use the pressure sensitivity of the Wacom pen to control the size of the stroke.

8. The next step will give us more of the effect that we want. Access Scattering and adjust the slider to scatter the birds (see Figure 6.91). Press lightly on the pen and notice that you will get small sizing to simulate distance and press harder to make the birds larger to come forward to the viewer.

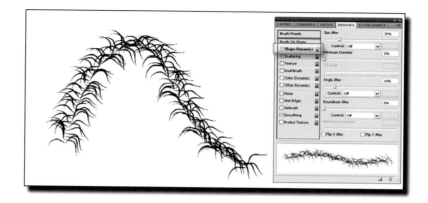

FIGURE 6.89 Experiment with the Size Jitter and Angle Jitter.

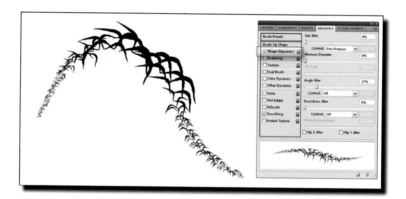

FIGURE 6.90 Designate the pen pressure to control size.

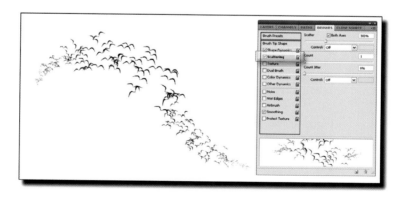

FIGURE 6.91 Apply Scattering to the brush.

9. Finally, save the brush and call it "flock of birds" (see Figures 6.92 and 6.93).

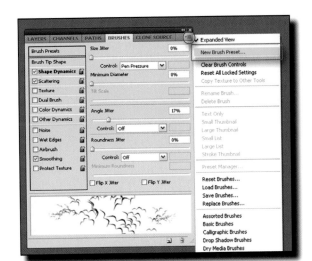

FIGURE 6.92 Save the brush as a new preset.

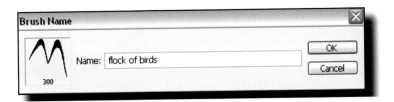

FIGURE 6.93 Save the brush as "flock of birds."

10. Don't forget to add a new layer and apply the birds to that layer. Then add a slight Gaussian Blur to imply a shallow depth of field in the extreme rear region (see Figure 6.94).

11. As a finishing touch to create a new layer above all of the other layers, change the Blend mode to Overlay (see Figure 6.95). Create a gradient that will give a purple accent on the top and bottom of the composition with the center being yellow. Next, add an additional ship so that it appears to speed off past the other ships in the foreground (see Figure 6.96).

We're done for now. That was pretty fun, wasn't it? Now let's move onto the next chapter where we will explore more extensive painting techniques on 3D models.

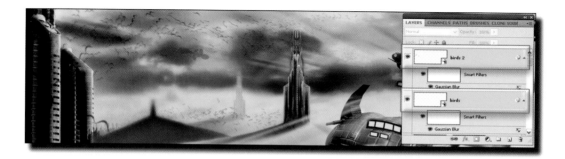

FIGURE 6.94 Apply the birds to a new layer.

FIGURE 6.95 Create a new gradient and add an additional ship.

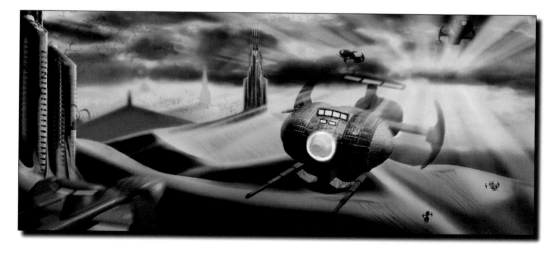

FIGURE 6.96 Add a speeding ship into the foreground, which completes the scene.

WHAT YOU HAVE LEARNED

- Creating foreground compositional objects gives the scene greater depth.
- How to create ambient light sources.
- How to create a shallow depth of field.
- How to create custom brushes.
- How to adjust your Wacom properties to control your brush techniques.

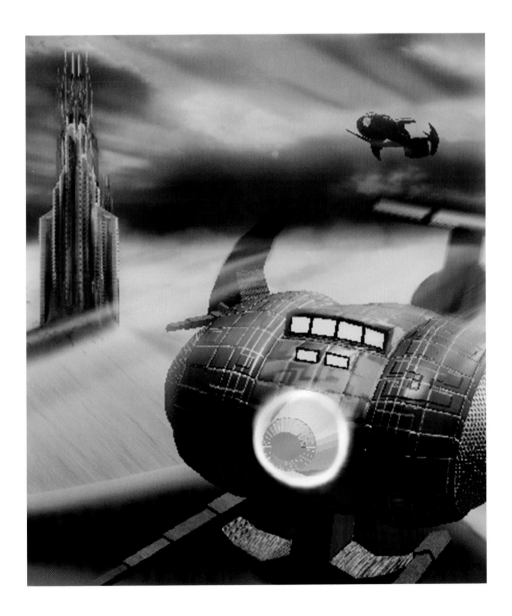

CHAPTER

7

CREATING YOUR CONCEPT USING A CUSTOM PERSPECTIVE

IN THIS CHAPTER

- Create perspective lines
- Alter images to match your chosen perspective
- Integrate custom textures into a photographic scene
- Create custom brushes from existing textures

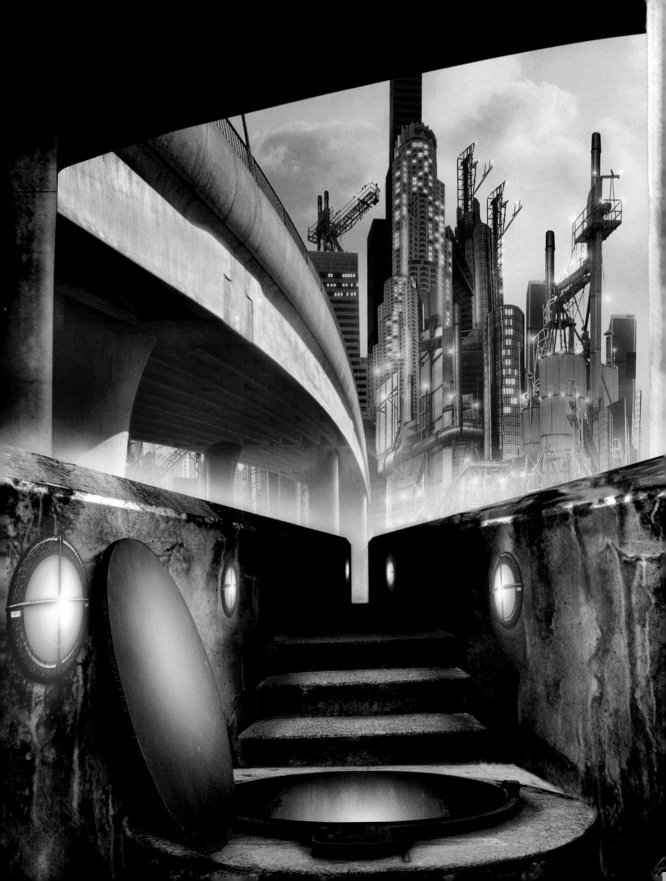

ESTABLISHING A CUSTOM PERSPECTIVE

In this chapter, the goal is to get you away from using the photograph exactly the way the camera has recorded it. Any photographic material that you choose to use will be subject to the perspective of the lens that recorded it. Here you will create a custom perspective using perspective lines, which have their own vanishing points. Then you will create the scene according to that perspective.

We will also create a metropolitan scene with the use of a chosen perspective. You will establish the foreground elements that will be the focal point and then add a cityscape that will provide the backdrop.

1. Create a new file with the dimensions of 8×11 inches with a resolution of 150 ppi (pixels per inch). Even though you always want a resolution of 300 ppi if you intend to print your work, for tutorial purposes, keep the file size low. Use your line tool or your paint brush to draw horizontal lines across your canvas, as shown in Figure 7.1. You will use them to create a perspective grid of your choosing. In this case, use the Free Transform tool (Ctrl+T/Cmd+T) and while holding down the Shift and Control/Command key (shortcut for Perspective), pull the top right corner upward so that the lines appear to flair outward. Duplicate this layer and flip it horizontally (Edit > Transform > Flip Horizontally); then position it so that the inside seams meet. Use Figure 7.2 as a guide. When done, place the layers into a layer group titled "guides."

FIGURE 7.1 Draw horizontal lines.

FIGURE 7.2 Duplicate lines and flip layer horizontally.

2. Open a file (Ctrl+O/Cmd+O). Access Tutorials/ch7 and select stairs.tif. Place the image into the new file and position it so that the top of the stairs meets one-third of the way into the composition from the bottom. Next, transform the image as best you can to align the edges to the perspective lines (see Figure 7.3). You want only a portion of the wall above the top stair. Use your Polygonal Selection tool to cut away the top portion, making sure that the cut is aligned to the perspective lines.

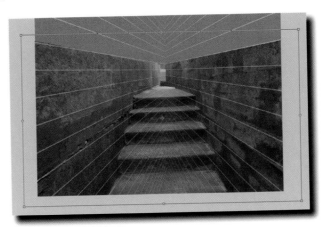

FIGURE 7.3 Transform stairs to match perspective lines.

3. As you can see, each stair does not match the lines because the camera lens that was used was working along a different perspective. Since you want everything to match your chosen perspective, you will have to transform each stair individually. Use your Polygonal Transform tool to select the bottom stair and copy it to a new layer (Ctrl+J/Cmd+J), as shown in Figure 7.4.

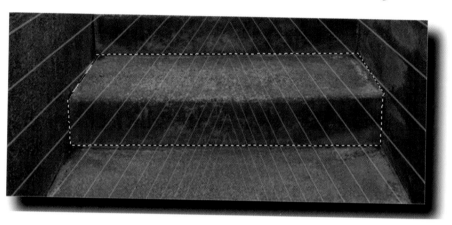

FIGURE 7.4 Select stairs.

4. Now use Free Transform to shape it to align with the perspective. Apply a mask as needed to shape the edges of the stair so that they blend with the wall on each side (see Figure 7.5).

FIGURE 7.5 Transform stairs.

5. Follow steps 3 and 4 on each stair and you should end up with something like Figure 7.6.

FIGURE 7.6 Final results of transforming stairs.

6. Open a file (Ctrl+O/Cmd+O). Access Tutorials/ch7 and select ground entrance.tif. Place and transform the image so that it sits at the base of the stairs, as shown in Figure 7.7.

FIGURE 7.7 Place ground entrance.tif at the base of the stairs.

7. You will use ground entrance.tif. to create a tube-shaped structure with a circular steel door as an entrance at the base of the stairs. Apply a layer mask to sculpt the shape similar to what you see in Figure 7.8. To create a sense of depth inside the entrance, create a new layer beneath the entrance and add a circular black-filled shape. Having the black shape will remind you that this is a location that leads to another space.

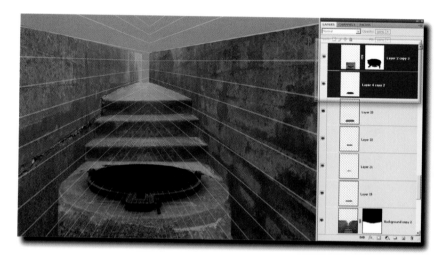

FIGURE 7.8 Create the circular entrance.

8. To match the perspective, widen the structure using your transform tools. Make sure that both the entrance and the circular, black-filled layer are selected so that the transformation is applied to both, as shown in Figure 7.9.

FIGURE 7.9 Transform the entrance.

9. The texture here is interesting, but not interesting enough. You could use Adjustment layers to enhance the contrast and character of the wall, but you can get better results by adding texture from another image. Let's make it more dynamic. Open a file (Ctrl+O/Cmd+O). Access Tutorials/ch7 and select wall 01.tif. Use the Perspective Command (Edit > Transform > Perspective) to make the texture in the foreground appear to be coming toward the camera. Using a layer mask, isolate the texture to match the shape of the right wall (see Figure 7.10). You don't want to completely ignore the texture underneath so edit the mask using your Brush tool to create a blend of the two. To finish this task, change the blend mode to Overlay.

FIGURE 7.10 Isolate the texture to the right wall.

10. Let's add a little more variety. The texture from step 9 is now in the Overlay Blend mode. Let's use it again to further add details to the wall, so duplicate this texture layer and change its Blend mode to Normal. Use a layer mask to reveal this new texture in the foreground areas of the wall, but leave the rear section untouched (see Figure 7.11). This addition will help catch the viewer's attention in the foreground to guide the person toward the rear of scene.

11. Continue to use this texture to create a ledge along the top of the wall similar to what you see in Figure 7.12. Don't forget to use the perspective lines as a guide to assist you in transforming the texture.

FIGURE 7.11. Isolate the texture to the front part of the wall.

FIGURE 7.12 Transform the entrance.

12. Use steps 10 through 11 to create additional texture for the wall on the left side of the composition, as shown in Figure 7.13.

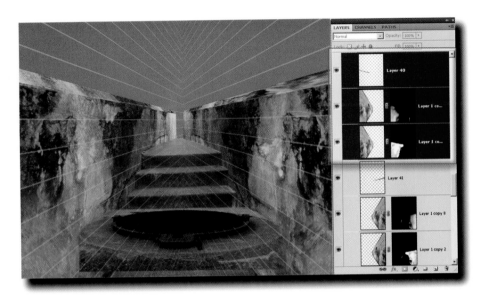

FIGURE 7.13 Create the texture on the left.

TEXTURING THE LOWER ENTRANCE

Next, you will add texturing to the lower entrance in much the same way as you did for the wall. The purpose is to integrate it with the rest of the scene. You will also extend the shape so that it appears to be extending up further from the ground. Your results do not have to be the same as shown here so feel free to experiment as much as possible. Have fun with this one.

1. Turn off the perspective grid. Extend the cylindrical entrance by selecting a portion of the concrete at the bottom of the original circular entrance and copying and pasting that texture into a new layer (see Figure 7.14). Give it a layer mask and blend the two textures together.

2. Let's balance the scene so that everything has one consistent color. The color of the stairs and the entrance is too bluish so apply a Curves Adjustment layer to apply both some contrast as well as shift the color toward yellow to match the rest of the scene. The black line in the Curves palette represents the contrast adjustment and the lowering of the blue line represents the addition of yellow (see Figure 7.15).

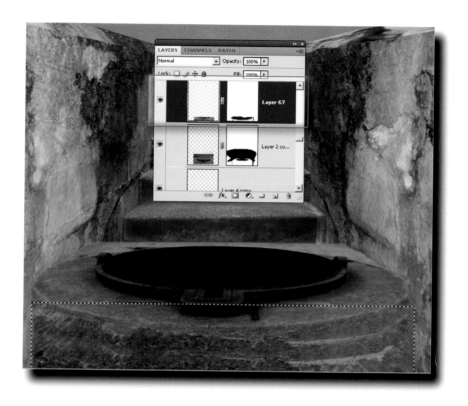

FIGURE 7.14 Extend the cylindrical entrance.

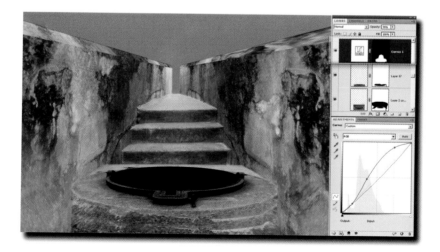

FIGURE 7.15 Use Curves to increase contrast and add yellow.

3. The circular entrance needs some separation from the rest of the scene. Apply a Curves Adjustment to make it a richer value and edit the mask to isolate the effect to the wall similar to what you see in Figure 7.16.
4. Apply step 3 to both of the walls to add some slight contrast, as shown in Figure 7.17.

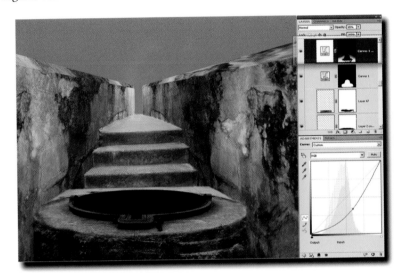

FIGURE 7.16 Use Curves to add density to the wall of the entrance.

FIGURE 7.17 Use Curves to add contrast to the walls.

5. Now with everything looking pretty consistent, it will be easy to adjust the color for the entire corridor with a single adjustment. You only want to apply the effect to the corridor and not the entire scene. So apply a Color Balance Adjustment layer to give it a cooler tonality and then isolate its effect to the corridor by editing the mask (see Figure 7.18).

FIGURE 7.18 Apply a bluish cast to the corridor.

6. Add some more texture details to the manhole entrance by applying the same texture, but this time give it a Blend mode of Hard Light to allow the original texture's character to be of some value (see Figure 7.19).

FIGURE 7.19 Apply additional texture to the walls of the manhole.

7. It's time to give the entrance some character. Continue to use the texture that you used for the wall for consistency's sake. Apply a mask that has the shape of the inside portion of the circular entrance and stretch the texture vertically to give the appearance that the shape is moving downward (see Figure 7.20). Duplicate it and change the Blend mode of the second one to Overlay to enhance the contrast.

FIGURE 7.20 Use texture to create the inner walls of the circular entrance.

8. Since we are looking slightly inside the entrance, it should appear darker. So create a new layer and change its Blend mode to Multiply. Paint along the outer edges and the top edge with black to give it a sense of roundness (see Figure 7.21). Now let's use this technique to create more depth for the hallway in the next step.

FIGURE 7.21 Paint with black to create depth.

9. Create another layer and paint with black using a soft-edge brush on the rear portion of the hallway (see Figure 7.22).

FIGURE 7.22 Darken the rear of the hallway.

10. Create a light source coming from within the manhole by painting a reddish glow inside of the entrance using a large soft-edged paint brush (see Figure 7.23). Use a layer mask to restrict the effect to the entrance.

FIGURE 7.23 Add a glow emanating from within the entrance.

CREATING THE WALL LAMPS TO ILLUMINATE THE HALLWAY

We have created a scene where stairs lead up a distant hallway, which has dilapidated textures on its walls. In the foreground, we have an underground entrance that should have some sort of security hatch associated with it. We will create that in just a bit, but for now let's add some lamps that will be embedded into the wall of the hallway that will illuminate its interior. We will start by creating the lamp housing, and then we will add the light source.

1. Create a new layer and fill it with 50% gray (Edit > Fill > 50% Gray). Then add some noise (Filter > Noise > Add Noise), as shown in Figure 7.24.
2. Apply some motion blur to get a pattern of streaks (see Figure 7.25).

FIGURE 7.24 Create a new layer and add noise after filling with 50% gray.

FIGURE 7.25 Use Motion Blur to add some streaks.

3. Increase the contrast of the texture using Curves, as shown in Figure 7.26.
4. Use your Elliptical Marquee tools to make a ring shape. After you have the ringed selection, Copy (Ctrl+C/Cmd+C) and Paste (Ctrl+V/Cmd+V) your texture into a new layer. Now give it a 3D look by adding the Bevel and Emboss style, as shown in Figure 7.27. This is the beginning of your lamp housing.
5. Use your Rectangular Marquee to cut thin slices into the side of the ring each at 45 degree locations (see Figure 7.28).

FIGURE 7.26 Apply Curves to increase contrast.

FIGURE 7.27 Create a textured ring and add the Bevel and Emboss style.

6. Using steps 4 and 5, make a thin cross on a new layer where the ends will fit into the slot locations that you had created. This will be part of the protection plate that sits on top of the light (see Figure 7.29).

FIGURE 7.28 Cut slices out of the ring.

FIGURE 7.29 Add additional details to the protection plate.

7. It's time to add the light source. Start by using your Curves to darken the lamp housing plate. Then use the Elliptical Marquee tool to create a circular gradient within the diameter of the housing that starts from white and progresses to a light green. Apply the gradient to a new layer underneath the lamp housing. Place them into a new layer group titled "front." You will eventually have a row of lights, and this one will sit in the very front. Since everything is in a group, select the "front" layer group and transform it into an ellipse and place it in the foreground, as shown in Figure 7.30

FIGURE 7.30 Add additional details to the protection plate.

8. Next, duplicate the greenish gradient that you created for the light and place it on top of the light housing. Change its Blend mode to Hard Light. This will give the effect of glare coming from the lights, as shown in Figure 7.31.
9. Let's keep organized (as shown in Figure 7.32) and create a new layer group titled "corridor lights left." In this group, place the "front" layer group and duplicate it twice. Rename the new layer groups "middle" and "rear." Resize each one and place one on the center and the other to the rear. Resize them so that they will get smaller as they recede into the background. Use your perspective guides to help you with this task. Turn them on from time to time to facilitate the process.

FIGURE 7.31 Add glare to lights.

FIGURE 7.32 Organize layer groups.

10. Next, apply lights to the right side by duplicating the "corridor lights left" layer group and rename it to "corridor lights right." Flip the new group horizontally and place them as shown in Figure 7.33.

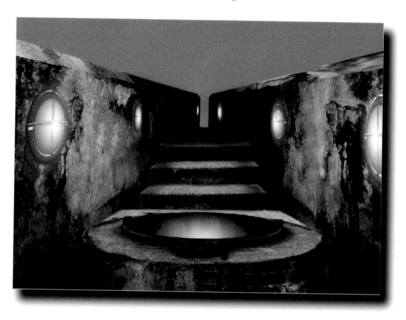

FIGURE 7.33 Place lights on the right side.

CREATING THE LID TO THE UNDERGROUND ENTRANCE

We have added a little more detail to the scene by adding lights. To help make the scene a little more believable, you are going to create the circular hatch that will sit against the wall to the side of the entrance.

1. Open the ground entrance.tif image and draw an oval selection around the lid. Copy and paste it into a new layer (see Figure 7.34).
2. The lid is too flat looking so you will need to give it some depth by creating an edge for the lid. Duplicate the lid, add noise, and give it motion blur. Use Figure 7.35 as a guide.
3. Place the texturized lid underneath the original and offset it to the left and downward a bit (see Figure 7.36).
4. Add another layer and use it to paint in details on the side of the lid. This is great for adding more texture or highlights. Experiment with this and add your own vision. Now, add another layer beneath them all and paint in a shadow (see Figure 7.37).

FIGURE 7.34 Copy and paste the lid. **FIGURE 7.35** Texturize the lid. **FIGURE 7.36** Offset the lid.

FIGURE 7.37 Create a new layer to add more detail and shadows.

5. The reddish glow coming from the entrance should spill over onto the lid. You can simulate this by adding the highlight to an additional layer that sits above the lid (see Figure 7.38).

FIGURE 7.38 Add a glow reflection to the lid.

FINAL FINISHES TO THE FOREGROUND

Often as you come close to completion of one compositional element, you will notice that all it needs is one additional thing to make it work. In this case, the texture on the wall looks a bit too repetitive so you will need to create a custom brush and alter the texture's contour by using the Paint Brush and the Stamp tool.

1. Open Wall 01.tif and desaturate the image (Ctrl+Shift+U/Cmd+Shift+U). Since Photoshop only recognizes black-and-white imagery for creating brushes, you will use its tonal values to create the initial brush (see Figure 7.39).
2. You will create a brush from the texture that you are going to enhance (see Figure 7.40). Use your Elliptical selection to select an area that will give you some randomness in the brush. Save this as a brush (Edit > Define Brush Preset).
3. Then edit the edges so that you do not have a circular shape. Figures 7.41 and 7.42 display the properties for the brush that you can use to edit the sides of the circular texture. When done, save this as a brush as well.

FIGURE 7.39 Desaturate the texture.

FIGURE 7.40 Select a location and define the brush.

FIGURE 7.41 View of initial brush.

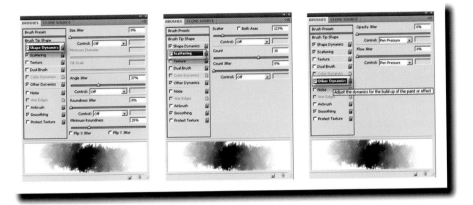

FIGURE 7.42 Variable Brush properties chosen from the Brush palette.

4. Use the Eraser tool to knock out the smooth edge to create one that is ragged by using the brush that you created in step 3. When you are done editing the edges, select the shape and define it as a brush as well, and you should have something similar to Figure 7.43. Next, apply the brush properties shown in Figure 7.44. After your properties are set, save this brush and give it a name of your choice.

FIGURE 7.43 Edit the initial brush.

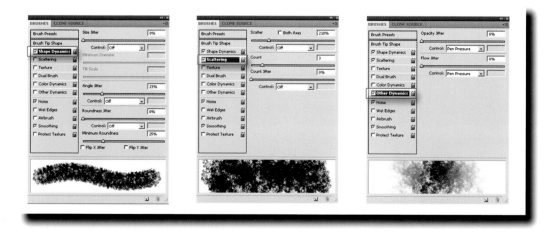

FIGURE 7.44 Variable Brush properties for the edited brush.

5. Use the Stamp tool with the new brush created in step 4 and clone details from other areas to get rid of the repetitiveness from using similar textures for the wall. Clone the textures onto a new layer and make sure All Layers is chosen on the Options bar under the Sample submenu (see Figure 7.45).

6. Switch the Blend mode for the brush to Multiply (see Figure 7.46).

FIGURE 7.45 Clone textures.

FIGURE 7.46 Switch to Multiply for the brush.

7. With the brush in Multiply mode, it will clone textures so that they have a much deeper tonality, as shown in Figure 7.47.
8. Create a new brush base on custom settings shown in Figure 7.48. This is a series of dots that will serve as dents to the concrete. Don't forget to save your brush.

FIGURE 7.47 Clone the textures with the brush in Multiply Blend mode.

FIGURE 7.48 Create a new brush made up of dots.

9. Apply the properties shown in Figure 7.49 to the new brush in the Brush palette similar to what you did in step 3.
10. Next, paint using black to apply speckles throughout the concrete, as shown in Figure 7.50.

FIGURE 7.49 Add variable properties to the new brush.

FIGURE 7.50 Apply speckles to the concrete.

11. Create a new layer and make sure that its Blend mode is set to Overlay. With white as the selected foreground color, paint a thin strip along the upper-right wall where the wall and the ledge meet. This will create a corner (see Figure 7.51). Use a slightly hard-edged brush for this.

12. Underneath the layers for the lid, add a reddish glow that will simulate glows that are coming from the entrance of the manhole (see Figure 7.52). Change the Layer Blend modes to Hard Light. Now let's go forward to add the cityscape in the background.

FIGURE 7.51 Create a wall corner.

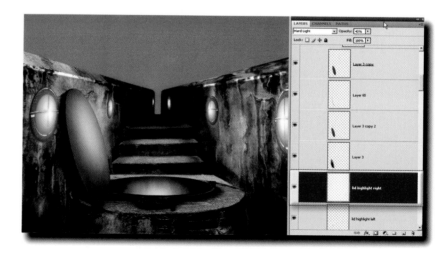

FIGURE 7.52 Create reddish highlights.

CREATING THE OVERPASS

The hallway is going to rest beneath a freeway overpass. Its freeway system extends toward the city to make a connection with it. With the focus on the underground hatch and entrance, you'll see a city in the rear of the composition with a background that is lit by a sunset. You will add the elements of the city and overpass next.

1. Open a file (Ctrl+O/Cmd+O). Access Tutorials/ch7 and select city.tif. You have already learned how to create cities using multiple images in Chapters 3 and 4, so use the one provided for you here and place it into a layer group called "city merged." Place "layer merged" underneath the "wall" layer group. Use Figure 7.53 to help you.

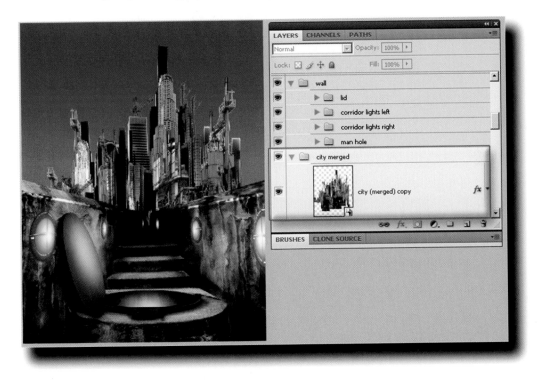

FIGURE 7.53 Add the city to the scene.

2. The basic sunset gradient starts with red and gradates to blue. This will affect the atmospheric haze around the city, so in order to simulate this effect, apply a Gradient Overlay to the city using the Layer Style, as shown in Figure 7.54.

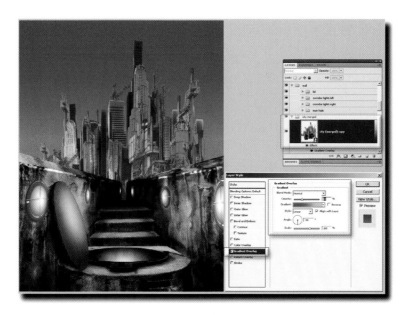

FIGURE 7.54 Add gradient to the city to reflect the sunset lighting in the background.

3. Now, add your lights and lens flare to liven up the city, as shown in Figure 7.55.

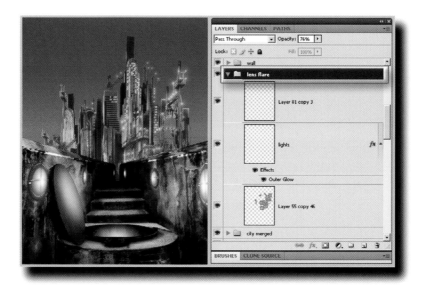

FIGURE 7.55 Add lights to the city.

4. Open a file (Ctrl+O/Cmd+O). Access Tutorials/ch7 and select overpass.tif (see Figure 7.56).
5. Place the overpass image on top of the "city" layer group but below the "wall" group. Use Warp (Edit > Transform > Warp) to cause it to curve into the scene a bit, which helps to offset the linear lines in the scene (see Figure 7.57).

FIGURE 7.56 Open overpass.

FIGURE 7.57 Warp the overpass.

6. The Warp caused the bridge supports to distort greatly; you can remove them by using a layer mask. Copy and paste the supports from the original file onto a new layer above the bridge. Elongate them to extend further toward the ground. Use a layer mask to integrate them with the bridge, as shown in Figure 7.58.
7. Duplicate the overpass, flip it horizontally, and compose it the way that it is shown in Figure 7.59.
8. Create additional supports to the rear and the foreground location of the bridge that does not display directional lighting from the photograph. This will assist you in establishing your own lighting effects without being at the mercy of the photo. Just select an untainted section of the bridge support and use Free Transform and Warp to shape it to the existing leg, similar to what you see in Figures 7.60 and 7.61.

FIGURE 7.58 Add support legs to the overpass.

FIGURE 7.59 Add another overpass.

FIGURE 7.60 Support added to the rear of the bridge.

FIGURE 7.61 Support added to the two front legs of the bridge.

9. Create a new layer with a Blend mode of Multiply and add shading to the legs using a soft-edge paint brush (see Figure 7.62).

FIGURE 7.62 Add shading to the supports.

10. Add a Color Balance Adjustment layer that will give the overpass a bluish tint. Anything in shadows will take on a bluish color, so use the mask to apply this effect to just the overpass (see Figure 7.63).

FIGURE 7.63 Give the overpass a bluish hue.

11. It's time to add some haze, and it should reflect the color of the sunset (see Figure 7.64). Use a soft-edge brush and lightly apply a haze to the lower section of the city. Change the Layer Blend mode to Hard Light.

FIGURE 7.64 Give the overpass a reddish hue.

12. Add another layer, and this time paint with white with the Blend mode set at Normal. Vary the Brush properties so that Scatter and Shape Dynamics are added. This will help get a more fog-like effect (see Figure 7.65). In addition, add some contrast to both the overpass and the city using the Curves Adjustment layer, which will add depth to the scene.

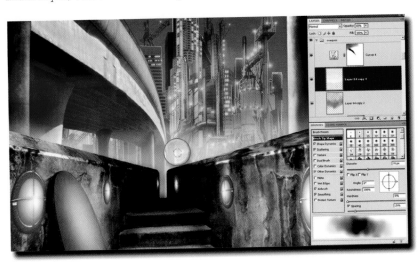

FIGURE 7.65 Add more haze.

13. Now, add some clouds (Tutorials/ch7/clouds 0019.tif) to liven up the sky. Give it a Layer Blend mode of Screen and place it above the red to blue gradient in the "sky" layer group. (see Figure 7.66).

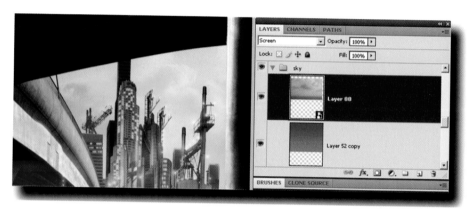

FIGURE 7.66 Add clouds to the sky.

14. After adding the additional color effects in the sky and city regions, the hallway gets a little lost. You will often not notice this until the completion of the image when you will see that some areas need a little more color or contrast boost to work. Boost the hallway's color by adding new layers to paint a greenish glow on portions that will receive the greenish light glow (see Figure 7.67).

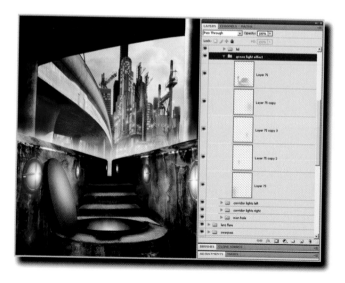

FIGURE 7.67 Add greenish glow to the hallway.

15. To further balance things out, add a red to blue gradient to the overpass and city areas using your gradient tool (see Figure 7.68). Change the layer's opacity to 20% and the Blend mode to Overlay.

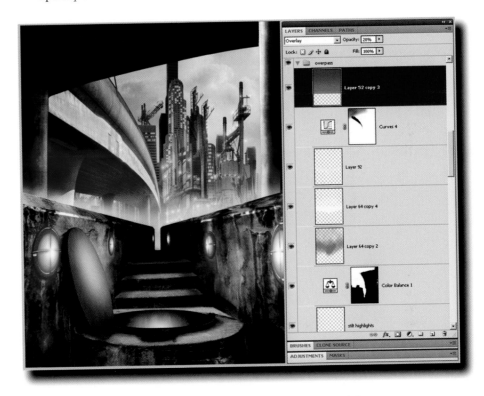

FIGURE 7.68 Add a gradient to the overpass and city.

16. Finally, add a slight shallow depth of field. Make sure that the uppermost layer is selected. This should be the "wall" layer group. On your keyboard, press Ctrl+Shift+Alt+E/Cmd+Shift+Opt+E. This will merge all visible layers into a new layer. Make this layer a Smart Object and apply a Gaussian Blur (see Figure 7.69).

17. The Gaussian Blur will be a Smart Filter, which will have a mask attached to it. Edit the mask so that the blur only takes place on the overpass, city, and a small portion of the rear wall. The haze and the Gaussian Blur will help to establish the shallow focal point (see Figure 7.70).

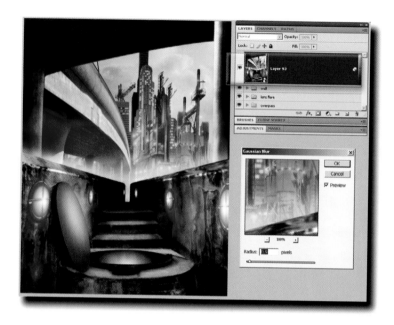

FIGURE 7.69 Create a new merged layer and apply a Smart Filter.

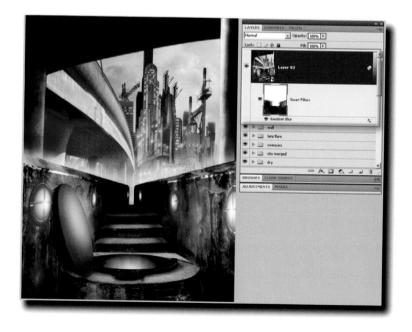

FIGURE 7.70 Apply a shallow depth of field.

Figure 7.71 shows the final results. In the next chapter, you will add a humanoid 3D object to interact with the scene.

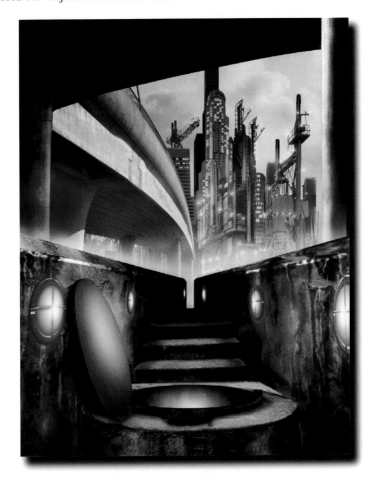

FIGURE 7.71 Final view of the cityscape.

WHAT YOU HAVE LEARNED

- How not to be a slave to the photos and instead create according to your own perspective.
- How to use brushes created from photographic textures.
- How to create foreground compositional objects to give the scene greater depth.
- How to create ambient light sources.
- How to create depth using atmospheric haze.

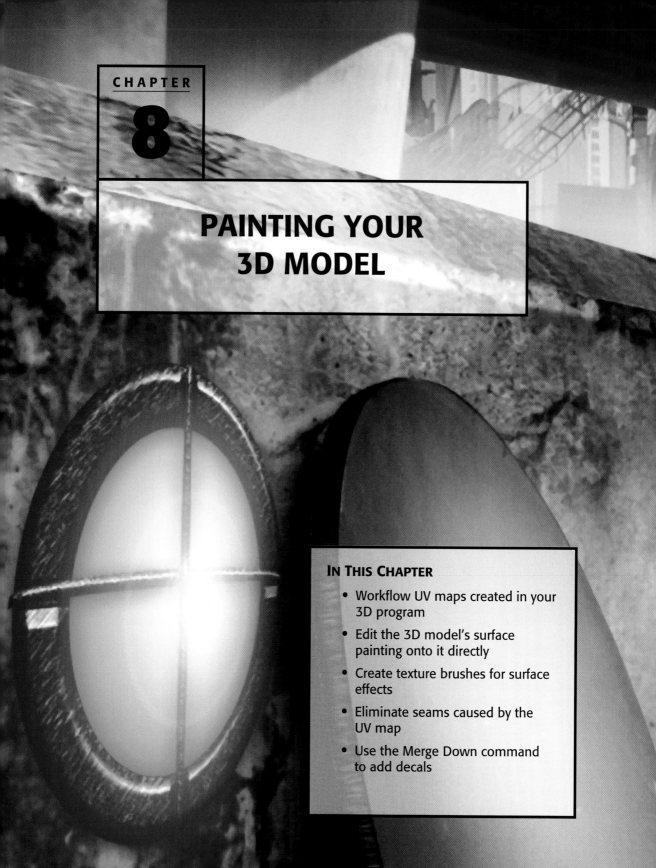

PAINTING YOUR
3D MODEL

IN THIS CHAPTER

- Workflow UV maps created in your 3D program

- Edit the 3D model's surface painting onto it directly

- Create texture brushes for surface effects

- Eliminate seams caused by the UV map

- Use the Merge Down command to add decals

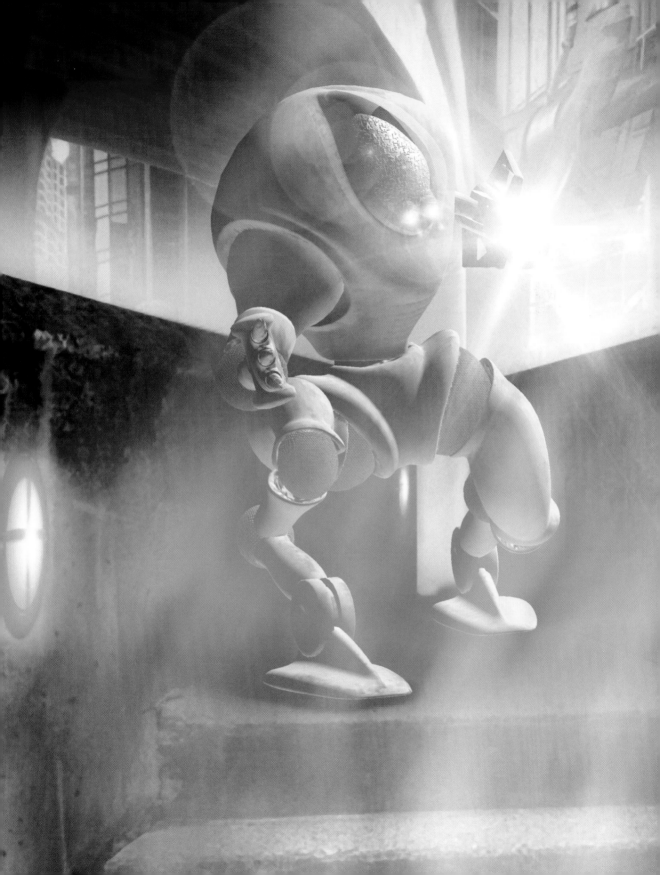

UV WORKFLOW FOR PAINTING IN CS4

This chapter is going to help you reminisce about the days when you worked with plastic model kits that required you to assemble and decal them. Your model kits probably consisted of space ships, planes, boats, toy soldiers, and so on. Putting the model together was only half the fun. After putting up with the Testors cement glue and waiting patiently for the cement to dry completely, you returned to the model excited about placing some color that would bring your models closer to reality. With your variety pack of Testors enamel paint (www.testors.com), you had to decide what color you should use to paint the model. As you experimented, the joy welled up as your models took on a character of their own. We are going to explore this joy once again as we use our digital paint tools to bring life to our 3D model.

To start, load your brushes titled CS4 Trickery & FX.abr from the CD-ROM located in the brushes folder.

Figure 8.1 displays the android that was created in LightWave 9. It is a design based on an illustration given to me by my friend and artist Lee Kohse. It is a simple model with very little detail because you will concentrate on adding the details using the Paint Brush in Photoshop CS4 Extended. Also, take note that the surfaces applied to the model are listed under the Texture menu in LightWave.

If you plan to use the Paint Brush directly on your model, it is a good idea to keep your surfaces simple and designate as few of them as possible so that Photoshop does not use too much of your graphics card resources trying to keep track of multiple surfaces.

All 3D programs have the capability to allow you to select geometry and designate it as a separate surface so that it can be textured independently. Take a look at Figure 8.1 and observe that color coding has been applied to represent each individual surface on the android. This helps keep you organized, and it is a good idea to designate color surfaces no matter what 3D package you are using. In general, for the best detail, you should designate quite a number of surfaces to your model. This will allow the best control of the UV mapping process. However, for this tutorial and for avoiding slowdown due to limited graphic card resources, we will keep the surfaces minimal so that you can work quickly in CS4 Extended. Again, the better your resource card is with Open GL, the better CS4 Extended will perform with the 3D features.

After you specify a surface, your 3D program can create a UV map from it. Figure 8.2A shows the helmet geometry highlighted in red. From this shape, the UV map is created in LightWave, as shown in the lower-left window. Your 3D program will create a UV map from a few different perspectives, and sometimes the shape of the final result is not always intuitive for you if you choose to paint on the texture layer in Photoshop directly. So keep an eye out for third-party programmers who make free UV creation plug-ins for your particular package.

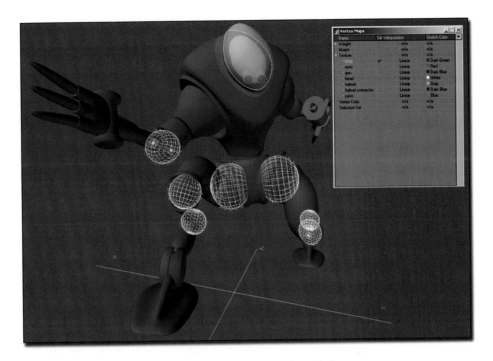

FIGURE 8.1 Surfaces are color coded.

You want something that will simplify the shape of the UV map. For example, Figure 8.2B shows the UV for the android's helmet that was created with a plug-in from LightWave called "Make-UV." You can find it at http://homepage2.nifty.com/ nif-hp/index2_english.htm. As you can see, the plug-in simplifies the shape of the UV so that it is intuitive as to where you will be painting on the geometry.

Figures 8.2C, D, and E show the different types of UV maps created by Light-Wave with Planar, Cylindrical, and Spherical views. Although they will work, they are not as intuitive as the one created by the Make-UV plug-in. You can decide when you assign surfaces to your models what works best for you.

The UV map must be saved as an EPS file so that you can import it into Photoshop as a digital image that you will use to paint on to create the colorful surface of the android. In this example, the LightWave 9's Export command (File > Export > Export Encapsulated PostScript) is used (see Figure 8.3).

Once opened in Photoshop, you can save the file as any format that your 3D program will accept. TIF and JPEG are the most common formats. Figure 8.4 displays the rendered UV map.

The mesh on the image represents the outlines that show the exact layout of the geometry and points on the model. So if you import this digital image back into your 3D model to be applied to the surface it was made from, you will see the texture flowing across the surface of the model similar to Figure 8.5.

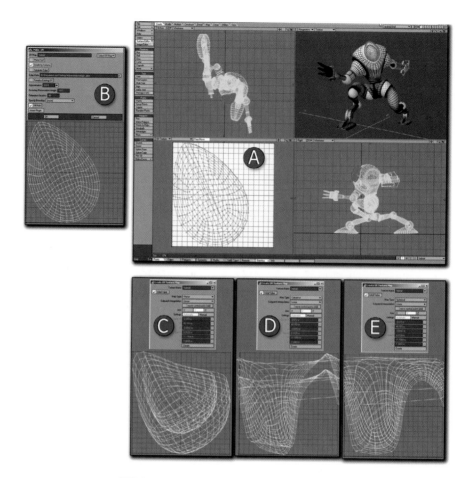

FIGURE 8.2 UV map displayed for the helmet surface.

FIGURE 8.3 View of the Encapsulated Postscript Export command in LightWave 9.

FIGURE 8.4 UV map rendered in Photoshop.

FIGURE 8.5 Results of the UV texture applied to the model.

LET'S START TO PAINT

Let's go back into Photoshop and set up the parameters so that you can paint on the correct surface. Then you can begin texturing the android so that its surface takes on a battle-worn appearance.

1. Go to the 3D palette (Window > 3D) and select Diffuse in the Paint On menu (see Figure 8.6). Note that working in a render mode like Ray Trace often causes a slowdown. Next, go to the Tutorials/ch 8 folder and open android.tif, where you'll find a Photoshop document with the UV maps already applied. To speed up productivity, set the Preset option to Solid and choose Draft for the Anti-Aliasing option.

FIGURE 8.6 Set the painting surface to Diffuse.

2. To start, use a basic round, soft-edge brush and paint an olive color on the surface of the model (see Figure 8.7).
3. You will notice immediately that this functions best when the surface is parallel to the face of your monitor (see Figure 8.8). Use the 3D Rotation tool (K) consistently to make sure that the surface is painted on accurately.

FIGURE 8.7 Use Paint Brush to paint on the android.

FIGURE 8.8 Rotate model to face the monitor surface.

4. Use your 3D Slide tool to zoom in to further isolate the region to be painted. Use this in combination with the 3D Rotation tool to get the best results, as shown in Figures 8.9 and 8.10.

FIGURE 8.9 Zoom in and rotate your model as you paint.

FIGURE 8.10 Results of the painted model.

5. Let's navigate to the weapon that the android is carrying. Select a grayish blue of your choice from the Color Picker and paint the weapon with that color (see Figures 8.11 and 8.12).

FIGURE 8.11 Select a grayish blue from the Color Picker.

FIGURE 8.12 Paint the weapon.

6. Here is the really fun part. Any and all tools can be applied to the surface of the 3D object, so you are going to use the Stamp tool (S) to clone some texture from an independent image onto the weapon. From the Tutorials/ch8 folder, open basic texture.tif and place it side by side next to the android. Use the Stamp tool to grab the texture and paint it onto the weapon (see Figure 8.13).

FIGURE 8.13 Clone texture onto the weapon.

7. Continue to apply paint to the legs and feet. Worn painted surfaces will have variations in color throughout, so change the foreground color to yellow and apply it over the initial olive coat. Move quickly around your model and paint at first with a light pressure to build a blend of the two colors, as shown in Figures 8.14 and 8.15.

8. Add some rusted areas by adding a reddish brown color. Use a brush that has a harsher edge—one of the Chalk Brushes would be good. Set the Opacity and Flow options to Paint Brush and begin painting on the back of the android (see Figure 8.16).

FIGURE 8.14 Apply color to the feet.

FIGURE 8.15 Vary the contrast by applying a yellow hue.

FIGURE 8.16 Add rust to the android.

9. Now, select the Smudge tool and blend the brownish colors with the olives so that the texture looks like it is embedded onto the surface (see Figure 8.17). Use the same brush from step 8 to accomplish this.

FIGURE 8.17 Apply the Smudge tool to blend the colors.

10. Let's add some grunge to the surface. Select the "grunge 005" brush from the menu, as shown in Figure 8.18. Add some additional scattering to the brush to get varying placement of the paint. Next, give the brush itself a Blend mode of Multiply. This will blend the paint as a darker color on the android.
11. Now select your Smudge tool. It should default back to the original brush used before. Use it to blend the grunge texture a bit, as shown in Figure 8.19.
12. Open the texture for the helmet. If you spilled over a bit while painting, then you will see something like Figure 8.20.
13. Fill the painted layer with white so that the result will be a clear glass dome (see Figure 8.21). In the 3D palette, give it an Opacity of 50% so that you can see the head behind the glass.

FIGURE 8.18 Apply grunge to the brush.

FIGURE 8.19 Use the Smudge tool to blend the texture.

FIGURE 8.20 Open the texture for the helmet.

FIGURE 8.21 Fill the layer with white and change the surface Opacity to 50%.

14. Moving forward, let's change the Diffuse color for the ball joints. Open its texture layer and use joints color.jpg to place in a layer above the UV map for the "joints." Instantly, the model is updated, as shown in Figure 8.22.

15. Access the Bump channel for the "head" and load in the head bump.jpg (see Figure 8.23).

FIGURE 8.22 Change the texture for the joints.

FIGURE 8.23 Load head bump.jpg for the head Bump channel.

16. Open the "body" texture and use the body texture.jpg to place on a layer above the "paint" layer (see Figure 8.24). Since you will specify a Blend mode of Darken to the top layer, duplicate it and place one below the paint layer as well. The Darken Blend mode will allow the darker texture to be most prominent.

FIGURE 8.24 Apply the body texture.jpg to the body texture layer.

17. After applying this texture, you will see that the model will display seams where there is no smooth transition. This is unacceptable so use the Spot Healing tools to assist you with blending the texture right on the model (see Figures 8.25 and 8.26).

Reminiscing once again, when you completed your model kits in the past, you would add decals in the finishing stages by dipping them into warm water to activate the glue and applying them to the model by sliding them onto its surface. When dry, your model was ready to display.

18. You will use a similar technique by using an image of a grill to be placed on the belly of the android. Try to have the surface that you will place the decal onto facing straight forward to you. Open grill.jpg from Tutorials/ch8. Place the image face onto the belly of the android and resize it as needed. Use Figure 8.27 as a guide.

FIGURE 8.25 Use Spot Healing to blend the texture.

FIGURE 8.26 The results of the Spot Healing blend.

FIGURE 8.27 Resize and place the grill in front of the belly.

19. Make sure that the grill layer is positioned directly above the android 3D layer. Access the Layer's submenu and choose Merge Down (see Figure 8.28).

FIGURE 8.28 Choose Merge Down from the Layers submenu.

As you can see, the merging is not perfect because the side of the model is not facing forward (see Figure 8.29).

FIGURE 8.29 Results of the Merge.

20. This time, let's turn the model to the side and position one of the duplicated grills so that the ends are located where you want the shape to end and then reapply the Merge (see Figure 8.30).

Now Figure 8.31 looks much better.

Experiment and come up with your own texturing concepts. We will now take the model and place it into the final scene that you created in Chapter 7.

FIGURE 8.30 Reapply Merge technique.

FIGURE 8.31 Results of the Merge applied again.

FINISHING TOUCHES

For the finishing touches, we will use the completed scene from Chapter 7 as the background for the android. You will add some additional lighting effects to the hallway lamps, as well as light the model to integrate it better into the scene.

1. Open the finished scene from Chapter 7 and flatten the layers, as shown in Figure 8.32. This will allow more memory to be available to Photoshop when you utilize the 3D tools. Place your 3D model over the finished scene. Position the lights so that the model appears to receive illumination from the greenish corridor lamps.

FIGURE 8.32 Flatten the image and place your 3D model.

2. Add a new Layer Group and title it "green glow." Place this group on top of the android layer. The goal is to make the android a better part of the environment. User a round soft-edge paint brush to paint the glow emanating into the interior (see Figure 8.33). Do this over several layers for the best control.

FIGURE 8.33 Place a light glow above the android.

3. The corridor is a little dark and dingy so give the android a flashlight on the tip of its gun. Use a soft-edge brush and paint two white lines crossing one another (see Figure 8.34). Change the Blend mode to Hard Light.

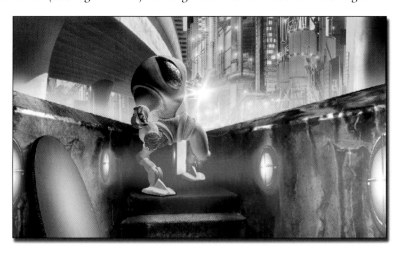

FIGURE 8.34 Use a soft-edge brush to paint in the lens flare.

4. On a new layer, use the "basic smoke with scatter" brush provided for you in the Brush palette. Set your foreground color to white and use a light pressure to apply a steam effect that starts from the top of the manhole toward the bottom of the bridge (see Figures 8.35 and 8.36).

When done, use the Warp Command (Edit > Transform > Warp) to shift the steam toward the right to give the effect that the wind is having a slight effect on the shape of the volume.

FIGURE 8.35 Select the "basic smoke with scatter" brush.

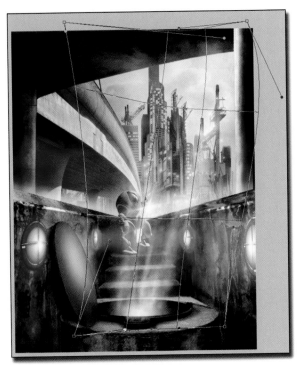

FIGURE 8.36 Paint in the steam effect.

5. Finally, the eyes and the flare detail seem to be drowned out with all of the lighting and fog details added, so use your paint brush again and add a glowing effect to the eyes and an additional flare to the light on the gun (see Figure 8.37).

Now that you have a more comprehensive look at texturing 3D objects, let's explore how to animate them using the Animation tools in CS4 Extended.

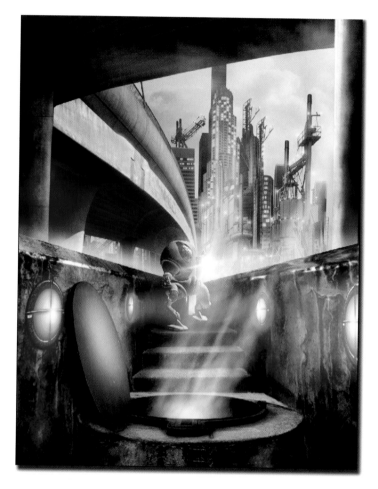

FIGURE 8.37 Enhance the eyes and add additional flare effect to enhance the scene.

WHAT YOU HAVE LEARNED

- The surface that you are painting has to be facing you for the best results.
- How to apply images as if they were decals using the Merge Down command.
- You can use all of Photoshop's tools directly on the 3D object.
- You can use restoration techniques directly on the 3D object.
- It helps to set the Render settings to Solid so that you can work more effectively without any slowdown.
- The Spot Healing brush is a good tool to use for eliminating seams caused by the UV map.

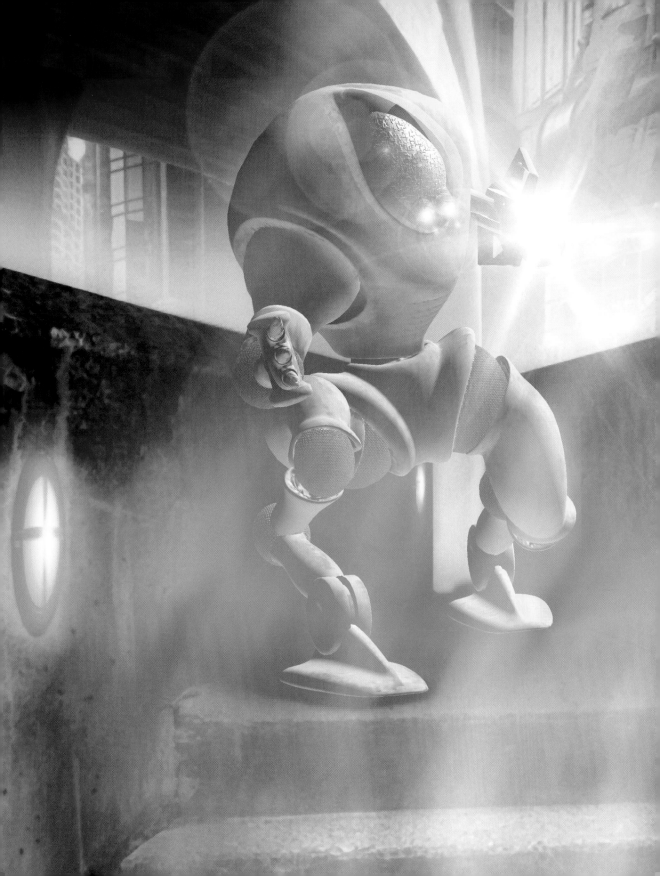

ANIMATING YOUR 3D MODEL

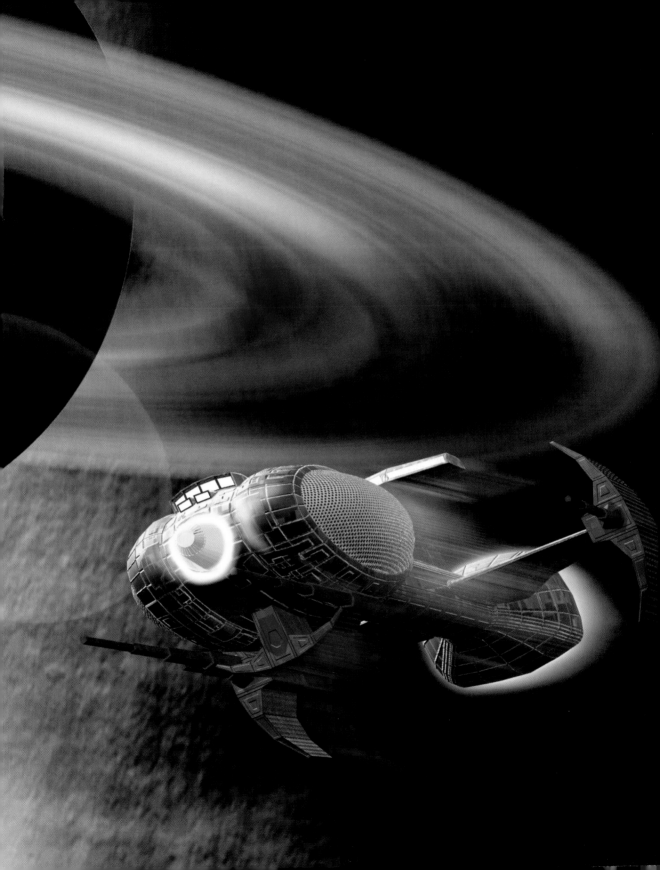

UNDERSTANDING THE ANIMATION TIMELINE

Now that you have a handle on how to texture and integrate 3D objects into your concept art, let's explore another aspect of CS4 Extended. After you have created your scene, what if you want to animate any or all layers in your scene? Photoshop CS4 Extended gives you that capability with the use of the Animation timeline for that purpose.

I am going to start with the finished product from Chapter 6 and explain the functionality of the Animation timeline. Keep in mind that the more layers you have open, the greater the amount of memory and processing power CS4 Extended will require. This is particularly true when you activate the Animation timeline. There are three things to keep in mind when applying animation features. First, it is important to realize that if you have high-resolution images that make up the surface textures of your 3D object, this will slow down the computer's resources. So for practice, you might want to consider reducing your textures so that the file size will be reduced to something more manageable. Second, consider reducing the overall size of the file itself. The animation features in Photoshop CS4 Extended are still elementary so be open minded as to their capabilities and do some experimentation. Finally, make sure that the Rendering intent is set to Solid instead of Ray Tracing and that Draft is chosen for the Anti-Alias setting instead of Best (see Figure 9.1). If you don't choose these settings, CS4 Extended will consistently try to render a higher-quality output each time you apply a change to the timeline.

FIGURE 9.1 Change the Render setting to Solid and Anti-Alias to Draft.

To further conserve your resources, merge all of the layers that make up your background so that you have the 3D Object layers above it. For your convenience, you can use the 3D starship and the background located in the Tutorials/ch9 folder. Open the background and place the starship above it. Duplicate the ship twice so that you will have three starship layers. Place them according to what you like for the starting position and let's begin.

1. Open the Animation palette (Windows > Animation) and notice that every layer has been given its own timeline. The layer that you have selected in the Layers palette will be highlighted automatically on the timeline. In this example, you have the background image and three copies of the 3D starship (see Figure 9.2).

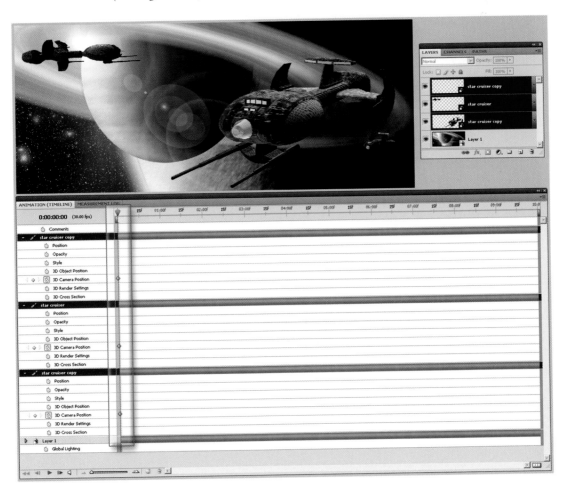

FIGURE 9.2 View of the background and the 3D objects.

2. Select all of the star cruisers. On the timeline, open the animation variables by clicking the triangle that is to the left of the title on the timeline. You will see the variables to animate for 3D objects (see Figure 9.3). They consist of Position, Opacity, Style, 3D Object Position, 3D Camera Position, 3D Render Settings, and 3D Cross Section. With the playhead at frame "0," create a keyframe for the 3D Camera Position for each ship by clicking the yellow diamond to the left of the timeline title.

FIGURE 9.3 Create the keyframe at frame "0" for each layer.

3. Let's animate the 3D Camera Position to make the ship fly from the scene and off the page (see Figure 9.4). Next, move the playhead to approximately three seconds and move the 3D Camera for the larger ship in the foreground. Move the ship so the star cruiser is positioned toward the bottom left and off the canvas. In three seconds, the ship will move from its standing position and off the page. Do this for all of the other ships by using varying time distances to portray different speeds for each ship. As you can see in Figure 9.4, each ship after the larger one is animated later in time to give each one a unique speed.

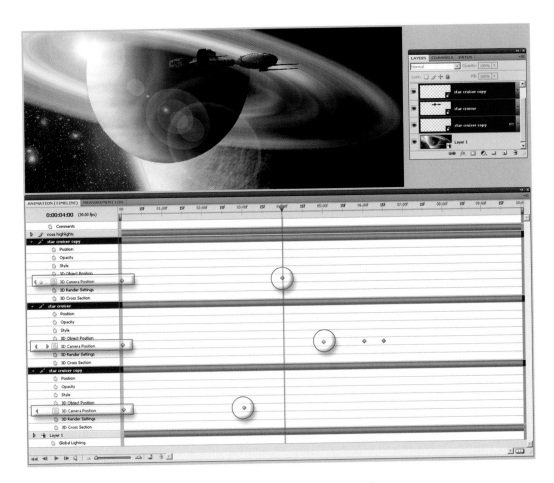

FIGURE 9.4 Animate the 3D Camera Position.

TAKING A CLOSER LOOK AT THE ANIMATION CAPABILITIES

As you can see, you can animate any and all of the 3D ships in any direction that you want, but let's simplify this process and take a closer look at the animation capabilities.

1. Go to your tutorial folder and open star ship.psd. Use your 3D tools to place the ship in the upper-left portion of the composition. Now, establish a keyframe at frame "0." Use Figure 9.5 as a guide.
2. Place a keyframe at one second and rotate the ship so that it points toward the lower-right corner (see Figure 9.6). Scroll the playhead to see the animation results.

FIGURE 9.5 Open star ship.psd and set a keyframe at frame "0."

FIGURE 9.6 Set the keyframe at three seconds and rotate the ship.

3. Now, place a keyframe at four seconds and move the ship to the lower-right corner and rotate it (see Figure 9.7).

4. Add an additional layer above the star cruiser and with a soft-edge brush, paint a reddish flare that covers the diameter of the starship's engine (see Figure 9.8). Title this layer "flare." Notice that another timeline has automatically been created. Apply some Gaussian Blur to soften the edge. Next, give it a Blend mode of Lighten. Position it in front of the engines to simulate an energy signature.

5. You will now use the timeline to animate the Opacity of the flare so that it will only become visible as a 1/2-second blast to launch the ship forward. At frame "0," set the flare's Opacity to "0" (see Figure 9.9). The ship will be at its starting position.

FIGURE 9.7 Move the ship to the lower-right corner.

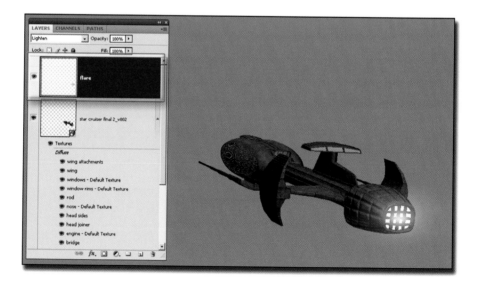

FIGURE 9.8 Create a flare on an additional layer.

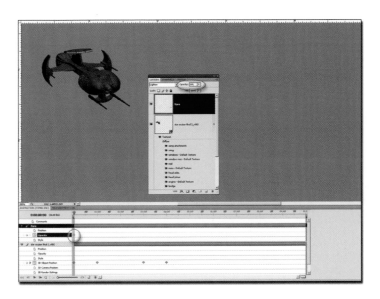

FIGURE 9.9 Take the Opacity of the flare to "0."

6. At the "4 second and 15 frame" mark on the timeline, set the flare's Opacity to 100% (see Figure 9.10). In addition, place a keyframe at the same location for the Styles timeline, and we will animate that in the next step. You can animate your layer styles effects as well.

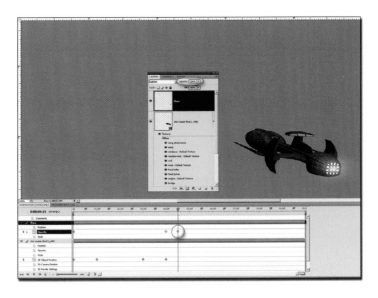

FIGURE 9.10 Take the Opacity of the flare to 100%.

7. Double-click the right portion of the flare layer to open the Layer Style palette. Add an inner shadow using a yellowish color. Also, add an outer glow using the same color and keyframe as the one you used at the five-second mark. Use Figures 9.11 and 9.12 as a guide. Figure 9.13 displays the styles attached to the flare.

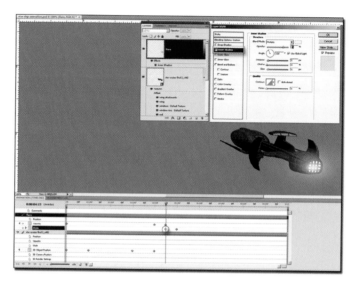

FIGURE 9.11 Apply an Inner Shadow style.

FIGURE 9.12 Apply an Outer Glow style.

FIGURE 9.13 Layer styles attached to the flare.

8. Within the next 15 frames, you want simultaneously to move the ship to the upper-left corner and fade the flare effect to 0%. Select both keyframes by selecting one and using the Shift key to select the other. With that keyframe still selected, right-click it and use the Copy and Past Keyframes command to duplicate it into the "5 seconds and 15 frame" location (see Figure 9.14). When you paste it, make sure that the playhead is on the "5 seconds and 15 frame" mark (see Figure 9.15). Now, use your 3D Pan tool to move the ship to the top-left corner and then use the 3D Slide tool to place the ship further into the background (see Figure 9.16). This will simulate the ship moving quickly forward after the energy discharge from the engine. Then set the flare layer Opacity to 0%.

FIGURE 9.14 Right-click and choose Copy Keyframes.

FIGURE 9.15 Right-click and choose Paste Keyframes.

FIGURE 9.16 Use 3D navigational tools to reposition the ship.

Create another keyframe at "5 seconds and 16 frames" for the ship and use it to make the ship 100% transparent; set its layer Opacity to 0%.

You can place any background where you would like to add a story to the scene (see Figure 9.17). I provided a simple one for you called planet.jpg. Play around with different ways to animate your objects and have fun with them.

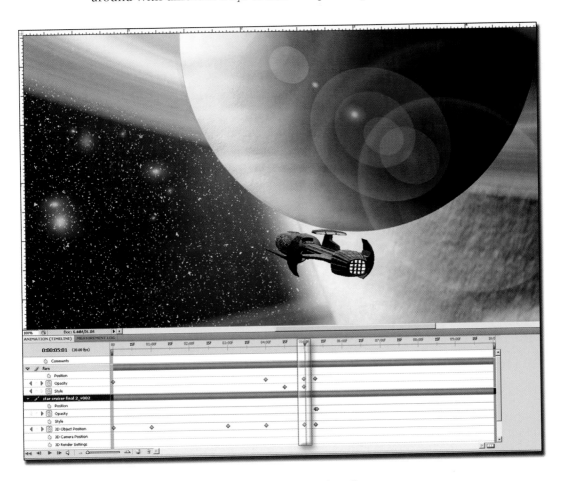

FIGURE 9.17 Add a background to tell a story.

ADDITIONAL NOTES ON ANIMATING EFFECTS

Also, keep in mind that you can animate every 3D feature in CS4 Extended, including color transformations, in the Layer Styles. Figures 9.18 through 9.21 display the color and width of the Stroke being animated over one second of time, as well as an Outer Glow and Color overlay being applied with an additional one second of time.

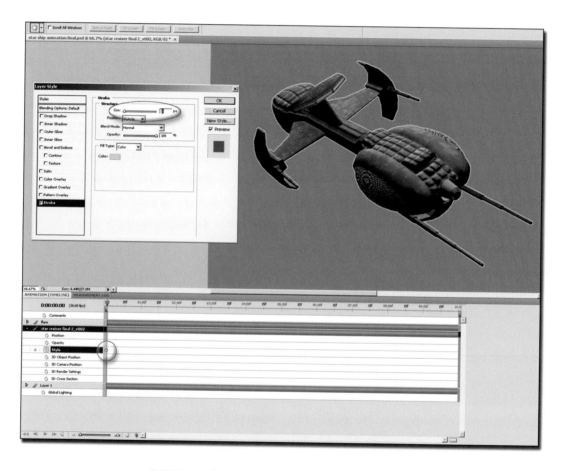

FIGURE 9.18 Three-pixel Yellow stroke applied at frame "0."

FIGURE 9.19 Ten-pixel Red stroke applied at the one-second frame.

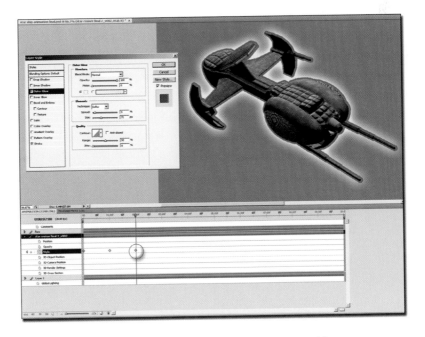

FIGURE 9.20 Outer glow applied at the two-second frame.

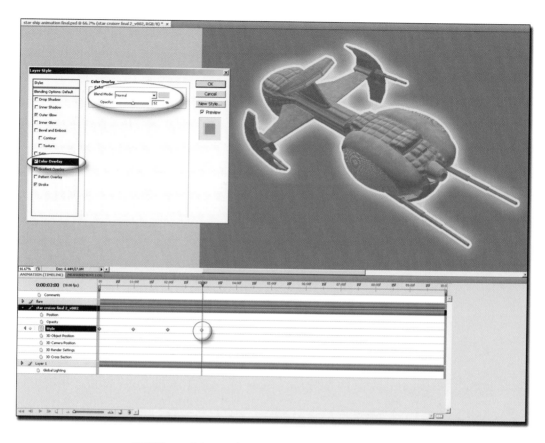

FIGURE 9.21 Color Overlay applied at the three-second frame.

Next, you can animate the Cross Section command. Notice in Figures 9.22 and 9.23 that the Layer Styles effect includes the cutting plan as well.

As a final note, if you want to duplicate a layer with all of the keyframes that you established, then select the timeline for that layer and access your submenu located on the top right-hand corner of your Animation palette and choose Split Layers, as shown in Figure 9.24. This will duplicate both the layer and its timeline so you can add additional objects like a fleet of ships moving in the same direction.

We're finally done. Please experiment as much as possible. Although it would be nice to animate features like Smart Filters, you already have much to work with. Try experimenting with animating your Adjustment layers and masks as well and see what you can come up with.

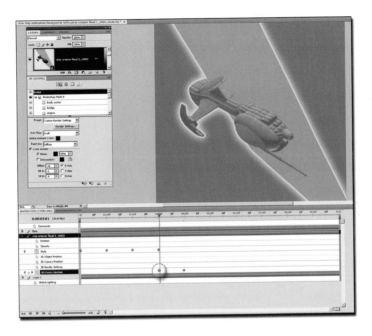

FIGURE 9.22 Cutting Plane applied vertically at the three-second keyframe location.

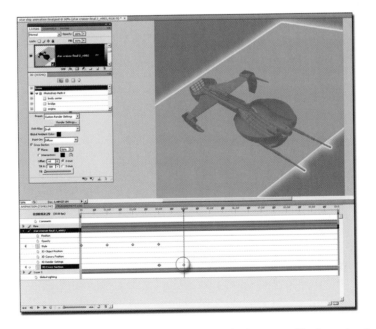

FIGURE 9.23 Cutting Plane applied horizontally at the four-second keyframe location.

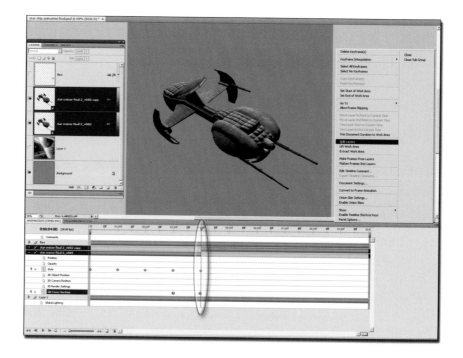

Figure 9.24 Use Split Layers to duplicate the timeline.

I hope that this book has given you some insight as to what you have to look forward to in Photoshop CS4 Extended. Experiment and have fun creating your masterpieces.

Enjoy,

Stephen Burns (www.chromeallusion.com)

WHAT YOU HAVE LEARNED

- You can animate any 3D object using its 3D navigational tools.
- All layers in your file are given an independent timeline with which to animate all objects in that layer.
- Once a timeline has been established, it can be duplicated, which will, in turn, duplicate the associated layer and all objects residing on it.
- You have the capability to animate a 3D object's Cross Section.

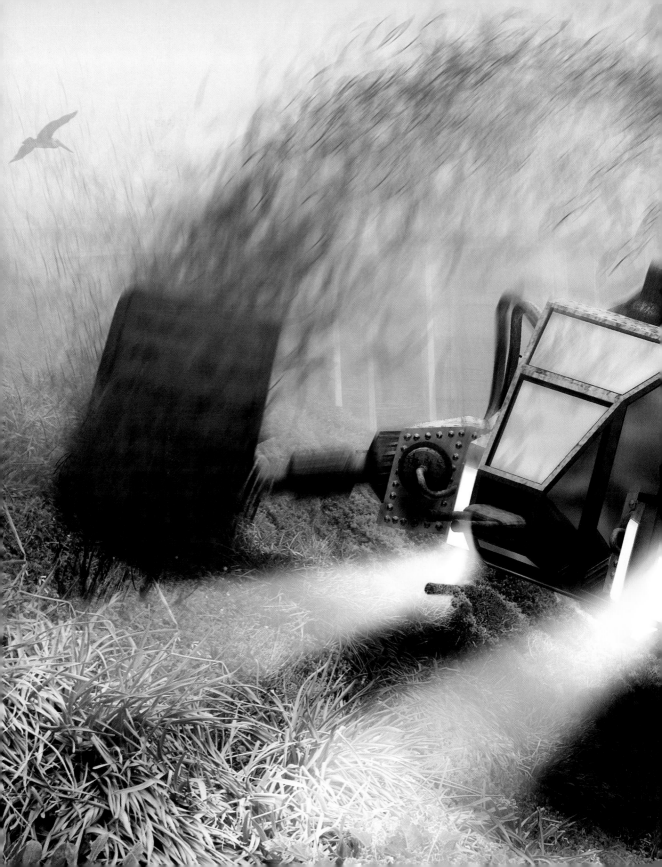

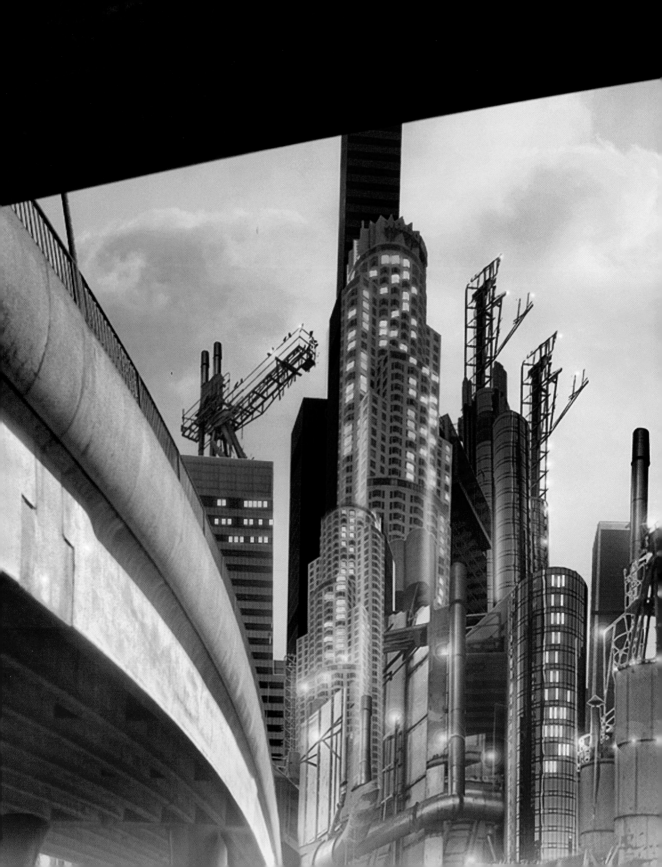

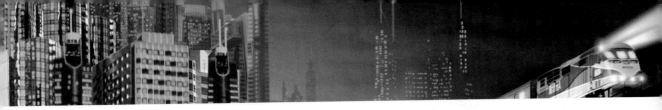

INDEX

"\" key, 67

A

ACR (Adobe Camera Raw)
 customizing through Options panel,
 34–36
 features in, 38–42
 interface, 29–34
Adjustment layers, 68. *See also specific*
 Adjustment layers by name
Adjustment palette, 236
Adjustments submenu, 13
Adobe Bridge
 Camera Raw Preferences, 31
 interface, 20–22
 opening images in ACR from, 30
 viewing options, 22–24
 workflow in, 25
Adobe Camera Raw (ACR)
 customizing through Options panel,
 34–36
 features in, 38–42
 interface, 29–34
Advanced Dialog button, Photo
 Downloader, 46
Alignment tool, 34, *35f*

Alpha channels
 creating layer masks, 67
 creating masks from channels, 79, 81
 editing, 64–65
 overview, 63, *64f*
Alt/Option modifier, 95, 135, 149
Ambient color swatch, 3D Materials panel,
 113
ambient lighting, 204, *205f*
Angle Jitter slider, Brush palette, 16–17,
 257, *258f*
animated paint brushes, creating, 16–18
animating
 3D models
 capabilities, 333–341
 effects, 342–346
 timeline, 330–333
 with Open GL, 2
Animation palette, 331, 344
Animation timeline, 330–333, 335, 337, 344
architecture. *See also* cityscapes
 adding light poles to, 155
 creating additional to frame composition,
 186–192
 creating upper, 182–186
 editing UV maps on 3D objects, 226–228
 integrating photography and 3D objects,
 175–180

Note: Page numbers referencing figures are italicized and followed by an "*f.*"
Page numbers referencing tables are italicized and followed by a "*t.*"